First published in the United States in 2000 by Chronicle
Books

First published in the U.K. in 2000 by Laurence King
Publishing

Text copyright © 2000 by Lewis Blackwell
Designed by David Carson

Library of Congress Cataloging-in-Publication Data
available.

ISBN 0-8118-3024-1

Printed in Italy

Distributed in Canada by Raincoast Books
9050 Shaughnessy Street
Vancouver. BC V6P 6E5

10 9 8 7 6 5 4 3 2 1

Chronicle Books LLC
85 Second Street
San Francisco. California 94105

www.chroniclebooks.com

Revised EDITION

The End of Print: The Grafik Design of David Carson

BY LEWIS BLACKWELL + DAVID CARSON

CHRONICLE BOOKS
SAN FRANCISCO

His work sought to reconnect with audiences for whom print had failed in its emotional range, and as a result had often failed to engage readers at all.

Hello David

Dear Tony

My name is Tony Atherton. I am a third-year-degree student in electronic graphics at Staffordshire University in England.

I am currently writing a design research report on contemporary graphic design legibility. In order to complete this research, I would be grateful if you could answer the following questions:

DO YOU THINK THAT YOUR WORK HAS STARTED A DEGENERATED STYLE TREND INFLUENCING PRESENT YOUNG GRAPHIC DESIGNERS, AND IF SO, WHY?

HAS YOUR WORK CREATED A STYLE-OVER-CONCEPT WAY OF WORKING?

YOUR WORK COMMUNICATES EFFECTIVELY TO ITS TARGET AUDIENCE (GENERATION X). SHOULD IT NOT ALSO COMMUNICATE TO PEOPLE WITHIN A WIDER RANGE OF SOCIETY?

DO YOU FEEL THAT YOUR WORK RELIES TOO MUCH ON STYLE RATHER THAN CONCEPT TO COMMUNICATE ITS MESSAGE?

My name is Lewis Blackwell. David Carson forwarded me your email some time ago. Did he ever reply? If not, I'll do it now and I'll remind him he owes you a message, too. He can be a little hard to pin down at times. Much to some people's chagrin, he still does spend a fair amount of time off surfing or doing something other than working. He does the things that inform his graphic design (not that he does them for that reason).

Your letter comes at an opportune moment. It is a concise introduction to some of the reaction to *The End of Print*. You suck up five years of critical comment on the work and summarize it in less than a hundred words. Such crisp analysis is something I could use right now as I write the foreword to a new edition of the book.

The reason for doing the new edition is that the original has come — for good or bad — to be one of the defining books on design at the end of a century, of a millennium. This claim may be made based on its popularity with younger designers. In more than just the title, it seemed to encapsulate some sense of an ending. The pages prompted debate about print culture being at an end and agitated commentators for and against, with enthusiasm for the work being countered by a few vitriolic critics.

Perhaps it is time to weigh this material. Clearly not objectively, because just like those fans and critics, we cannot be objective. But we can be analytical, and we can have fresh thoughts. Instead of continuing to reprint the earlier version, which is no longer where David or I or any reader quite stand, we want to frame it and discuss it and make it into an active contribution for now.

First of all, the answers you requested:

No.

No.

No.

No.

If these replies seem a little abrupt, if they don't fill out what you need for your professors, then you might want to read on while waiting to see if David replies. But believe me, this one word repeated is the answer you seek. Design is what you do, not what you think. Master a few practical, technical things, then start thinking about all the other things that really make a difference and underpin doing design well. We need to think

Looks like your phones and fax won't stop ringing from here on out! If I may offer a word of advice--save your money--they like to build you up and then rip you down.

f⸴⸴k to you soon.

after a front-page article in a section of *the new york times*. carson received this fax. 1994

about all the other incredible information out there that has a bearing on what a designer does, not on what some previous designer did. (Yes, I know this is an argument for throwing this book in the trash — or at least the words.) Perhaps that is the single best lesson to take from Carson's own career: his difference comes from what came before he designed, rather than what he has in common with the graphic design world. It is by far the most preferable way of designing — to not design according to any book. Good designers look outside design for influences. They see something significant in the world beyond their own culture and help it develop.

I shall now attempt a more detailed answer to your questions.

DO YOU THINK THAT YOUR WORK HAS STARTED A DEGENERATED STYLE TREND INFLUENCING PRESENT YOUNG GRAPHIC DESIGNERS, AND IF SO, WHY?

Looking around, there doesn't seem to be much evidence that the Carson influence has caused anything degenerate. Rather, it helped regenerate interest in the issues of graphic design, taking them away from the dry and remote theories that no longer seemed relevant and encouraging graphic designers to dream that they are makers who can question and change the world a little. The kind of work that makes up the bulk of this book did — perhaps even still does — provide some stimulation for students and practitioners. It encourages them to experiment in a way that is not in the syllabus, it asks them to look for differ-ence and go there. And, yes, I suppose many did at first reduce Carson's visual elements to man-nerisms, as they took the work apart and started reconstructing their own version. But when you look at any magazine rack, television broadcast, piece of advertising, whatever, you do not see work like this. It has not prompted a wave of styl-istic similarity. What you see everywhere are graphics that, for the most part, don't look a whole lot different from those we saw a decade ago. The visual revolution is still to come. What we see around us follows genre or corporate rules, pays lip-service to some hand-me-down modern ideas of typographic construction, ideas rooted in the mechanisms of earlier print culture. The odd exception stands out and exposes the general con-servative mass.

This lack of radical change is to be expected, given our natural resistance to change, but I doubt whether it is a good thing. Resistance to change, conformity, in an activity that can be so expres-sive, is a sign of our fear. It hides the fact that, underneath the graphic surface of our day, there

has been massive development. The way in which communications are produced has undergone a radical transformation (in 1990, you could still hear designers questioning how pervasive comput-ers might become — now design is all digital apart from quaint exceptions), and the media context into which they fall is also rapidly shifting (the Internet). Despite *The End of Print* forecasting a radical evolution in visual culture (and our thoughts came true with the Internet revolution and Net fever of the last three to five years), the ideas of how this evolution would drive a much more fluid media have yet to be truly realized. The forces of dogma and of old-style rationalism ensured that much of what *The End of Print* offered still appears radical. Note: this is not about sur-face style, but about the underlying reason why these graphics happened to look and work the way they did. I say "did", because now they work in a different way, now they are used a little more. But they are still about change, rather than stasis and safety and stability — which is where the mod-ernist orthodoxy holds us.

So were we wrong in suggesting that the end of print was nigh? Of course not! I could be very tedious and quote from the numerous statistics that show how much activity has moved to email and websites, chat rooms and channels, portals and vortals and snortals. Indeed, I will be that boring later. But the look of this stuff is still in its toddler phase. When the much-vaunted broadband communication comes along worldwide, it will be possible to have rich, fluid graphics that can incor-porate both still and motion media to deliver visu-als more intense than traditional print. *The End of Print* showed work that pushed print, that chal-lenged it to respond to a society in which tradi-tional reading behavior was not how younger con-sumers took in information. (No, strike that: as research into book buying and newspaper reading shows, the reality is that the description "multi-media consumer" applies to almost all age groups in the Western world — studies demonstrate that most people do not read orthodox texts but get information in soundbite form from all over. This is not an endorsement of such literacy, but the reality.)

The multimedia richness of the pages of, say, *Beach Culture* or *Ray Gun* was an experimental statement about how information might be deliv-ered differently to stimulate a new way of engag-ing with text. I am not claiming great prescience here: these magazines were not designed with some grand agenda of anticipating the future. In fact, Carson has always resisted getting over-enthusiastic about the Web and criticizes the bandwidth restrictions as an obstacle to the work he would like to do. However, he has always designed with a firm awareness that the media

reality of his audience was one in which television, radio, and advertising saturation was an overpow-ering stimulation, eclipsing the dull orthodoxy of print. His work sought to reconnect with audiences for whom print had failed in its emotional range, and as a result had often failed to engage readers at all.

Carson's work does not really have significance in influencing a style of graphics. Some of the "style" aspects of it would have happened any-way, were happening, as digital technology invited graphic designers into the realm of typographic construction to a much greater degree. How *The End of Print* and the work connected with a trend, indeed trends, is more complex than noting a few stylistic mannerisms.

But here they are, those mannerisms, those tricks and tics that could be appropriated stylistically. Yours to pick'n'mix.

Changing type sizes and fonts

Unusual or custom fonts

Richly cluttered pages

Stripped-down pages

Mistakes

No grid

Big ideas

Typographic play was the trick that stood out first. From *Transworld Skateboarding* and other work undertaken in the 1980s, Carson was already attempting to disrupt preconceptions about how and where the relationship between headline, cap-tion, body text, image, and page border was established. Into the editorial mix he threw "big ideas" for openers and constructions, sometimes visual puns, sometimes more subtle or disturbing thinking. In doing this he was merely bringing the influence of advertising and pop videos, of mass communication, into the editorial equation. Nothing too radical, really, except that most art directors subscribed to the genre and construction of their particular magazines, rather than seeking the direct path. Carson did not observe, or perhaps did not really know, these rules. And so he put into his layouts the tricks and techniques that he had taken out of mass communication: television, movies, and ads were his primer, along with the expression of the subcultures he worked within. These were his rule book, his influences, more than anything he received from design.

When stripped down to its components, none of the mechanisms of his work could be claimed as revolutionary. Dadaists and Futurists performed some of the same graphic tricks with fonts around the time of the First World War, but for different purposes. The postmodern exercises of Wolfgang Weingart in the late 1960s and early 1970s, followed by the work of April Greiman and Dan Friedman in the late 1970s and early 1980s, could also be identified as part of this change: subverting the grid, aggressive reversals, surprising type-size changes. Meanwhile, in the 1980s, the likes of students at Cranbrook and CalArts in the U.S.A., or the more avant-garde Dutch designers or students at the RCA in London, were all experimenting with type and layout. Nothing new there. Of course they would, and nobody ever claimed otherwise. It is easy to disprove the carping of those who have suggested that Carson hijacked other people's innovation and work in the mid- to late-1980s; look at his first graphic exercises in 1982. From the outset, his approach was expressionist, with its own flavor, however raw it was in its techniques at first. For all that you can place the work in a line and at a time, Carson's pages looked different. Not just a little, and with *Transworld Skateboarding* and then *Beach Culture* they really started to have impact – and to win acclaim from his peers. The difference was how he put all the bits together.

For all the praise that started to come Carson's way, from as far back as the 1980s, you will not find similar work that borrows from him and applies the look. This is because there are no clear rules. As it is based to such an extent in the personal, intuitive reaction, it does not lend itself easily to copying – there is no guide to follow. For example, by the time everybody started mixing up different fonts, Carson was stripping back to a minimal palette of typefaces. And again: he was using illustration in an unusually open way, drawing in many unconventional styles and ways of conceptualizing throughout his time on *Ray Gun*. While that practice might be linked to the current "new illustration" trend, the look is different.

The charge of causing a "degenerate" culture can be dismissed. The only possible way of making it stick would be to blame him for the current plurality in graphic design. Yet that plurality of values is everywhere. Graphics reflect that culture of doubt, seeking, and choice. We could counter this accusation, praising him for encouraging a pluralistic, expressionistic culture. How about charging him with causing a regenerate culture of enthusiasm for graphic invention? A case could certainly be made for that.

HAS YOUR WORK CREATED A STYLE-OVER-CONCEPT WAY OF WORKING?
Even the harsher critics might admit that there

are some ideas in the work, some ability to create concepts. After all, if there were no ideas to grab hold of, the work would have as much effect as a lively sheet of wallpaper. But this question, from its aggressive no-room-for-argument position, does get to the nub of one reaction to the first edition: that the work is all about being a master of a style. But look at it and you have the material to argue strongly that there is not one style. (And that is perhaps the point of departure for a different and sharper critical questioning.) If you are doing things without a grid, with no continuation from one spread or ad or cover to the next, then a single style is hardly likely to develop. What binds this stylistic diversity together, however, is the coherence in the thinking, in the concepts that come across. Perhaps the tendency to view this as a "style" is a result of seeing great variation as a clear point of difference, a position that opposes the uniformity and rules characterizing most layouts.

The 27th issue of Emigre magazine was almost completely devoted to Carson and his work. To this day, he remains the only American designer so honored. In this opening spread, Carson incorporated a technique learned from his Swiss teacher Hans Rudolph Lutz, and utilized the photocopier machine to arrive at an image that resembled two figures quarreling...

This question made me reread some of the text in the first edition of *The End of Print*. Did that not deal with this concern? It did, but clearly to little or no effect for you, Tony. From the preface by David Byrne, through parts of my text, to the variation of the layouts themselves, comments were made about the conceptual side of the work. But for the best defence, perhaps we should turn to one of the more dogged critics of Carson's work, the design writer Rick Poynor. In a lengthy review of the first edition, he aggregated his discussions with selected critics to suggest that Carson's skill was for a "synthesis" of other people's ideas, arguing that Carson

managed to put the results about with a talent "that verges on genius." (As if this were not how all art, design, or culture in general progresses, through powerful work being effectively distributed.) That Carson had an ability to carry such synthesis to a high level of provocation suggests thoughtfulness, even if you might argue that the result was superficial stylistic appropriation (which would seem to be the implication of Poynor's long, browbeating piece). Poynor also writes that Carson got away with introducing "big ideas" thanks to the generous slack he was cut by his editors, and that was why he achieved such a high profile. So you could either say that Carson seized opportunities with both hands, or accuse him of being an opportunist. Poynor quotes Rudy VanderLans, another commentator pulling a critical punch, on how Carson resorted to shock value rather than progressing "toward something a bit more challenging." What this challenge might be was not revealed.

I agree in part with both Poynor and VanderLans: Carson resorts to provocative statements, things that really excite in purely graphic terms, but often do not have a whole lot more to say than "look at this, look at it now, look at it and explore." My difference in position might be that I can't see what's wrong with that. The duty of a graphic designer is to provide a visual experience that communicates the given content effectively. If that designer's work seems to be saying some pretty potent things about the changing values of our time, well that's good – and the response to Carson would suggest that he has achieved this. He did not have to take on global capitalism or arcane points of design theory to achieve impact with his work. When you explore his pages or films, the elusiveness of the precise reasoning behind the form ensures that there is a vast territory of further meaning (it doesn't matter whether or not those meanings are intended, but rather how interesting or valid the meanings are that we extract). That is because his approach, his core concept (rather than his style) is always to be leaving things slightly unresolved, slightly unsaid. There is a conceptual space that extends beyond whatever graphic concepts he has introduced, a space in which the viewer can respond

and construct meaning. You could draw analogies between this approach and other applied and pure arts.

The difference between this kind of graphic design and a more rationalist approach is the difference between an abstract painting and a wiring diagram. They could actually be very similar graphic objects, but one has a very locked-down meaning, one opens out to infinite possibilities. Carson's work takes the latter approach – because it often can. This is not to say that his graphic design would always be so deeply personal, so indulgent in randomness and mystery, but that he tends to have that space to explore in the kind of projects he does. Yet, as Carson said himself, if he were designing the instructions on an aspirin bottle, he would handle it very differently from the kind of layouts that tend to appear here. He would find the response that seemed appropriate, he would look for that point that lies at the interface between his graphic lexicon and the likely needs and experience of users opening the aspirin bottle. The approach would not be about imposing a style, but about evolving a conceptual path to communicating the necessary and the desired. With aspirin bottles, "necessary" probably runs well ahead of desire-provoking, multiple messaging.

To conclude "style-over-concept" thoughts: let's not forget that style is in itself a concept, and made up of a synthesis of concepts. It is a shorthand, a reference to other ideas. Used carelessly, it becomes meaningless, but if stylistic elements are part of a conceptual solution, then you can feel virtuous. The real trick in all this is to ensure that the varied or precise group of viewers that the work is designed for respond to, and understand, the point of the exercise, style or no style.

The debate of "style-over-concept" is a false one. It comes down to this: style that works is a concept, and a concept that doesn't work has not been styled effectively.

YOUR WORK COMMUNICATES EFFECTIVELY TO ITS TARGET AUDIENCE (GENERATION X). SHOULD IT NOT ALSO COMMUNICATE TO PEOPLE WITHIN A WIDER RANGE OF SOCIETY?

We have a number of assumptions here, ones that have been made before about the appeal of magazines, commercials, posters, and other work by Carson. The first assumption is that it *does* communicate effectively – let's not jump to that conclusion. *Beach Culture* and *Ray Gun* magazine are no longer around, and Carson no longer works with many of the clients

he used to. So if you want to play the critic, you could add two and two to make five and say he has a record of failure, unable to sustain anything effectively, his work a mere passing fad (which your line of questioning seems to be suggesting anyway). The second assumption is that Generation X is easily defined. Well, just what age, location, wealth, color, creed, and so forth defines Gen-X? It's a good game for the planning departments of advertising agencies, but the reality is that such groupings are not so easily nailed down. And the third assumption: When you do get your cluster, are they somehow less significant for being a group, a group that is highly sought after, notoriously hard to target, and yet is as powerful and emblematic a group as you might define at this time? The answer is no, the work does not always target this group, and no, there is no obligation to communicate more widely. But that is not to say that Carson's sundry work for publishers, agencies, and others has not communicated pretty widely. That *Newsweek* and other general press wrote about *The End of Print* shows they found the content relevant to their wide audiences, even though it supposedly targeted Generation X. In the final analysis, there is only one society worldwide, and it gets smaller (and faster) as the media gets bigger. Given the chance, I guess Carson could do something interesting and valid with a children's book or an annual report. Do you really doubt that? Come to think of it, children's books are one area in which you are most likely to see a freer exploration of type and image combinations of the kind Carson is known for. Is Lewis Carroll or Dr. Seuss really his inspiration? Add that to the charge sheet!

DO YOU FEEL THAT YOUR WORK RELIES TOO MUCH ON STYLE RATHER THAN CONCEPT TO COMMUNICATE ITS MESSAGE?

Hey, Tony! Wake up! Isn't question four much the same as question two? It's the same point, but you have just styled it differently.

I have answered the questions. I could answer them again, differently. That's the fun of an age of plurality. As to where I stand: I stand for questions, and this work prompts questions – it is unresolvable. I am confident that critics will never be able to bottle how the work works, exists, or why it had or has impact. I am happy to leave them to their pickling.

Is there anything left to say? Just this.

Way back in 1995, to say that the deconstructing graphics featured in the book were an indication of massive industrial change seemed to some to be unsustainable. The Internet was firmly established, but few believed it would

move so rapidly to become the overheated commercial reality and hype that it is today. It was only beginning to be talked about seriously as a force of major change. By 1996, the projections of Internet growth were starting to rocket, and now we know just how fast industrial change can move, and how new ideas and new money can take over. The AOL merger with Time Warner, the world's biggest convergence of money, was confirmation of this. The front-page news story told of an Internet business that had swallowed up many of the most venerable brands and content in the print, film, and TV media. AOL's intention was to lever this old media content onto the rapidly evolving webspace and ultimately to dump the old media. If such business activity seems to involve a certain amount of hype, it also involves a certain amount of hard evidence: the U.S. magazine industry has seen a 50 percent decline in overall ad pages in the 1990s compared with the 1980s, while American newspapers have continued their thirty-year losing streak on circulation. We were not that provocative with our title.

One aspect of the work in *The End of Print* is about celebrating the multimedia, multiprocess potential of graphics today. It seems credible now to claim that the print media is evolving through a late stage of development where it will become, or is becoming, increasingly marginal as a mass medium – back then in 1995, it proved incredible to many. Today, despite all that has happened and that is projected to happen in the next few years, there are still those who cannot accept that the costs and limitations of print will condemn it to exist as a specialist medium rather than as a means of true mass communication. Indeed, mass communication has been redefined by the digital revolution: it means as much "mass-customization" as the brute generalities delivered by print. Websites and emails are rapidly eroding the need for printed paper. Now we are a little clearer on how *The End of Print* links to our general culture. There is nothing challenging in the idea that print is most definitely a "sunset industry."

The End of Print made no huge claims to understanding how this process of change would happen but recognized that in the distressed, decayed, unreadable, and technology-celebrating forms of its pages, there was an intimation that we were at a crucial point of change in print communication. "The End of Print" was a title that simply captured the notion that we were seeing the end of our certainty in print as The Communicator – an illusion that was long overdue for destruction. The work celebrated the resonance of print and its processes, as well as the potential for a more intense visual media.

œ　‡°g·;̣ˇˊC~D@C→@CIntro
﹛ction by Tom Wyatt

For those of you too young to remember David Carson, here are some guide notes.

In the April 2000 issue of a magazine I have on occasion contributed to, an article began: "In the old days of design — and not too long ago — individuals carved a name for themselves: Rand, Brody, Carson. The books they published served as personal manifestos and their reputations as gurus grew strong. But this is changing."

It went on to claim that in the age of new media, the group is the dominant heroic model. We shall see: **HISTORY STANDS WITNESS TO THE FAILURE OF THE GROUP TO EVER TRIUMPH LONG-TERM OVER INDIVIDUAL LEADERSHIP.** Heroes are spotlights turned on our individual and collective needs and aspirations. But the slightly ironic yet serious point of the article contains bold assumptions: that Carson embodied the 1990s, Brody the 1980s, and Rand stood for the rest of time, flattering and insulting to all concerned. Can any designer really sustain such a position?

Possibly. Let us recap on the modest phenomenon that was the first edition of this book. Published in fall 1995, it is reputed to have sold more than any other design monograph up to now. Which in itself is perhaps no big deal. We're not talking John Grisham or Stephen King. This kind of graphic design is still an acquired taste. But we are addressing a significant event in one corner of the industry that shapes the look of our communications the world over.

More significant than the book's sales was the wave of coverage, events, and discussion around it. As a result of the publication of *The End of Print*, David Carson cemented his reputation as a major innovator in graphic design and was soon heading an international group of followers. This group assimilated ideas through talks and workshops around the world, through articles in a wide range of press, and through broadcast coverage and exhibitions in many major cities. And, of course, through Carson's work itself — magazines, ads, films, and more. The followers constituted a group with no agenda, no creed, no structure. That was perhaps the reason in part for the movement's easy growth and also for its dissolution. There are many designers out there who must have been influenced by Carson to some degree (even if it was in reaction to him), and yet their work is their own: it does not follow any rules that Carson laid down. And if you don't set rules, only pass out attitude, you don't get to build a church. There will be no assembly on Sunday, no grids on Monday.

It was in the nature of Carson's self-expressive work, and in that of his followers, that you could not sign up to the movement or its "principles", but simply empathize with them through the appearance of similar work. In many ways, the course of this movement had run as soon as it was apparent that there

"History stands witness to the failure of the group to ever triumph long-term over individual leadership."

Table of Content. (New uses for print: coffee table books) By Geof Kern, 2000

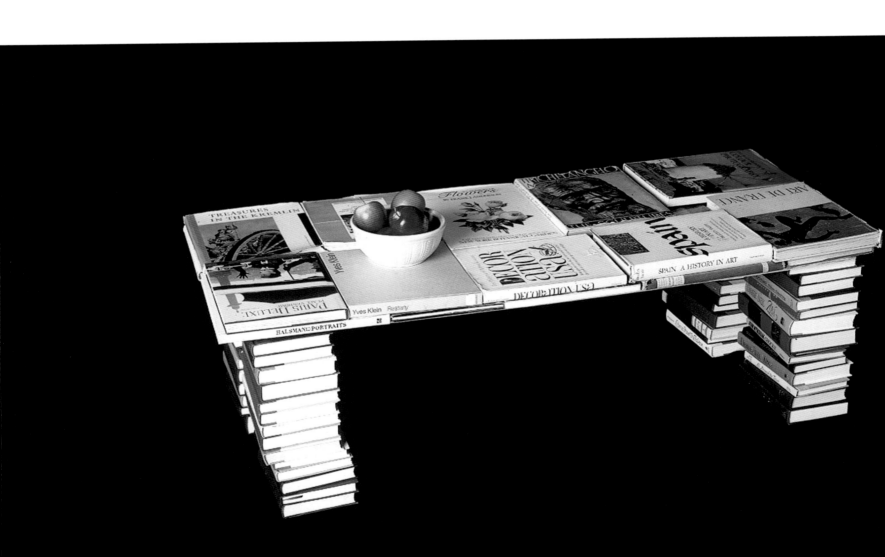

The appropriation of Carson's graphic tics, his particular forms of expression, becomes a mannered excess when done too generally by others.

Table of Content. By Geof Kern, 2000

was a common body of work. For it was in the nature of what that movement stood for that it should reject the familiar and move on to something new. The appropriation of Carson's graphic tics, his particular forms of expression, becomes a mannered excess when done too generally by others. What was revolutionary in 1995 is now in the history books, part of the toolbox of graphic communication. It is almost, but perhaps not quite, establishment.

THE CONUNDRUM IS THIS: the success of Carson's work was the seed of its own growth into something very different. The commitment was to original expression, ceaseless exploration, an unending quest to originate and assimilate, and to change what you were doing if you recognized it was looking rule-bound. It is quite likely that you wouldn't necessarily recognize that "new Carson" (and this would apply to some other designers, including, for example, "new Brody"). But if told so, you would retrofit into the preconceptions of the designer and find that, yes, it did fit the profile (which you would have just expanded if necessary to include any strange new elements in the work).

But to understand the context of the success of the first edition, we should go way back to the early 1990s. In those days, free-form and highly expressive graphics were a little harder to do. Technology made it hard, and so did people. The weight of professional expectation for grids and rules, plus the grinding difficulties encountered while mastering the emerging digital work world, meant that the fluid and merging media landscape that we view today was beyond the horizon for all but the most Net savvy.

Rules of many kinds were lying around and heavy to lift. Many are still relevant, while others have vanished as part of industrial as well as aesthetic change. But now we know that in graphics, rules really shouldn't be seen as too fixed. As a result, our magazines, websites, posters, and moving images seek out variety and question form. The freedom with which we think out of the box, the flexibility with which designers cut, paste, blend, write, link, draw,

animate, and manipulate all manner of visual and other data on their screens is very recent. There cannot be a design college in the world today that would not agree that it is desirable for students to be as at home (or more so) with computers as they are with pencils. Less than five years ago, the majority of colleges would have rated drawing skills on paper well above being able to draw or work on screen. That both have their place now seems irrefutable when the communication landscape has become embedded in a virtual world as much as in the physical one.

The connection with Carson as a pioneer of this — since he is no great tech-head or Web designer — is perhaps not immediately apparent. But it is absolutely clear: the rule-dissolving, highly fluid forms of his work were made for the new digital designer to pick up and explore. Never mind that he was doing much of it with scissors, photocopies, and paste-up type — he showed that self-indulgent play with endless possibilities was the most personally and professionally satisfying way of making graphics sing.

There is an ongoing dialogue between the notion of communication design as a transparent carrier of messages and the belief that the graphics should be part of the message, should celebrate their construction and the hand of the maker behind it. The value of the random and the unschooled has now been taken up and incorporated into the graphic process globally, and Carson was the great popularizer of this approach.

So perhaps slick corporate and media design has on occasion been pushed back a little, or covered up, as a result of Carson and his followers loosening up the boundaries of graphic design. But the change is often illusory. It is the nature of large business interests to be conservative. They regroup against attack. They subvert the threat, appropriating it to their cause if possible. This process has at times perhaps taken place in the rapid spread of Carson's work (indeed, he himself led the move) from subculture to corporate culture. But the "expressionism" of his work at its most unfettered is an act of rebellion and reaction, or resistance, that can never speak the language of big business comfortably.

Rather like the arrival of remixing in music (a technological tribute to, and extension of, the potential unleashed by jazz) or outsider art stimulating fine art culture (a reaction to art becoming remote from intuitive practice), a choice emerges from a whole new area of practice. The kind of graphic expressionism celebrated in *The End of Print* has helped define an alternative to locked-down rationalism in graphics. It was always there, but it took something quite excessive to really define the position.

The kind of graphic expressionism cele-
brated in *The End of Print* has helped
define an alternative to locked-down
rationalism in graphics. It was always
there, but it took something quite exces-
sive to really define the position.

The swell of graphic culture that Carson finally rode in on in the 1990s has its origins in the late 1960s. That was when the Swiss designer Wolfgang Weingart started the process of breaking with the hard-line graphic modernism of the International Style, beginning what became the New Wave in typography, graphic design's indication of Postmodernism. This style would be picked up by American designers April Greiman and Dan Friedman in the 1970s and imported into the U.S. There, it spread beyond a typographic elite into a wider cultural and commercial presence during the early 1980s.

The late 1960s was also the point at which the origins of Deconstructivist thought would be mapped out. This philosophical development would first map over literary theory, then architecture, finally influencing typographic exploration in the 1980s, notably through the teachings at Cranbrook, near Detroit. The results of this intellectual theory would come to generate dislocated graphic explorations by many students that, on the surface, had some stylistic connections to Carson's work. However, Carson's journey to this position was very different, albeit still with a link to what little conventional theoretical base he had: his largely self-taught approach took on a combination of self-expression, subcultural clients, and a workshop in 1982 with the post-Weingart teachings of the Swiss designer Hans Rudolf Lutz.

Carson in his studio in Del Mar, California, working on the first issue of *RayGun*, 1992

Much of the criticism of Carson during the initial wave of response to his work centered on whether a) he had any radical, original, profound, or different message, or b) he was the latest clown in the capitalist circus, entertaining us with cool graphics while selling stuff. That he could be both, and that such a position was the inevitable fate of inhabiting the center rather than the margins in the late-20th century, was somehow rarely accepted as a credible position by orthodox design critics. That any designer could produce work acclaimed as "popular art" was also particularly suspect and extremely irritating: it was as if the designer was finding a get-out clause from the responsibilities of the designer to be serious, responsible, professional, and just a little dull. Nowhere is it written in stone that design must observe certain laws of practice and that designers should have their own version of a Hippocratic Oath relevant to good deeds and principles: BUT TO JUDGE BY THE REACTION TO CARSON'S WORK, THERE CLEARLY IS THIS ODD NOTION OF "GOOD DESIGN" BEING PRECISELY DEFINABLE.

This strange dichotomy in the reaction to Carson was neatly summarized in a review in *Blueprint* in late 1995 by Ken Wilson. He wrote: "Carson has become significant at least in part because he has provided a reference point for these opposing visions: on one side those who accept, indeed welcome the inevitability of a kind of electronically induced entropy in graphic design; on the other the puritan advocates of a firmer grip on fundamental principles."

>

For Wilson, *The End of Print* was even then "to some degree a documentary record of a defining period for the profession as it moved abruptly and rather bewilderingly into the digital world."

From this it is possible to see that Carson's achievement is perhaps to stand out as the heroic focus of the first wave of radical digital change. He occupies this position just for being the most "out there" in the radical new look of his work, even if we don't permit him any distinct talent (and his harshest detractors tend to admit he has a genius for something – putting type in interesting places, even if for unsound motives).

The big irony of this is that Carson, despite all his innovative form, was one of the least digitally switched-on graphic designers for many years. He ground away on Pagemaker for longer than necessary before switching to QuarkXpress, was a type hero with hardly a clue about managing his font suitcases, and had a desktop littered with more icons than a Russian cathedral. But, of course, that chaos (and much more) was all just the manifestation of a contrary attitude that kept the design from falling into any of the "rules" that sprang up for digital design.

But that is the past. If Carson wants to lead today and tomorrow, like all designers he is increasingly aware that his work needs to embrace motion and the Web – a direction he has moved in since the mid-1990s.

This drift in his working life, identifiable in the careers of many designers, proves that there was more than just gesture in the grandiose title The End of Print. The Internet revolution has proved that print is an industry in decline, a fact reflected not just in business statistics, but in the look and feel of print. As the excitement moved to the Web, there was a retreat from the deconstructive extremes of Carson and his many contemporaries and followers in print. The game was over.

Even if you don't buy the argument that print is on the way out as a mass medium, there is still

ilson, *The End of Print* was en then "to some degree documentary record of a ining period for the pro– ion as it moved abruptly and rather bewilderingly into the digital world."

AUTHOR:

PHOTOGRAPHER.

>

ray gun 30, opening spread.

another way to read the "end-of-print" prophecy. Perhaps it referred to Carson and the wave of experimentation that took print to the edge – as far as print could go. This was to the ends of what you could achieve by putting ink on paper in the cause of graphic design – at times the type was more intentionally illegible than ever before, and the breakdown of order was more exuberantly and provocatively done than in anything since the Futurists set forth. Most of all, these self-conscious games with print form touched a nerve in a way that more academic exercises in theory and style – such as the work associated at times with Cranbrook or CalArts students or with Emigre magazine – failed to. Carson's work was enjoyable and understandable on an intuitive level, while being at the most extreme. He was "experimenting in public," as Ralph Caplan put it, with popular content, and it was seen as a bravura performance to be enjoyed.

Now, with print looking less demonstrative and needing to find fresh impetus to keep its end up, there is every reason to expect a further wave of extreme experimentation in the new millennium. After a period of restraint, expect more pyrotechnics. Print needs another pep pill to keep it going for Generation X and Generation X-Plus. This process will involve some serious questioning of how print design works, and at the same time some serious fun, a combination that design critics might struggle to recognize as credible, but one that the non-designer requires as a matter of course. I wouldn't count David Carson out from contributing. He's still surfing.

|HH
ˇ‚ˇ‰+6G{fiHH
d'ê@–œ ‡°g·;ˇ‚

PHOTOGRAPHER: AUTHOR: QUOTE RAYGUNMAGAZINE

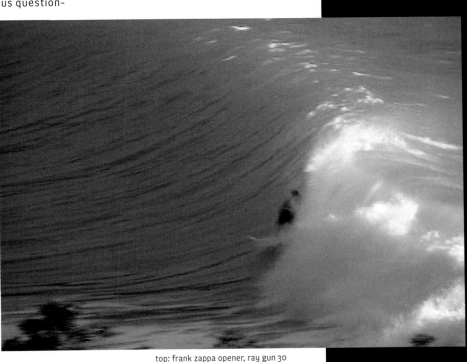

top: frank zappa opener, ray gun 30
above: dc, caribbean surfing. video
grab by christa skinner

Douglas Coupland

Yeah, right...

I studied typography for a few years in art school, back in the early 1980s.

It was torture. We had to hand-draw Helvetica, Times, Bodoni, and Zapf

dingbats with gouache, including, I might add, diacritical marks and numbers.

We were taught in the Swiss Modern tradition, and I still get a bit misty-

eyed when I see Herbert Bayer's work. Getting type computer-set back then was

almost more torture than it was to hand-draw it. It had to be formatted much

in the same way html is formatted in the year 2000, except it was a much longer

and far less intuitive process. (Yes, it's true.) And it took three days

before the results even came back to you.

One refrain that still comes back after two decades is the voices of my

typography teachers moaning, "Type is dead! There is nothing more that can

ever be done with type. It has reached its end-point as an art form." Well, it

came as a big pleasure to see David's book published – a big touché! of

sorts. But my teachers truly did believe type was dead. So the message here is

that the moment something seems dead is the point where it most likely

sproings back to life, like one of Superman's villains, more powerful than

ever.

One must remember (kids, are you listening?) that back in the early 1980s, Macs

were still a cockamamie dream, and maybe 10,000 people in continental America

knew what kerning was. Nowadays your teenage nephew designs your wedding

invitations but...I don't know. I'm still not used to the profligacy and

freedom allowed by computer-aided type. I'm still feeling like it's all a

dream. And the fact that David's book is being reissued means that type is

only going to explode once again. This time everybody's ready. Come on,

David, quick, plunge the detonator!

> ...the message here is that the moment something seems dead is the point where it most likely sproings back to life...

URDAY
A TREMENDOUS Cou
—— TO BE
The Volunteer William
0 8 4 F E A T U

T H E

EST: **N.W. STRING BAN**
BOB MITCHEL
$7.00 Under 15 Years $3.5

Discarded "scrap" from Hatch Show Print in Nashville, Tennessee. Carson rescued this piece from
the trash bin during a visit in the early 1990s. The original poster never had its second color
applied, and was also cut up into sections before being discarded. Carson found the juxtaposition
of font, photo, and white space to be of his liking. It now hangs in his New York studio.

illustration by henrik drescher. *beach culture # 2*

jessica helfand

Sticks and stones can break my bones but print can never hurt me

(A Letter to Fiona on First Reading *The End of Print**)

(*with apologies to Fay Weldon, Jane Austen, and David Carson)

21 March 2000
Dear Fiona:
You are turning 2 in a few weeks and I think it's high time you understood a thing or two about graphic design. After all, you are part of Generation ABC and what are ABCs, after all, but typography?

And what is typography, you ask?

A good question.

Typography is letters (and numbers) and why they look the way they do. Sometimes letters are BIG AND LOUD and sometimes letters are small and quiet. Typography can make words look good. It can also make words look bad.
But the way they look — whether they're pink or purple or big or small or quiet or noisy or happy or scary or funny or weird, well, that's something that comes from typography.

Which is also called type.

Which is sometimes called print.

Which is a word that occasionally causes people to wrinkle up their noses and describe a time when it was customary to wear burlap shoes and sit hunched over, by candlelight, scratching painstakingly written messages to one's friends and neighbors using quill pens. This really happened, back in

ancient times. Like back when there were mummies and dinosaurs. Before
television. Like when Daddy was little.

Printing is what you do when you write letters one at a time, as opposed to
script, which is when you write letters so-that-they-connect-to-each-other-
like-this. Printing is also used to describe what happens when machines
(called "presses") get hold of all those words, all that typography, and
actually press the letters together onto paper.

Paper is a word that occasionally causes people to wrinkle up their noses
and describe a time when it was customary to wear burlap shoes and sit hunched
over, by candlelight, scratching painstakingly written messages to one's
friends and neighbors using quill pens. This really happened, back in
ancient times. Like back when there were word processors and 8-track tapes.
Before computers. Like when Mommy was little.

Now here's the really confusing part. A lot of people say print is dead.
Flat and not moving. Dead, like when we drive down our road and see a rabbit
or a woodchuck that didn't make it across in time. The whole concept of
roadkill is something I had hoped to put off for a few years, but I think
it's important for us to be clear about one thing.

Print isn't dead, sweetheart. It's just sleeping.

So as you begin to learn your ABCs, remember that your mind is like a giant
alarm clock that wakes those letters up so that they spell something, so
that they mean something, whether they're on TV or in a book or scratched on
the side of a wall somewhere. And while you're at it, remember that S isn't
the same as 5 and L isn't the same as 1. Remember that 1 LoV3 U isn't the
same as I LOVE YOU even though it looks cool. Remember that anything that
looks cool probably won't look cool for very long. Remember that very long
means, well, probably about a day-and-a-half. Remember that pictures may
speak louder than words, but that words speak volumes. Remember that
sometimes typography can help you understand something or react to something
or feel a certain way faster, but that it probably won't

help resolve
conflicts between embittered nations or advance your capacity for reason or
prevent you from getting bee stings or tick bites or chicken pox. Remember
that spelling mistakes are celebrated in email but not tolerated in
literature. Remember that literature is made up of stories that are what
they are because someone wrote them down, letter by letter, word by word,
intending for them to be read and remembered and retold for years and years
and years to come. Remember that this is why your father and I want you to
learn your ABCs, in the order in which they were intended to be learned,
even though you can, and will, mix up the magnets on the refrigerator to
proudly spell words like hrldgsno and wsigefoo and
pstwe6882ge. Someday when
you read the work of Gertrude Stein or look at the work of
David Carson, you
will make sense of such verbal and visual and perceptual
aberrations, but
until then, my sweet girl, remember that your ABCs are
what helps you to
read, and reading is what opens up your mind so that you
can learn about
anything you want. Turtles. Communism. Particle physics.
Reading feeds your
brain and helps your mind to grow. So today's *Goodnight
Moon* is tomorrow's
Charlotte's Web is next year's *Elmer and the Dragon* and
before you know it
you'll be reading Thomas Hardy and Thomas Mann and A.S.
Byatt and V.S.
Naipaul, just as your parents did, and our parents did and,
with any luck,
your children will. And even though we read them printed
on paper and you
will very likely read them emblazoned on a screen, do you
know what, Fiona?
It doesn't matter, because no matter what the typography
does (or doesn't
do), and no matter what print is (or isn't), words are just
ideas waiting to
be read. And reading will never die. Reading is your ticket
to the world.

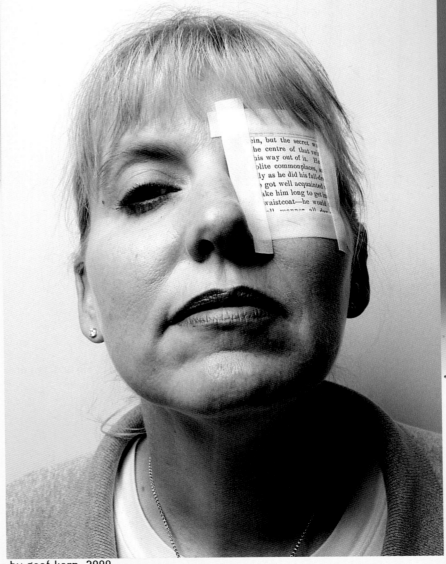

by geof kern. 2000

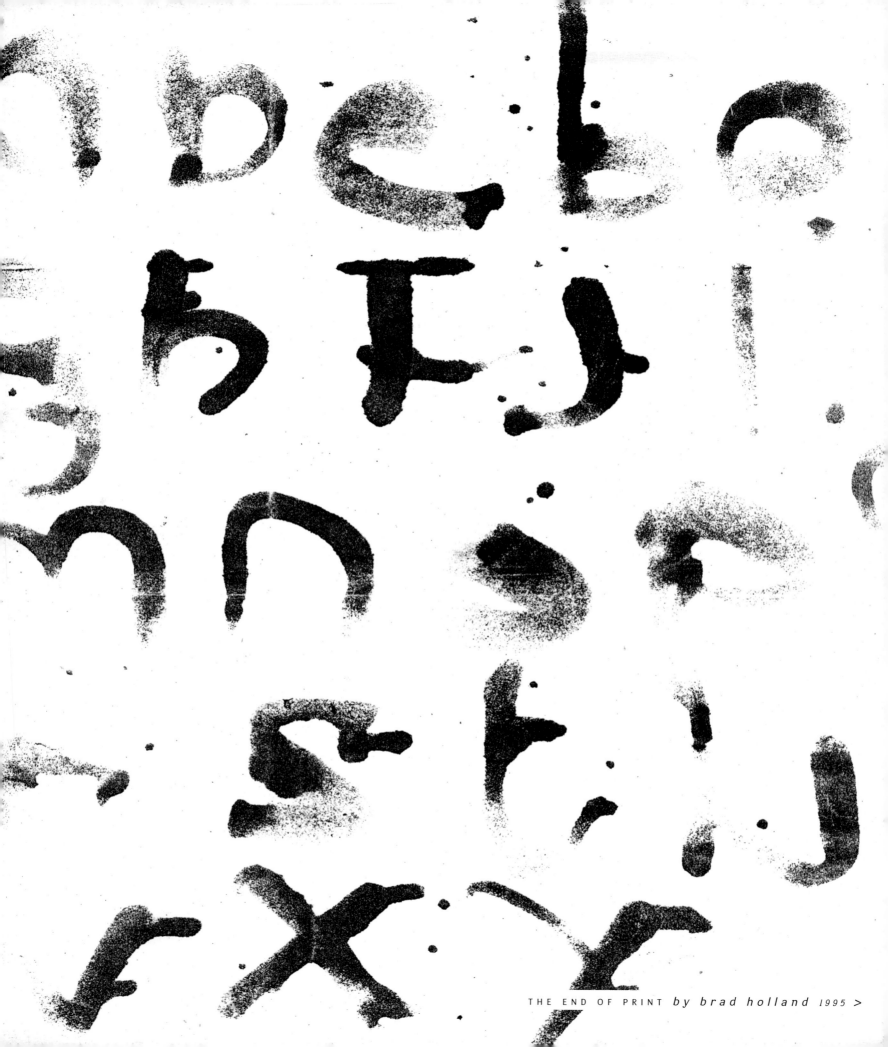

THE END OF PRINT *by brad holland* 1995 >

by bill gubbins

I love R. Meltzer! So, this little piece, this étude really, is dedicated to him! And to his work! And to his life!

And to the technique he pioneered, c.1973, in his still-unpublished autobiography, excerpted in an issue of *Fusion* magazine back t-t-t-then, that featured an exclamation point at the end of every sentence! Yes, every sentence!

I still remember! It was a big deal to me! I kept laughing so hard, I couldn't stop! But he was serious about doing this exclamation point thing! And I didn't know if it was okay that I found it so wonderfully funny! And so wonderfully great! And it was an epiphany that something so simple could cause such a powerful effect! He just let it go: and put an exclamation point, at the end of, every sentence!

And I went: How simple! How brilliant! And then: I could have thought of that! I should have thought of that! But I didn't! And now, he had! And forever I be there, but worthless besides him!

Now, of course, it was hilarious (and hea-vy, too) that he left in that exclamation point! (At the end of every sentence!) But his words were good, too! And I paid damn close attention to that, because I did not — I repeat did NOT — want to feel that I got carried away by some goddamn gimmick! By some trick! By some ROCK CRITIC trick! And I was worried that somehow I would be deceived — no, better yet, see-duced — into thinking that what I was reading was great writing when, in point of fact, it was mediocre writing in the service of a little known (and — ah-ha! — I later found out: Céline inspired!) literary gimmick that was pulled out faster than you'd need Alka-Seltzer on The Good Ship Lollipop!

So, man, oh man, I went back and pored over that damn story of his, over and over again, and over and over again, to try to figure out how to separate the specialness of this device from the actual words it went with and to try to establish, clearly establish, you know, lawyer-style, that I hadn't been goddamn had! By R. ding-dang Meltzer of all people!

Now my conclusion — then, as now — was that no, he had really meant it, that he wasn't just trying to be s-s-s-silly, and that it was ALL RIGHT for me to just lean back and enjoy it, to . . . let it be!

And I knew, just knew, knew, knew it; that this technique, this exclamation point thing (at the end of every sentence!) was soo good, sooo smooth, as it sent chills right down my b-b-b-backbone, that it would be picked up by every damn writer everywhere and that this exclamation thing (!) was going to be everywhere, all at once, at the very same time, ubiquitous!

But I can't get away from how impressionable I was and what it meant to me and how refreshing I found (that's the best word — refreshing), I found it that he used an exclamation point at the end of every single godforsaken sentence — every single sentence! — in that piece and I read it so carefully, time and again, over and over and over (again!) to see if I could find the one (one!) sentence that he'd buried that didn't have an exclamation point at the end of it!

And, no, I never found it, cause: every single sentence in this piece had an exclamation point! At the end!

And, yes, finally, after countless rereadings, and ponderations, of 1973 proportions, I concluded that: he meant it! Meant for every single sentence to have an exclamation point at the end of it! And that no, gimmick couldn't be separated from the words, nor the words from the gimmick, and it was okay that it was that way and I shouldn't worry anymore about it! Ever, ever, ever again!

I should just accept: R. Meltzer's a great writer and, gimmick or no, it worked! It just worked! Of course — ah-HA! All you epiphany hounds, here it comes: think how awful this gimmick would be in the hands of some writer — some hack! — so much less skilled than R. himself! Of course you do! . . .

Radical gear shift ahead! Grrrrrrind me a pound! Ungrrrrrungh!

The End of Print was an awful title for a book and I felt so at the time and I still feel so today! More presumptuous than all get out! And it bothered me so damn much that I had to sort of figure it out! In fact, the title had the same effect — but in reverse qualitative stool — than the exclamation point!

Man, that title made me mad! Who in the f' do Dave and Lewie think they are, soundin' this pretentious death knell for all this print stuff?!

You know, bad, bad, bad title, conveying a bad, bad, BAD thought! You know: oooohhhh, oooohhhh, the boogie men have come! Ooooohhhh, oooohhhh, Dave and Lewie am gonna blow the whole house down! They think print is gonna catch fire and die! All our hard word, our loyalty, our love of the printed word, or precious words, KILLED by a book (a folkin' BOOK!) that says: That's it! Adult swim! Everybody out of the pool! Party's over! Put on your clothes, boys, I'm taking you home! And, no more paper now, baby. . .blue!

But then I woke up! And I realized the title was just a marketing gimmick! A way of socking it to the reader! (Oh, you helpless reader, you, standing amidst the dusty airwaves of The Strand!) And, in the same way I reconciled myself to accepting my love of R.'s exclamatory technique, so I came to accept my hate of the title of *The End of Print* (think of it like an old-fashioned radio echo on WLS — the voice of labor! — in Chicago before rollin' "Woolly Bully": The End of Print-Print-Print-rint-rint-rint-int-int-int-nt-nt-nt-t-t-t-t) cause it was just, it was just: TOO MUCH!

But just think about how David's technique has fared in the hands of those lesser talents than himself!

Of course you do.

Bill Gubbins is Senior Vice President of iPIX, Internet Pictures Corporation.

EXIT Setup ▶ Process

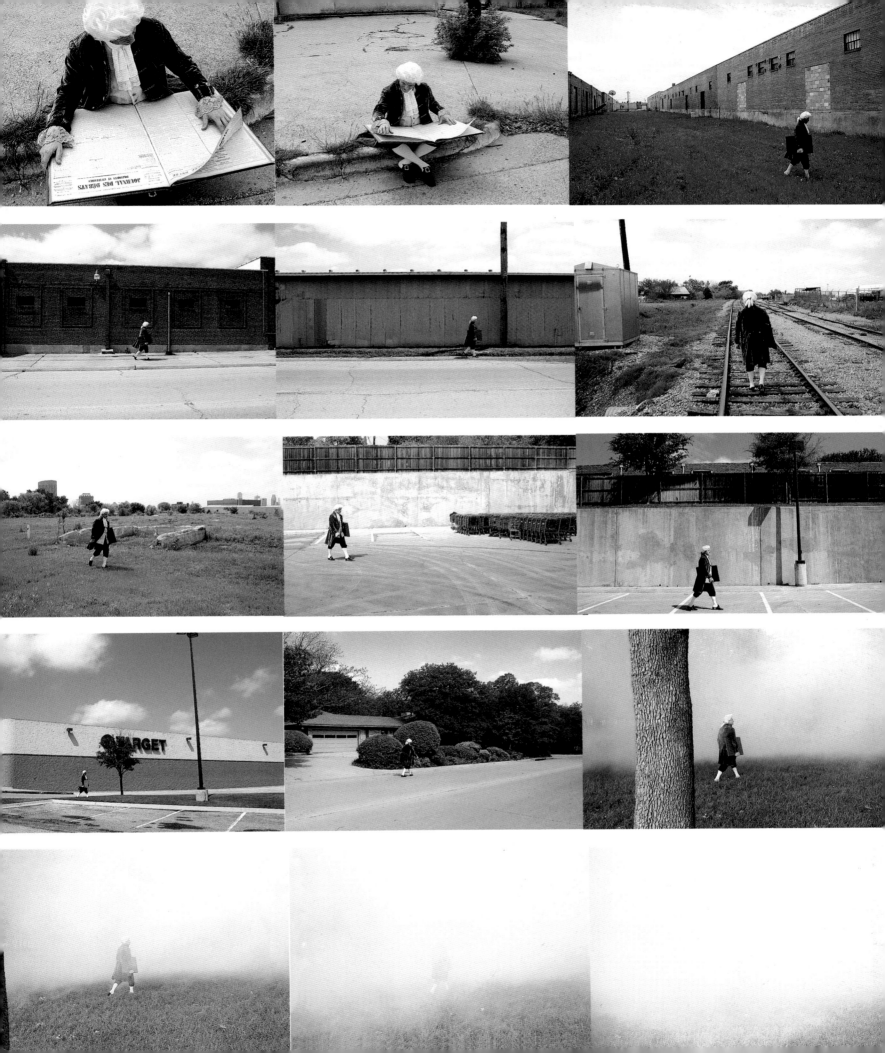

I first saw David Carson's work, as did a number of others, in the short-lived magazine called Beach Culture, and I immediately wondered what the hell was going on. Who was reading this amazing magazine that seemed to be in the wrong place, directed at the wrong audience? It seemed to act like a popular mag, but sure didn't look like one. Were surfers really into this radical design? Were they actually more savvy than I gave them credit for? Well, Southern California was the home of Kustom Kars and Low Riders, both examples of beautiful, radical, impractical design of and by the people. Maybe this was another step along those lines? Popular culture proving once again that it could be more revolutionary than high culture.

Then Beach Culture disappeared and we never found out the answers.

I was beginning to despair that rock music culture was becoming square, conservative, stuck. The mass-market mags were all towing some kind of party line, getting excited when they were supposed to, and narrowing their interests and focus until the world started becoming a suburban backyard. And that was what we were trying to escape from!

Then along came Ray Gun, and hey, it's that guy again! Now we're talking!

Design was cool again! Suddenly, visual expression was, as we always knew it was, as hip as Rock & Roll. Even the readers were contributing great drawings, paintings and sketches. This was not an isolated designer freaking out, but a catalyst for who knows how many people who knew that there is no difference between anything anymore - between "professional" musicians/artists and amateurs.

For decades, public art programs have tried to "bring art to the people": museums and great institutions of learning strive to "enlighten the masses". When all along the "masses" have been doing it for themselves - maybe unrecognized, and in slightly different forms. With guitars and offset fanzines. With kustom kars, surfboards and skateboards.

I suppose a lot will be made of David Carson's work being the perfect example of McLuhan's theory of sprung life - that when a means of communication has outlived its relevance, it becomes a work of art. That print-books, magazines, newspapers will become icons, sculptures, textures - that they will be a means of communication of a different order, and that simple information transfer will be effected by some other (electronic) means. Print will no longer be obliged to simply carry the news. It will have been given (or will have taken, in this case) its freedom, and there is no going back. Print is reborn, resurrected, as something initially unrecognizable. It's not really dead, it simply mutated into something else.

David's work communicates. But on a level beyond words. On a level that bypasses the logical, rational centers of the brain and goes straight to the part that understands without thinking. In this way it works just like music does - slipping in there before anyone has a chance to stop it at the border and ask for papers.

- **d a v i d b y r n e,** nyc, 1995

the end of print *BY MATT MAHURIN>*

Gilbarco

CALCO-METER

SOLGT FOR

DAGSPRIS

1 2 5

ØRE

is a vital means of expression. At least to the end of this book.

One day ink on paper may be marginalized as a source of information, but for the foreseeable future it

For now, print is as relevant as you find it: in that you are reading this, it would seem to be working

communications.

aries.) Print and broadcast media are under pressure from the digital, online media that are reshaping

Carson's work celebrates this uncertainty of knowledge, ceaselessly questioning and revising bound-

media, not replaced. Or perhaps not. If we know one thing, it is that everything changes. (At one level

are seeing the emergence of a new graphic language in print, stimulated by the developments in other

ing with the pieces at the end of a spent culture, but rather signs of a new understanding. Perhaps we

Perhaps the strange new configurations of information in Carson's layouts are not some decadent play

of a dying culture. But can we claim "the end of print", when there is more of it than ever before?

One direction is hinted at in the title of the book: it suggests these designs are experiments at the edge

tions as emblems of our age and consider where mass-communication is heading.

seems to be a movement. It is that which makes the case for this book. We can look at these construc-

music have at times worked for or with Carson. He is in the vanguard, out there riding scout, on what

many other respected and innovative artists across fine art, photography, illustration, advertising and

young designers who have found in the work a convincing new take on how graphics can communi-

c a t e

find some new messiah to lead them through our media-rich age. However, it is not only stu-

dents and

Of course, his disciples may only follow through a desire to reject the advice of their teach-

ers and to

preserve the structures in which they have been comfortable.

the ways in which he has cracked the apparently flimsy edifice of design "rules", his opponents seek to

leading to wild acclaim from some and savage criticism from others. While his supporters appreciate

ic arts. His work has explosively challenged treasured conventions concerning the handling of content

But while pioneers can be heroes, they can also get shot at. For some, Carson is a criminal of the graph-

he has opened up new territory for the graphic designer.

aries of invention. In cutting up, layering, disrupting and distorting (and often not) words and images

enough area in which to experiment, yet Carson has somehow reached beyond the acceptable bound-

recently by his work for a wider range of clients in publishing and advertising. It would seem a safe

He has done this by, initially, the striking originality of his designs for niche magazines, followed more

tors in the world, the most closely-watched by his peers. And perhaps the most vilified.

an unknown designer of a short-lived specialist magazine to being one of the most awarded art direct-

of graphic design" with "deliberately senseless" art direction. In five fast years he has gone from being

our subject, David Carson, that he is "the master of non-communication", a man who "breaks the laws

Ah yes, the layout of a magazine. How could such a small thing provoke people to make remarks upon

cuts of a television commercial or the layout within a magazine?

rubbish in the gutter, the security cameras on a building, your home, the high heel on a shoe, the hot

What else takes responsibility for the values represented by the look of the exhibition in a museum, the

Every society gets the visual environment it deserves. Doesn't it?

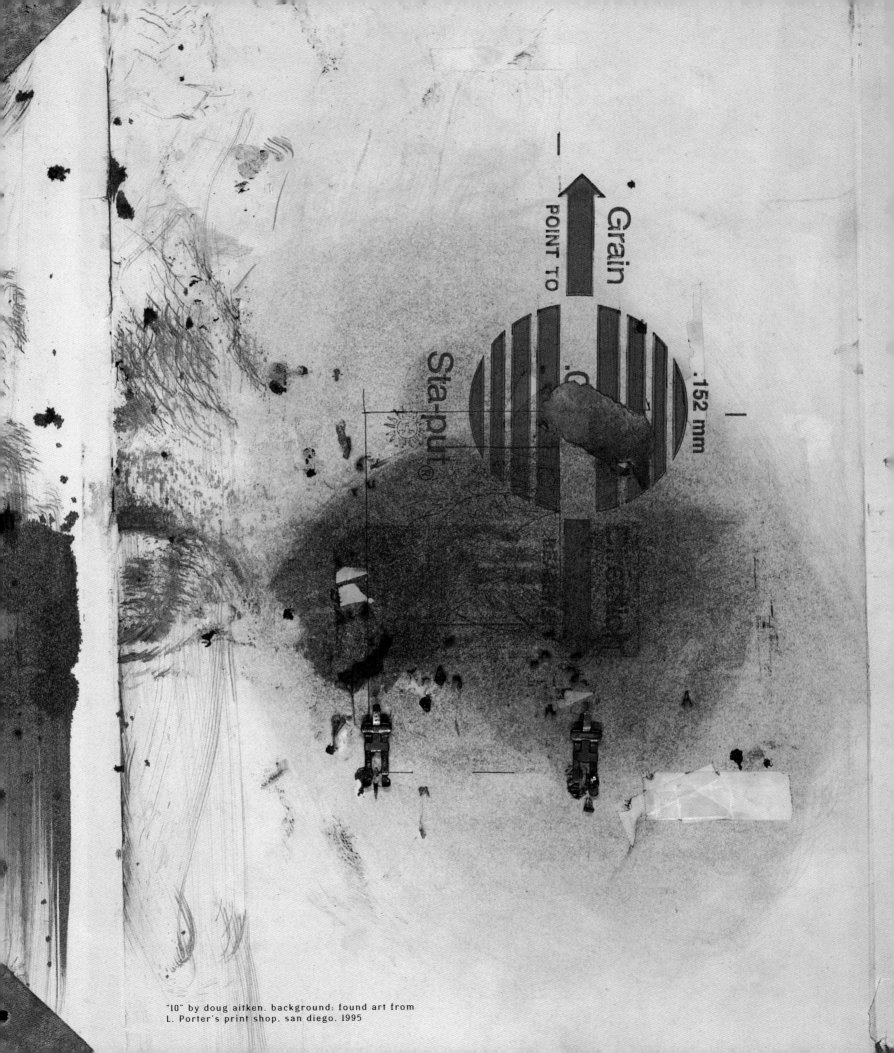

Grain

POINT TO

.152 mm

Sta-put®

"10" by doug aitken. background: found art from
L. Porter's print shop. san diego. 1995

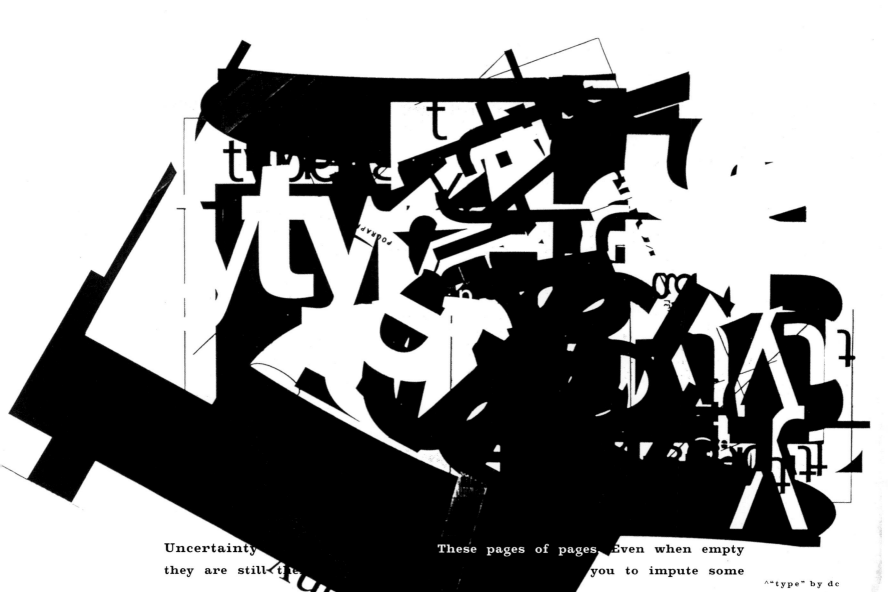

Uncertainty　　　　　　　These pages of pages. Even when empty they are still there　　　　　　　you to impute some

it is worth remembering that　　　　　　　here with expectations. these are unavoidable.　　　　tations　　　st, if not specifically of

Uncertainty rules in these pages. These pages of pages. Even when empty the subject then in general　　book　　know which language to they are still there, saying something or waiting for you to impute some assume, that the leaves will need turning, that the beginning is at the front, purpose.

and so on. these are assumptions, not rules or laws. it is not necessarily it is worth remembering that as you will have come here with expectations. our intention to fulfil thes these are unavoidable. the expectations must exist, if not specifically of

¿CONFUSED?　　　PICTURES.

the subject then in general of a book　you will know which language to these pages, people are trying to communicate. They range from assume, that the leaves will need turning, that the beginning is at the front, spokespersons of youth sub-cultures to the advocates of corporate America. and so on. these are assumptions, not rules or laws. it is not necessarily Diverse our intention to fulfil these circumstances and clients involved may be. they have all done

he end of print <BY MATT MAHURIN

¿CONFUSED? THERE ARE PICTURES.

Behind these pages, people are trying to communicate. They range from

spokespersons of youth sub-cultures to the advocates of corporate America. Diverse

as the subject matter, circumstances and clients involved may be, they have all done

LET'S TALK ABOUT

this through the conduit of David Carson's imagination. He is there as the art director of articles and photographs; as the commissioner of illustrations in magazines; as the designer of some of the very characters of the typeface or calligraphy; as intermediary of the advertising message, moving pictures and type within tight confines of meaning in order to extract some new inflection on the brief and a revised relationship with the consumer; as the creator of 25 frames per second that test our eyes' responses to television; or as the maker of books, of this page.

ARTIST stella

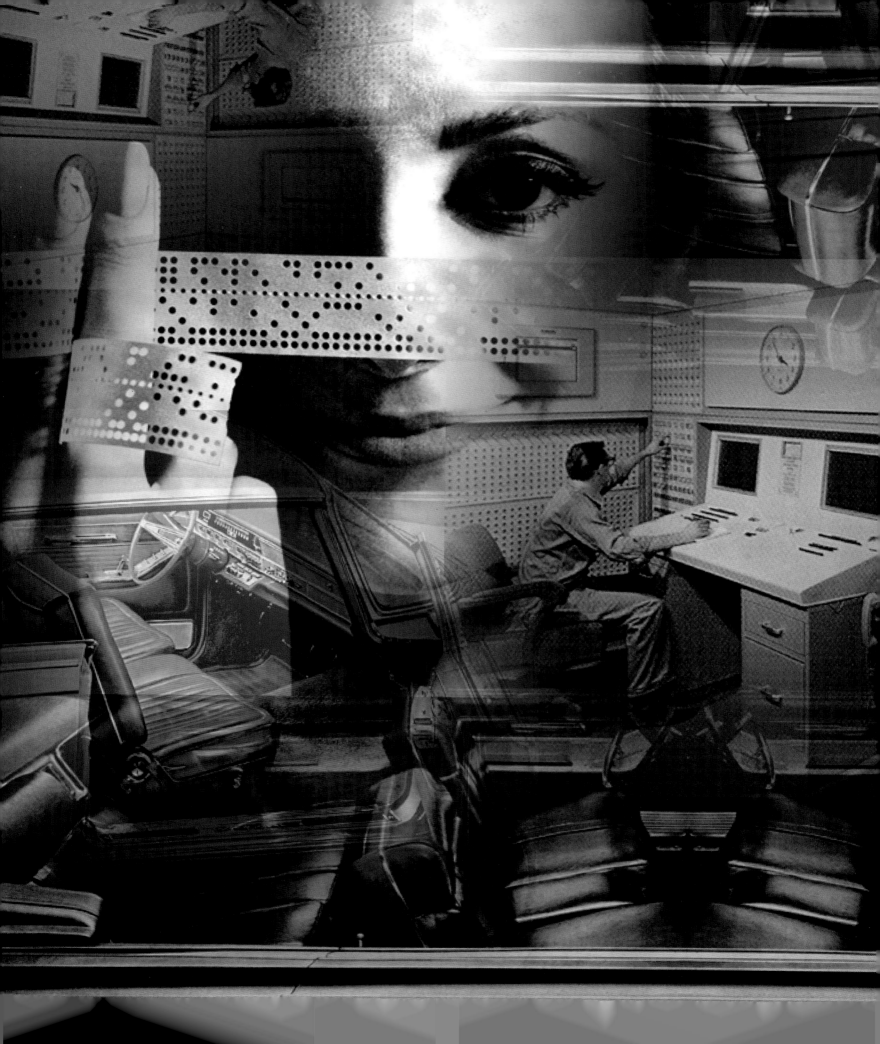

The work evades capture within a set of rules about **"what is good design"**. The work doesn't⠀⠀⠀⠀⠀,⠀⠀⠀⠀⠀ther does its maker. In the numerous interv⠀⠀⠀⠀talks, wo⠀⠀⠀⠀and other public explorations of his id⠀⠀s in the past thr⠀⠀⠀⠀ur years, Carson has declined to arrive⠀t some pat stateme⠀⠀⠀⠀tent that may be used as a broad interpretation of the wo⠀⠀⠀⠀ad, he prefers to let it stand on its own terms, piece by⠀⠀⠀⠀and admired [or rejected] by those it was aimed⠀⠀⠀⠀g he likes others to show what is in them, ques⠀⠀⠀⠀work which reflects his own or the styles of others.⠀⠀⠀⠀lection of new artists, there is a tendency to admire the n⠀⠀e; in his commissioning of established illustrators or photographers, there is a tendency to offer these artists the freedom to e⠀⠀eriment, to break from the strictures that are normally⠀⠀⠀⠀on a brief. In the same way that he refuses to give him⠀⠀⠀⠀clusive structure, or acknowledge the theoretical framewor⠀s and critiques applied by others,

reduce and nei

iews,⠀⠀⠀⠀rkshops

ea⠀⠀⠀⠀ee or fo

a⠀⠀⠀⠀nt of in

rk. Inste

piece, seen

at. In teachin

tioning the

In his se

aiv

xp

contingent

self a con

k

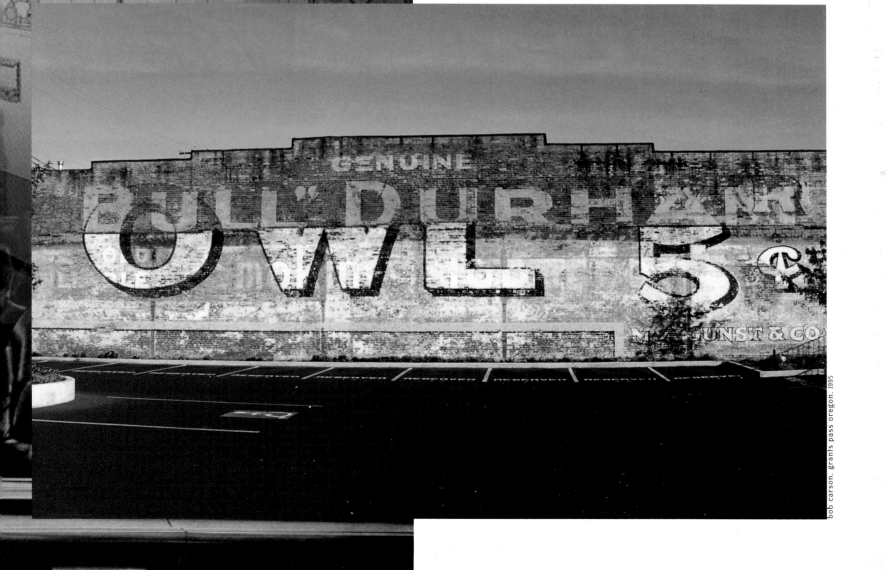

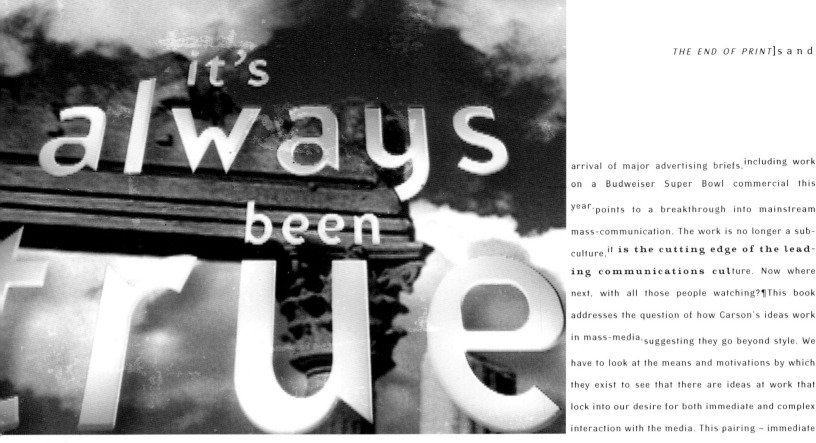

it's always been true

arrival of major advertising briefs, including work on a Budweiser Super Bowl commercial this year, points to a breakthrough into mainstream mass-communication. The work is no longer a sub-culture, it **is the cutting edge of the leading communications culture.** Now where next, with all those people watching?¶This book addresses the question of how Carson's ideas work in mass-media, suggesting they go beyond style. We have to look at the means and motivations by which they exist to see that there are ideas at work that lock into our desire for both immediate and complex interaction with the media. This pairing – immediate and complex – is almost a pair of opposites in terms of putting across an intelligent message, but it is one grappled with by mass-communications every day, every hour. Carson has taken this tense relationship and forged a new amalgam of graphic materials in order to withstand the strain.¶We have laid down an extensive route through Carson's projects [although it still shows only a fraction of the material created for the magazines]. Behind this tour are two intentions. Firstly, seen together the work suggests its own evolutionary principles, from the late 1980s to the mid 1990s. Secondly, it provides a real portrait of the artist, if not the theory of the art. For the latter, there will be plenty of clues for the construction of

[your own theories.

so he passes this attitude on to his collaborators and followers. At these various points – in designing, commissioning, teaching, speaking – he betrays what could be described as an expressionist approach, if a label is requireD .his work is full of devices that visualize an emotional and non-figurative, non-literal response to a brieF .but the expressionist tag is likely to be as misleading as it is helpfuL. while he admires artists such as mark rothko and franz kline, both key participants in the heyday of american abstract expressionism, so he also draws on other art forms, from street imagery and elsewherE .he doesn't become a musician or a documentary artist as a result of these influences, so it would also seem sensible to beware of too easily labelling the work expressionisT .[A tag which, after all, can and has been applied to much of 2oth-century Western art.]

set left, whi te mo vement

¶the difficulty of categorizing and the lack of an off-the-shelf theoretical standpoint has both helped the Carson culture and has hindered it. While some may seek out the work, all the more convinced by its avoidance of categorization, others can chafe over the lack of an expressed unified theory, sneer at the unconventional aspects of the work **and dismiss them as irrational gimmicks, at best the fashion of the moment. Such negative reactions are to be found within some parts of the small world of design critics, plus the odd elder of the graphic design community. To the broad mass of creative professionals, to the lay reader coming to this work fresh, the initial reaction is one of surprise, perhaps shock, and almost definitely curiosity. Albeit Carson has been working in a distinctive vein for more than five years, until recently it was in specialist markets and he relied on design awards to give the wider visibility.** But the growth of Ray Gun magazine, the

Outside of the readers of Ray Gun, there has been little mass-distribution of the work: Carson's early layouts on Transworld Skateboarding, Surfer and Beach Culture magazines are still being discovered [and sometimes cannibalized]. His more recent

The End of Print
by Rick Valicenti, 2000

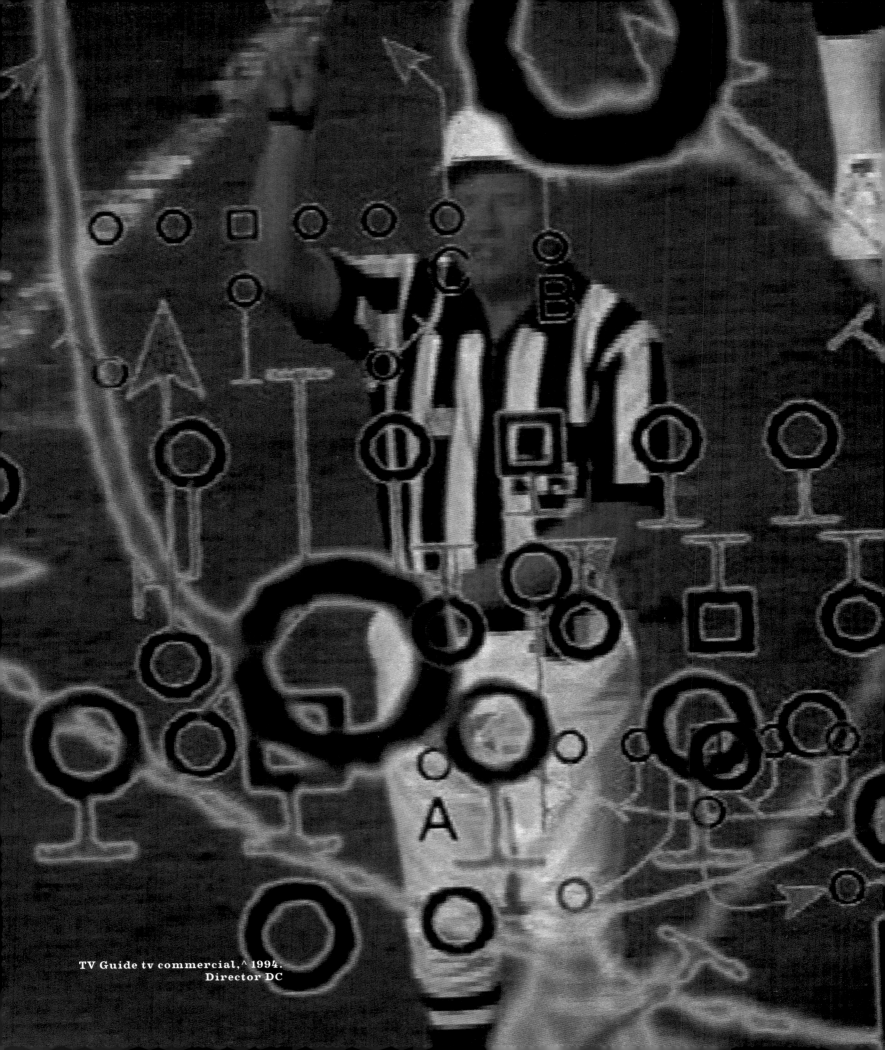

contributions to advertising campaigns for major clients around the world, both in print and film, are at once projected to millions, but also prey to the ephemeral lifespan of advertising.

This book at last gives a considered record of the work and provides some explanation. It also takes on the challenge of the comment by the designer Neville Brody [Creative Review, May 1994] that Carson's work signals "the end of print", a comment that has continued to resonate since.

But before you can have a response to that provocative description, there is a need for some questions to be answered. As a result, much of the text in these pages asks questions [the title itself is really an implied question]. Some of these questions others have asked of Carson and have either failed to get answers to; or have asked and have failed to publish the answers; or are questions that have not been asked but where the answers have been assumed, perhaps mistakenly. In the Venice interview these inquiries are renewed and responded to at length.

For now, let us consider a general, catch-all question that seeks to sum up [or perhaps introduce] the puzzle for many in looking at the work. I could put it like a design critic: "Is there really a coherent set of principles behind this work?" Or I could just ask: **IS THERE A POINT TO THE DIFFERENCE?**

The answer is throughout the book, but it can be answered simply here.

The answer is "yes".

But don't expect those principles to be set down in a row, with points of difference itemized and explained.

For one thing, the attacks on convention in these pages are not done with a consistent armoury of weapons. Neither are they done from one standpoint: the artist evolves with the work. For

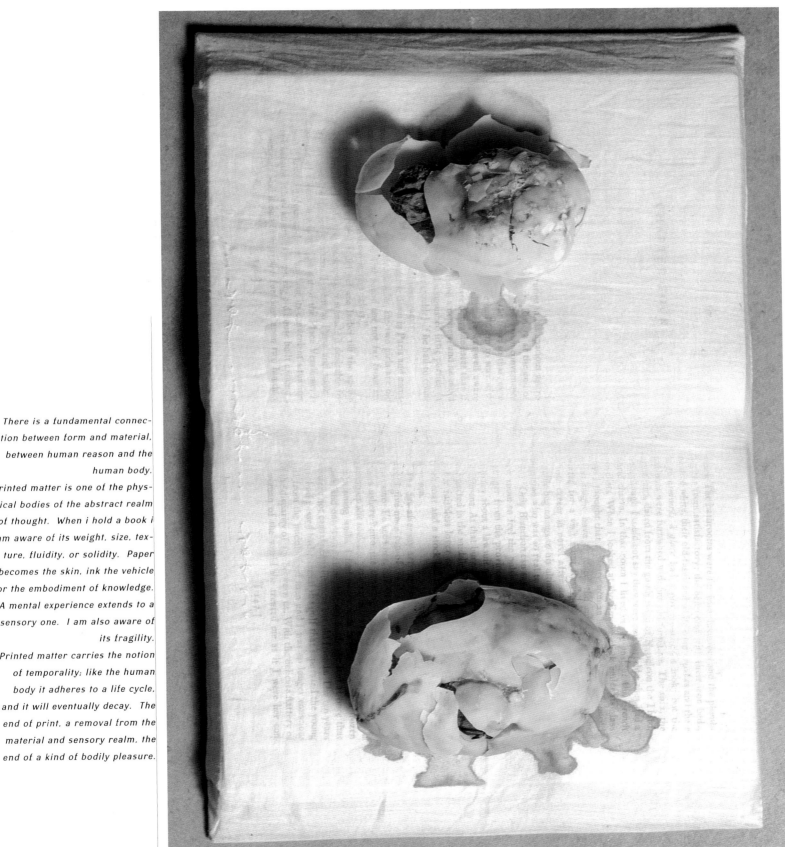

There is a fundamental connection between form and material, between human reason and the human body.

Printed matter is one of the physical bodies of the abstract realm of thought. When i hold a book i am aware of its weight, size, texture, fluidity, or solidity. Paper becomes the skin, ink the vehicle for the embodiment of knowledge. A mental experience extends to a sensory one. I am also aware of its fragility.

Printed matter carries the notion of temporality; like the human body it adheres to a life cycle, and it will eventually decay. The end of print, a removal from the material and sensory realm, the end of a kind of bodily pleasure.

the end of print (image + words) BY REBECCA MENDEZ 1995

example, the fact that the layouts of Beach Culture and Ray Gun have no discernible grid, doesn't mean that they would always reject the grid. They might be freeform, but that doesn't make it a rule. Sometimes when a pattern seems to be emerging, it will be disrupted [as within the pages of Cyclops, where an overall restrained style is arrived at by an approach to the typography that consistently shifts in font, scale and positioning]. There simply isn't a system to be taken apart and detailed. There is not the reductive methodology of the Swiss style school of graphic design, or of the teachers at the Bauhaus, or even of the more recent Deconstruction graphics theorized out of Cranbrook [even though some might misleadingly associate Carson with some of those designers].

The lack of a big theory, of a rulebook, doesn't necessarily mean the work is intellectually unsound, or that its freedoms imply chaos. But it does mean that it consistently challenges and never arrives at a situation where there is a complete, common understanding of the thinking behind the design.

Consider: this book is readable, as are the magazines. The fact that not everyone feels comfortable with them is inevitable, but that is a problem faced by each and every communication. But in contrast to the manner in which much mass-communication seeks to reinforce shared understandings, adopting familiar constructions as vessels for content, here there are highly individual responses, every piece of design being uniquely expressive of the content, being part of the content. The overlapping structures, ad hoc logic, sympathies of image and word — these and other devices seek out and connect in different ways with the readers, enriching the initial content, be it an article, set of pictures, sheaf of letters, or other. Instead of a system, the design takes place more organically. And the connections change not only in the internal logic of the resulting images, or word-images, but also in how they connect with the viewer/reader.

This lack of set-down principles is contrary to the mainstream,

conventional awareness of innovation in design. Even some supposedly radical designers can be related to a movement, an area of thought. Carson's work could be seen as related to the burst of typographic experimentation that came out of some of the colleges and was associated with certain magazines in the late 1980s. But it won more fans and awards and upset more people than the likes of CalArts or Cranbrook students' work and picked up wider and more mainstream attention than the activities of, for example, the experimental type magazine Emigre.

Perhaps because the design community could once again

L.A. car shot. dc

focus on a personality at the centre of the work, rather indeed like the attention Neville Brody received in the 1980s, so Carson has come to be seen as the leading figure in a movement of graphic expressionism, or the dean of deconstruction art direction. He wouldn't want either title. While he may be in a leading position, he has never worked, taught or published in a way that could be seen as setting himself up as a leader of any group or tendency. Indeed, it is remarkable how cut off in some ways he is from other parts of the design community, working out of a small studio in San Diego, southern California, previous to which he worked from home in Del Mar, just north of the city. It's not exactly Alaska, but it is away from the centre, out on the edge of the country, away from any regular group or design scene, such as exists in New York or London. Carson relies on telecommunications, freeways and airlines to reach his clients and to fulfil the requests for his lectures and partic-

MY THEORY, AND A FEW FACTS AGAINST IT.

ipation in work-shops. Any evan-gelizing he does is through *the* *appeal* *of* *his* *work in the mag-azines,* *books* *and* *advertising.* *And all of these outlets for his expression are commercial enterprises, unlike the output of design schools and theoret-ical magazines, which exist to serve themselves as much as a separate audience or a market.*

Despite the "real-world" production of this work it has often upset those who stress that design should "function". It clearly does function in some regard, otherwise Carson wouldn't have any clients and his magazine art direction wouldn't last beyond one issue. But the chief thrust of the criticism would seem to be that function in graphics requires that it carries either obeys established, on its agreed principles, or surface an explanation of that it any radicalism.

IT WOULD SEEM THAT GRAPHIC DESIGN IS OFTEN EXPECTED TO BE TRANS-PARENT OR FLATTERING OF A VIEWER'S PREVIOUS EXPERIENCE AND VAL-UES, OR BOTH. If a new approach is proposed then it is expect-ed to announce itself with a declaration of intent, outlining principles rather than just doing it. Carson has consistently

challenged this with work that does not acknowledge the theories. Despite finding a resonance in his targeted audi-ences [the readers of the magazines and books, the viewers of the advertising], this has not held back critics from sug-gesting the work is in some way wanting.

[something else to think about]

We are seen as being at the end of the age of enlightenment. These days are the age of uncertainty, of doubt, where we are losing our confidence in understanding the world by a remorseless scientific process of hunting down truth. Space programmes and nuclear technology were perhaps the final awesome flowering of the quest for

rationalism that began with the Renaissance. Now, instead of sharing principles of discovery, we are struck by the conflict of our theo-ries, along with the conflict in politics and the revival of religions [itself a sign of that loss of faith in science]. Perhaps it was always so. This uncertainty extends to our media. We don't know how we may communicate in the near future. ¿Will we all be on the internet? ¿Will we have portable phones wired to our ears? ¿Will computers be packed into what used to be a wristwatch? Whatever, we cannot assume books, journals or even televi-sion are lasting media: they are increasingly seen as way-stations alongside the superhighway to an interactive future. Such technology is with us now: we, as a global com-

munity, just have to choose.

In-this=context,what[logic]lies;behind accepting$the°hollow+structures;of—designers past?Their/grids,their· neo-classical-this=and[that,their- isms?You]can<accept$them;as°something+to;hold—on·to,or- y o u = c a n [l o o k for]a;new$way°of+seeing.Look;for—a·new-structure;for[our visions]of;the=world.

The inherited structures of graphic design are packaging. Useful sometimes as containers, as presenter and protector of the message. But they can be empty. And then they are as frames on a canvas that has yet to be painted.

Content is the big issue in design today. The question is; what relation-ship does the visual language have with the verbal one? We think we are so familiar with our own [verbal] language, it comes as a shock to realize it is never received pure, without being coloured by the trans-mission. We are used to seeing words as the content and then either as text that is typeset for a layout and perhaps illustrated, or perhaps as a script that is performed live or to a camera, again framed and illus-trated in various ways. However, we are increasingly aware that these words change in the telling; the emphasis, the context, the distractions. And we are aware that these words cannot exist in communication without some form of telling; thus the shaping and the shaper of that visual/verbal language inevitably goes beyond the word or the writer.
Perhaps this changing perception is one explanation of why the designer has been thrust up as some kind of hero of our age over the past decade; suddenly these former crafts operatives are seen as genius arch-manipulators that can make the world a better or worse place. This hype obscures the fact that any designer is just part of the whole process too, only able to add a personal contribution as an artist may or to abnegate this contribution and simply operate as some tech-nician in the vast message machine that goes on operating all around us, pumping out individual and mass-communications all around us,
But some people do stand out for expressing matters many thousands every day.
in a way that touches the many, or that first encapsulates an experience that others have shared but not recorded. This book's subject and designer could be put in that category. However, before looking at his work [or rather while looking at it, here, now, simultaneously] we all have to wonder how we are seeing, how we connect, if at all.

The writer struggles with uncertainty, then the designer struggles to make something of this. The partnership needs to extend beyond these contribu-tors to embrace a medium and at least one other participant. Communication happens, if at all, by that initial emotional spark reaching across the creative divide firing through the cerebral cortex and logging on to...[your name here]

the end of print. on the wall. david carson studio. san diego. california. feb. 1995. photo: Chiharu Hayashi>>

November 22/94

Hi David Carson!

Here's an unabashed fan letter for you — due to my being blown away this weekend (in a bookstore) on sleing* your design for The large photo Book (cyclops) with captions.

You can quote me on This!

You are the Paganini of Typographers!

Its' an absolutely amazing piece of work and stands totally alone as an utterly unique idea (and execution, also) that can only be done once; even you can't do it a second Time. I'm sure it will go down (up) in history as an original in book design and I nominate it as "book of The year" if it hasn't already been so. I could go on and on (& already have) but any doubts about you abilities among The stuffy academics and old professionl purists are surely put to rest by The quality of This work (and all very legible too!) Keep going... This stuff is GREAT!!!

Ed fella

* PS Now I got to save up The money to buy The damn book.

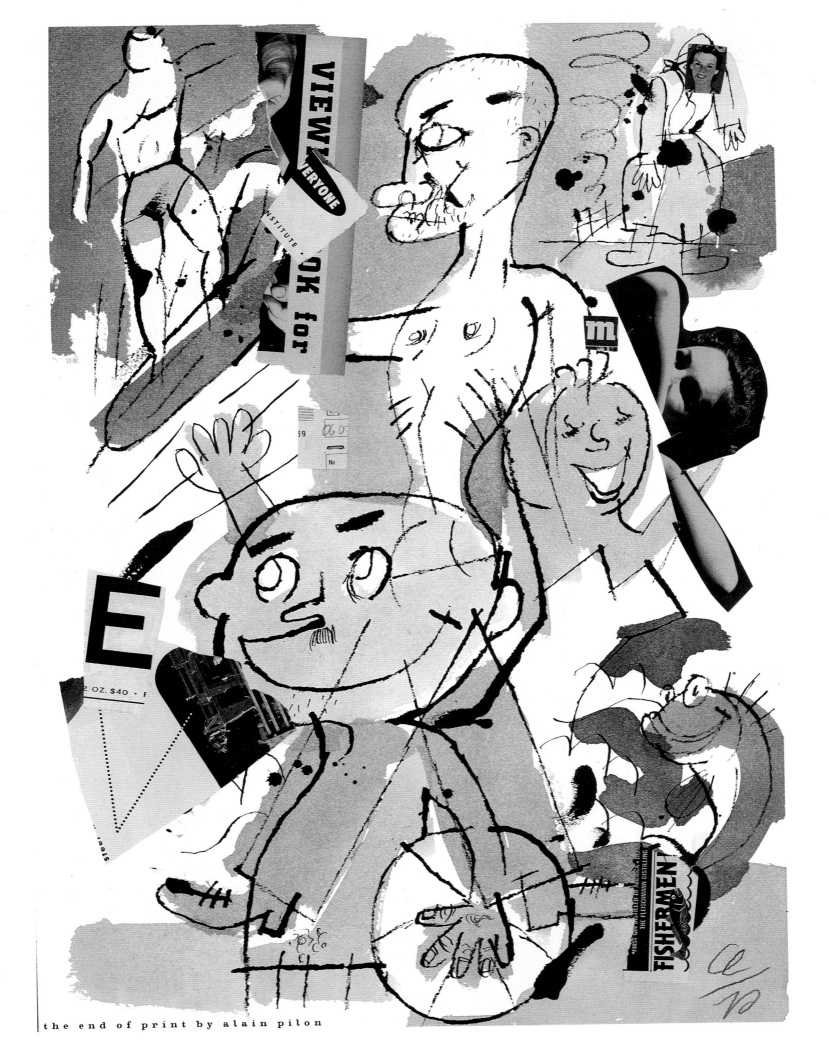

the end of print by alain pilon

m a g a z i n e s

TAKE THIS CHAPTER to a news-stand. Pick a busy one: we want to simulate the full media overload. Now tear out some of these pages and insert them into various magazines. Notice anything strange, besides the stare from the news vendor?

RIGHT, THE PAGES DON'T FIT. Against those columns of text, neatly boxed pictures, steady relationships of headline and body copy and captions, numbered leaves, these freeform inked sheets are more akin to paintings than publication design. The reliable features that dominate our daily diet of print are here questioned, played with, broken, or simply ignored.

THROUGHOUT A DECADE of magazine art direction, Carson has persistently pushed at the conventions of the medium, most controversially in his typography. This has raised cries that the work is illegible, despite the fact that for the target readers the magazine communicates, otherwise they would not buy it. In fact, readers' letters suggest that for many the art direction of the magazines helped establish a new relationship between them and their reading choice.

"YOU CANNOT NOT COMMUNICATE" is the designer's belief as he seeks to explore the full range of expression possible within the page. The work has moved to an integration of word, image and the medium, seeking to forge a new way of reading across sequential pages. From the early Transworld Skateboarding work to the more recent Ray Gun, there is an evolution from one-off visual and verbal playfulness to a position of, at times, graphic abstraction. Increasingly marks and color exist not as elements that build or frame pictures and sentences, but make emotional contact directly as marks and color. They are not metaphors, but often seem to exist beyond rational explanation.

SUCH AN APPROACH can be seen as aspiring to the condition that the artist Mark Rothko had in mind when he said "I'm not interested in relationships of color or form or anything else...I'm interested only in expressing basic human emotions — tragedy, ecstasy, doom and so on...The people who weep before my pictures are having the same religious experience I had when I painted them...And if you... are moved only by their color relationships, then you miss the point!"
Mark Rothko
(report of a conversation with Selden Rodman at the Whitney Museum of American Art)

The abstract forms, celebrating process also connect with the work of pioneers such as the Dutch printer Hendrik Werkman, or Dadaists, particularly Kurt Schwitters. However, while they were chiefly producing one-off or limited edition artworks, these pages are presented in a mass-communication medium.

AFTER NEARLY A CENTURY, are we absorbing the lessons of the modernist breakthrough in art, the rupture with realism? Although Carson does not claim to have a grand theory, being more concerned with working intuitively, the work resonates with ideas from fine art. This assimilation is not deliberate: the methodology would seem to be one that would reject sources, if they were spotted. However, in the same way that "you cannot not communicate" so you cannot escape the conditions of this time and place. Faced with the visual literacy of the audience, and armed with the tools of a radically changing publish-

ing technology that has merged text and image in one digital language and made the designer the typesetter, the opportunity to throw away magazine conventions and create design at the edge of our visual culture was there for the taking.

THAT THE NEWS-STAND is not full of such radical, questioning, ever-changing publications is more than the result of publishers' conservatism. The magazines that Carson has worked on are not of or for the mainstream: they are products serving particular sub-cultures. Even then, they challenge the expectations of the advertisers who are crucial to the success of a magazine. The death of Beach Culture after six progressively thinner issues was not just due to the recession, but also advertiser bewilderment at the radical editorial mix and the way it was expressed. Ray Gun has also had to work hard at times to find advertisers who feel comfortable with its uncompromising stance, despite a circulation that would seem to be worth reaching. But this coolness of corporate America appears to be thawing, to judge by the growth of advertising clients at Carson's studio.

IN ALL THESE MAGAZINES Carson held the position of art director and designer, being responsible for not only laying-out pages, but also overseeing the commissioning of artwork and establishing any design rules for the publication.

OF COURSE, it is the absence of rules that distinguishes these pages. Many of the familiar, cozy structures of magazine designs have been removed or re-engineered. Instead of a grid, the underlying bedrock that most magazine layout relies on, here pages are freeform, each one a fresh canvas onto which type and images are applied. And instead of a limited and consistent palette of typefaces, new faces tend to be introduced with every issue of Ray Gun, not as matter of novelty but as a matter of finding new expression for new content. Rather than "why change?" the question is "why not?". And, occasionally, even change is challenged by sharply limiting the type choice, at the same time handling it so expressively that old typefaces are seen in a new light.

WHERE MOST MAGAZINES want their readers to know what to expect, to know where to look and how to read through a page, the publications shown here established a different relationship with the reader. "Today's audience has changed. It has a different visual orientation than readers did just a few years ago," claims the designer. These are some of the pages that helped push (or is it "exploit"?)that re-orientation.

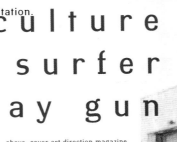

tws
beach culture
surfer
ray gun

above: cover,art direction magazine,
1993. dc. right:photo: doug aitken

Carson covers. Carson's Mother Dorothy held up the font sign for *Aldus* cover

When the first magazine Carson worked on (Action Now) folded in 1982, David returned to teaching sociology. But shortly after taking the part-time teaching position, he was offered the chance to design this up+coming skateboard-ers' monthly. (Skater/artist Stacy Peralta had recommended Carson for the job.) He did it in his spare time, after school, evenings, and at weekends. It was a glorified fanzine, with up to 200 full-color pages heavily sup-ported by advertising, and yet the editorial – copy and pictures – were largely the products of skateboarders. "It was a great opportunity for experimenta-tion," says the designer, who was able to respond to a readership eager for new ideas by committing himself to never repeating himself in any opening spread design. In these years he formed his approach of questioning any formal pre-conception.

SUBSC
RIBE

NAME _____

ADDRESS _____

CITY _____ STATE _____ ZIP _____

ONE YEAR $11 · TWO YEARS $19 · ONE YEAR FOREIGN AIR $28
One year Foreign Surface $18 Send check or money order U.S. DOLLARS ONLY

TRANSWORLD SKATEBOARDING
P.O. BOX 6, CARDIFF, CA. 92007

TRANSWORLD
SKATEBOARDING
MAGAZINE

SWANK

subscribe page. the photograph dictated the type and design treatment. 1985
opposite: skateboarding in the deep south, opening spread, 1985

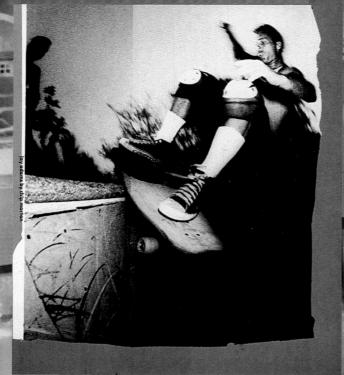

1

2

3

4

top l] Experiment in color acetate overlays. Photo J. Grant Brittain

top r] Subscription page, 1986. Photo J. Grant Brittain. Acetate overlays

bottom l] Subscription advertisement, 1986. Bauhaus type photocopied from a book and pasted down

bottom r] Wheel company advertisement, 1987. High school student photography class provided the images. Carson's concept and copy [note irony relating to speed]. Hate mail from readers who assumed the art director had set up the shoot

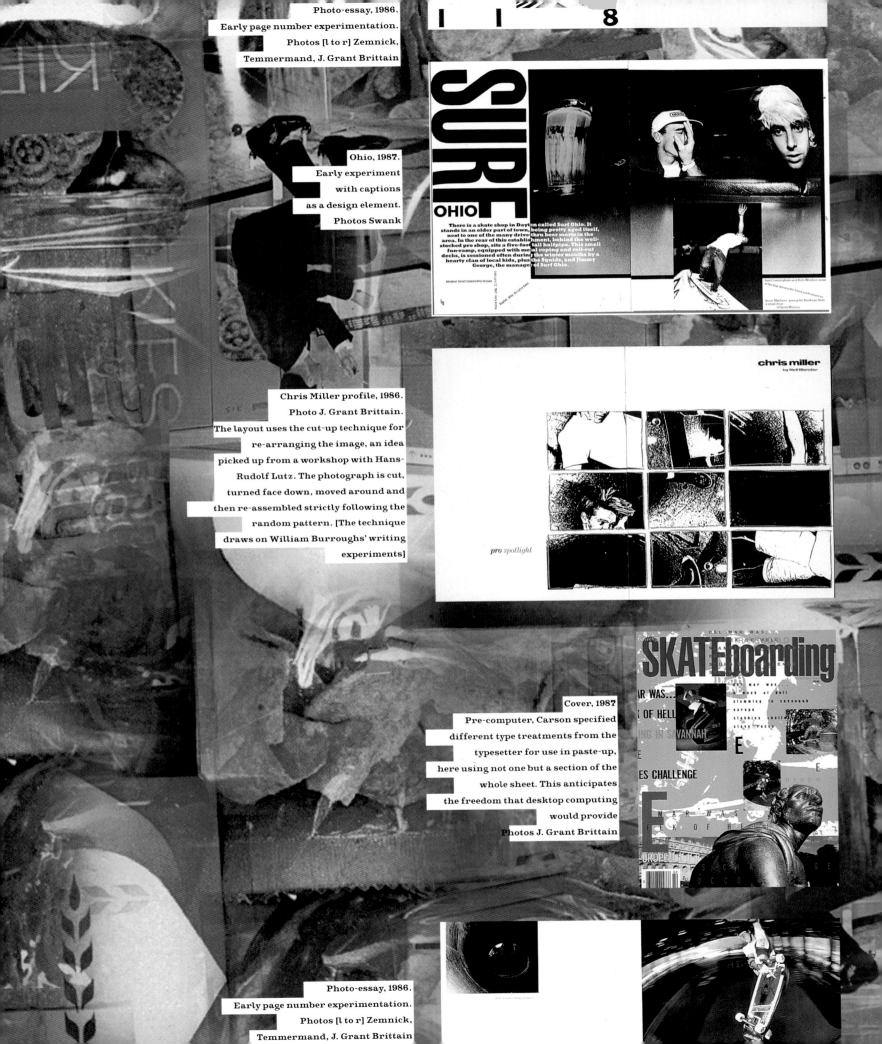

Photo-essay, 1986.
Early page number experimentation.
Photos [l to r] Zemnick,
Temmermand, J. Grant Brittain

Ohio, 1987.
Early experiment
with captions
as a design element.
Photos Swank

Chris Miller profile, 1986.
Photo J. Grant Brittain.
The layout uses the cut-up technique for
re-arranging the image, an idea
picked up from a workshop with Hans-
Rudolf Lutz. The photograph is cut,
turned face down, moved around and
then re-assembled strictly following the
random pattern. [The technique
draws on William Burroughs' writing
experiments]

Cover, 1987
Pre-computer, Carson specified
different type treatments from the
typesetter for use in paste-up,
here using not one but a section of the
whole sheet. This anticipates
the freedom that desktop computing
would provide
Photos J. Grant Brittain

Photo-essay, 1986.
Early page number experimentation.
Photos [l to r] Zemnick,
Temmermand, J. Grant Brittain

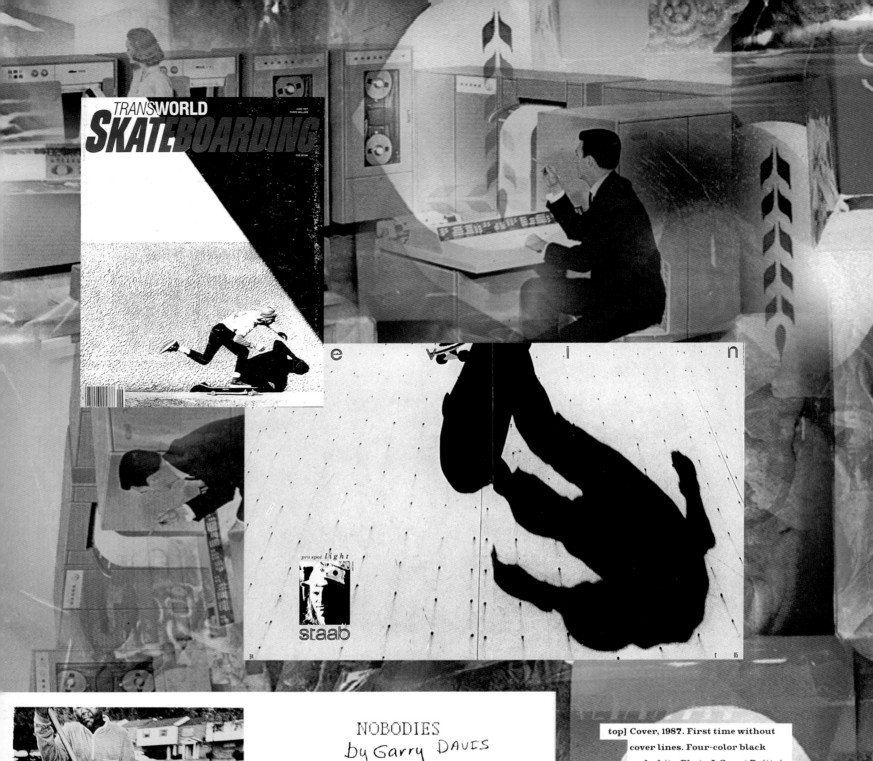

TRANS**WORLD**
SKATE**BOARDING**

pro spot *light*

staab

NOBODIES
by Garry DAVES

P: SWANK ALANTA

P. SWANK

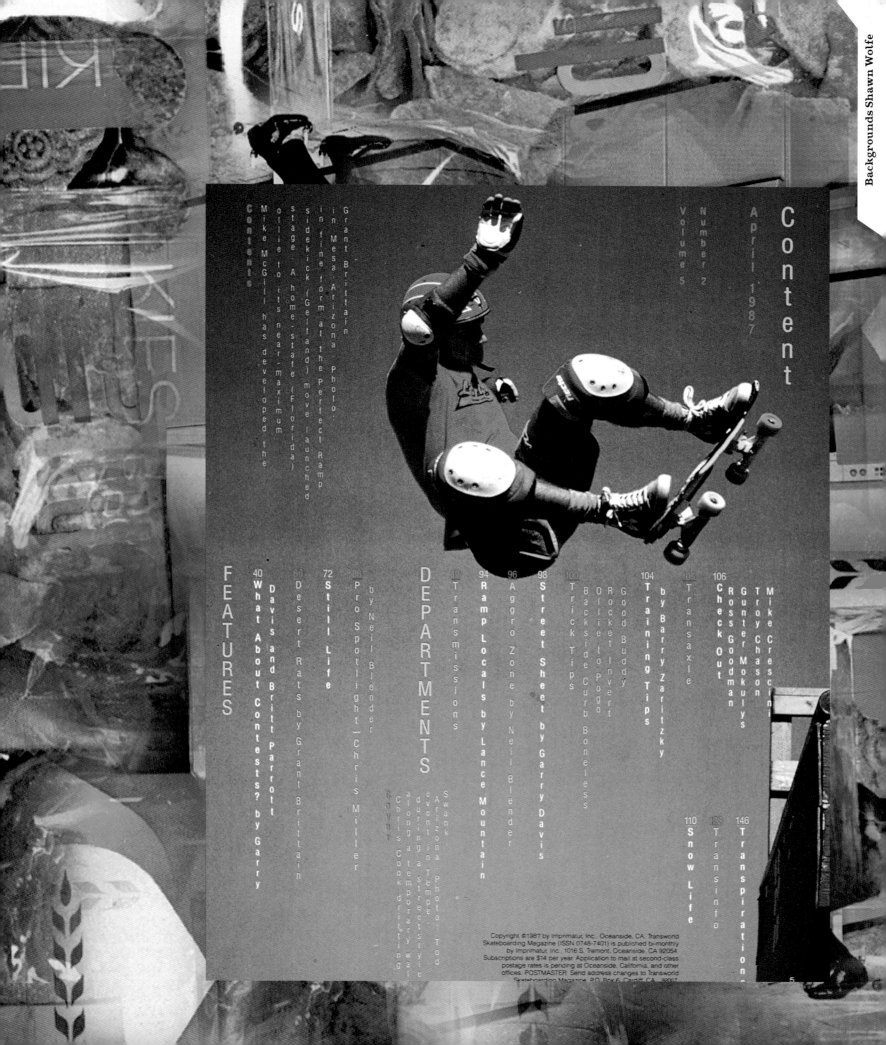

Content

April 1987

Volume 5

Number 2

Contents

Mike McGill has developed the ollie to its near-maximum stage. A home-state (Florida) sidekick (Gelfand) move launched in fine form at the Perfect Ramp in Mesa, Arizona. Photo: Grant Brittain

Cover Chris Cook drilling along a temporary street-style wall during an event in Tempe, Arizona. Swank Photo: Tod

TRANSWORLD
SKATEboarding

C O L D
BORING
ISSUE

MOUNTAIN/BRITTAIN

1
2
3

TWS—THE MAGAZINE FOR
TODAY'S NEW GENERATION OF
SKATERS. GET WITH THE
TIMES—GET TWS.

ONE YEAR $14., 2 YEARS $24. ONE
YEAR FOREIGN AIR $33. ONE YEAR
FOREIGN SURFACE $22. SEND
CHECK OR MONEY ORDER. U.S. DOL-
LARS ONLY. TO: TWS, P.O. BOX 6,
CARDIFF, CA 92007. INCLUDE YOUR
NAME AND ADDRESS.

NAME

ADDRESS

CITY STATE ZIP

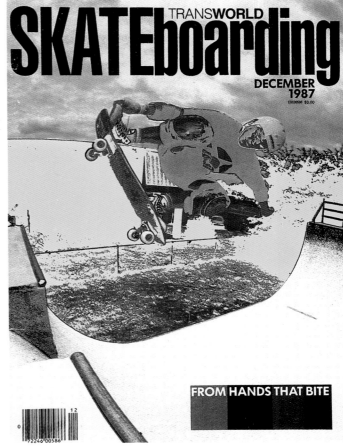

DECEMBER 1987

FROM HANDS THAT BITE

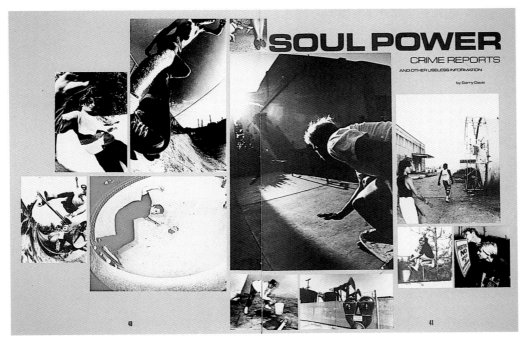

SOUL POWER

CRIME REPORTS

AND OTHER USELESS INFORMATION

by Garry Davis

SUBS CRIBE

<<OPPOSITE TOP: when many of the surf magazines were using cover lines that screamed "red-hot, exciting action!," carson came up with this copy and design. BACKGROUND: detail from cover of photo annual, 1986. ABOVE: mid-1980s *transworld skateboarding* work.

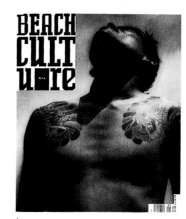

BEACH CULTURE

^
Sixth and final issue
cover, 1991. Photo
cover, 1991. Photo Matt
cover, 1991. Mahurin

Beach Culture 1989–91

Beach what? For some, the title was an oxymoron. In reality, the magazine was one of the most innovative of all time, if the 150 or so design awards are anything to go by, along with the radical mix of editorial subject matter that drew fanatical supporters but left many (including advertisers) confused, if not downright angry.

Initially, Carson was brought in on a freelance project to art direct Surfer magazine's annual publication Surfer Style, which was little more than a shopping catalogue of clothing ads supported by advertorial. However, the editor Neil Feineman and Carson had different ideas: they changed the name, the content and the frequency and managed to launch Beach Culture on a pre-recession wave of goodwill. It didn't last: the magazine got poorer by the issue, struggling along for six issues over two years before finally closing. Throughout this, though, Feineman pioneered an innovative mix of good writing on the alternative culture, using the surf scene origins as a metaphor rather than a strict template for editorial. Such freedom and inspiration was the stimulation for Carson to explore further the potential of print communication, targeting a similarly questing readership. They were out there, but they had to work hard to find the magazine, given the publisher's interest in serving the more traditional readers and advertisers. Carson was, incidentally, not oblivious to the financial straits of the magazine. "I was absolutely broke. I couldn't afford to run a car," he says, which is almost the equivalent of a white southern Californian having his legs removed. "I used to catch the train to the Beach Culture office and then walk for more than half an hour to get there."

harry

connick

jr.

There I was, doing my regular gig, managing a couple of Beverly Hills hair-dressers. I'm about to split when I notice a geeky-looking dude among the flash and models. A rare sight at this post-punk, ultra-neo cyber temple to pancuts and hairspray. Usually, you see a guy in this place: he's some poor old rich sucker who's hitched to one of the flags.

Anyway, I blow. I walk to the street and take a hard look at the gel as the streetlight waiting for the light to change. I do a differential equation in my head, trying to figure the vowel quotation of the black accent in front of me. Suddenly a dark brown voice comes from behind. 'Hey, man. Do you know where the Wiltern Theatre is?'

I turn reluctantly from my calculations. 'Go east for a while, turn south for about... the same and you're there. It's a ways.'

Dude don't dig dis. I take a closer look. It's the geek. Only he's Harry. Harry Connick, Jr. And he mutters he's more than two hours late for rehearsal.

'C'mon Harry, I say. 'I'll give you a ride to the rehearsal.'

Now, in case you're wondering who Harry Connick, Jr. is, read *Time*. It says he's the big talent on the jazz scene these days. So big that he's almost single-handedly making jazz sell like pop. Okay, so he had a little help from Billy Crystal and Rob Reiner. Say what you will, the soundtrack from *When Harry Met Sally* is still a platinum seller and Grammy winner.

Back to the narrator. Harry and I cross the street and jump in my truck. Before I'm bubbling over with thanks. He can't believe his luck. He can't believe he can't get a cab, and that there's no subway in LA. And he can't believe he met me, a commodifying guy with wheels. I gotta say I never occurred to Harry that I might be an ax-wielding fan nut n...

Anyway, we smoke all the way to the Wiltern. He's telling me about the mountains who have been waiting for him for two hours. I'm telling him that there there next...

We go there. Before he jumps out of the truck, he offers me tickets to the gig. But I'm busy that night. Maybe next time...

Until then, music steals. Harry is 22, and was born in New Orleans. He likes girls and thinks the ones in LA are particularly gorgeous, but he lives in New York, so what can you do? He has a whiskey voice, plays a mean piano, has four albums—two of which came out—and is currently on tour. Nice girls will love him, and the hip cats smart enough to play for days to the right gal at the right time. ✕

words by patrick o'donnell

⑤

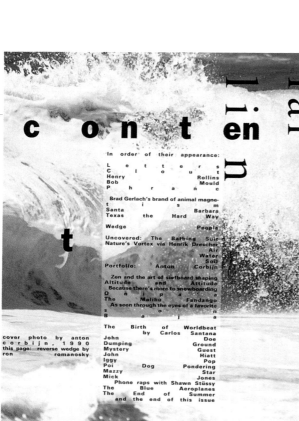
cover photo by anton
corbijn, 1990
this page: reverse wedge by
ron romanosky

<Harry Connick Jr. profile,
1990.
Originally the tape across
the face indicated
where the image
should be cropped, but
it gave the image a
structure that
prompted Carson to
include it fully

<Contents page, 1990.
Fall issue is reflected by
falling into the page. First
use of forced justification.
Photo Ron Romanosky

Lyle Lovett/Sinead O'Connor >
feature, 1990.
[Out-take Polaroid
Alan Messer.]
Shows Lovett standing
on position tape:
"I felt this showed more
about Lyle Lovett than some
of the shots where you saw
his face and guitar... stance,
clothing, boots, said it all."
Noisy type

hat's all this noise about anyway? wh

is all this noise abou

s all **this noise a b o u**

WHAT'S ALL THIS NOISE ABOUT ANYwAY? b o u t anyway?

lyle lovett photo by al an messer

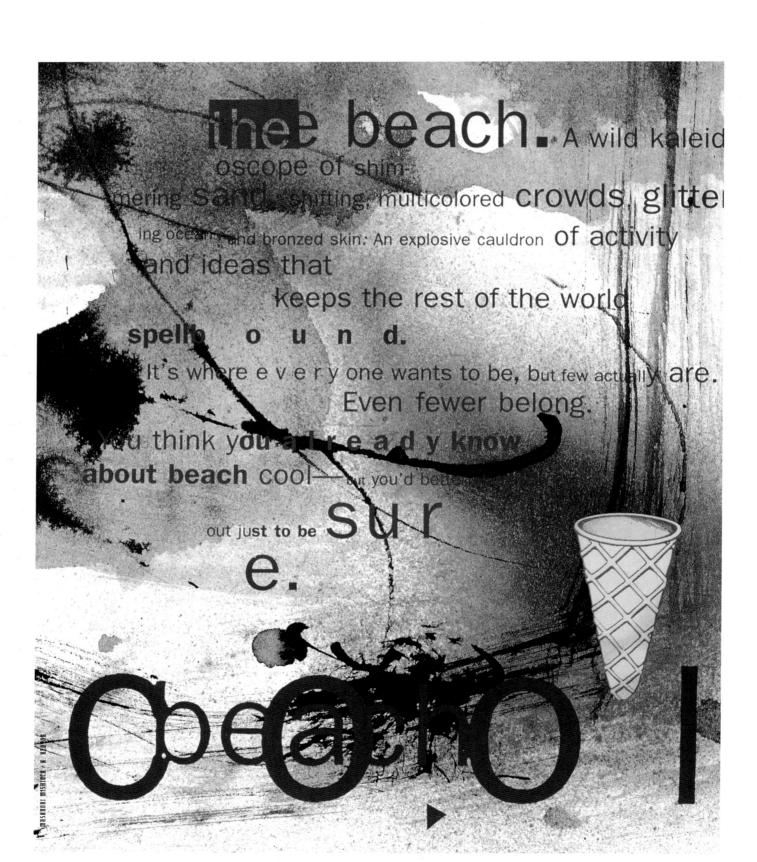

the beach. A wild kaleidoscope of shimmering sand, shifting, multicolored crowds, glittering ocean, and bronzed skin: An explosive cauldron of activity and ideas that keeps the rest of the world spellbound.

It's where e v e r y one wants to be, but few actually are. Even fewer belong. You think you already know about beach cool—but you'd better out just to be sure.

Ocean cool

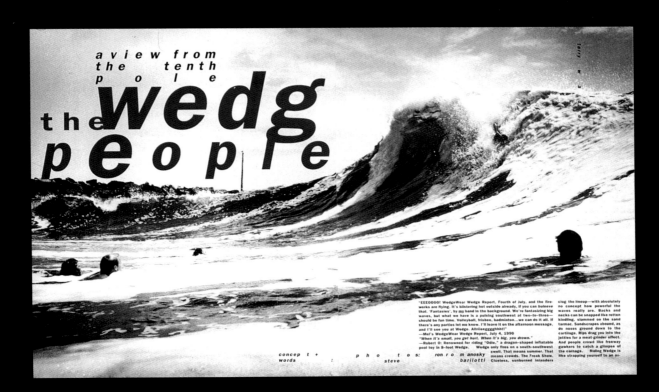

a view from
the tenth
p o l e
the wedg
people

"EEEOOOO! WedgeWear Wedge Report. Fourth of July, and the fireworks are flying. It's blistering hot outside already, if you can believe that. 'Fantasies', by my hand in the background. We're fantasizing big waves, but what we have is a pulsing southwest at two-to-three—should be fun time. Volleyball, frisbee, badminton...we can do it all. If there's any parties let me know. I'll leave it on the afternoon message, and I'll see you at Wedge. Alrifieeegggghhhh!"
—Mel's WedgeWear Wedge Report, July 4, 1990
"When it's small, you get hurt. When it's big, you drown."
—Robert O: Renowned for riding "Odie," a dragon-shaped inflatable pool toy in 8-foot Wedge. Wedge only fires on a south-southwest swell. That means summer. That means crowds. The Freak Show, Clueless, sunburned inlanders

clog the lineup—with absolutely no concept how powerful the waves really are. Backs and necks can be snapped like rotten kindling, slammed on the sand tarmac. Sandscrapes abound, as do noses ground down to the cartilage. Rips drag you into the jetties for a meat-grinder effect. And people crowd like freeway gawkers to catch a glimpse of the carnage. Riding Wedge is like strapping yourself to an av-

concep t + photos: ron r o m anosky
words : steve barilotti

< Beach Cool opener, 1990. Background art Masanori Mishiola/K. Kenyon

Body surfing
at Newport Beach,
California, feature,
1991.
1991. Uses simpler
typefaces in
expressive
treatment. Note E
in "wedge"
shifts to
shifts to "people"
Photo Ron Romanosky

Laird Hamilton
profile, 1990.
Hawaiian flowers
and licence
plate relate to
subject's
origins;
a printer
~~error~~
inspired the
typographic
approach.
Traditional
paste-up.
Photos Art Brewer,
Jeff Girard

B o b

m O u l d

Bob [Mould], co-founder of the legendary Minneapolis group Hüsker Du, talked to us about his life and his second solo album, *Black Sheets of Rain*, from his new apartment in New York, New York. We thought the move itself was a good place to begin: [B.C.]: Why did you move from Minnesota to New York? [Mould]: I wanted to close the book on my past. After the *Workbook* album, I went through a very strange period of upheaval in my life and changed not just musical directions but, as it turned out, a lot of friends too. While I liked Minneapolis' small-town feeling and lack of competition, I'm 29, and I'd lived there for 11 years and felt hemmed in. I didn't feel I could move beyond Hüsker Du or the resulting expectations people had of me there, so I had to leave. [B.C.]: How do you like Manhattan so far? [Mould]: I like it because it only cares about what you're doing now, not about what you've done. It's competitive and anonymous,

MORE IN BACK

ORIGINAL SPECIES

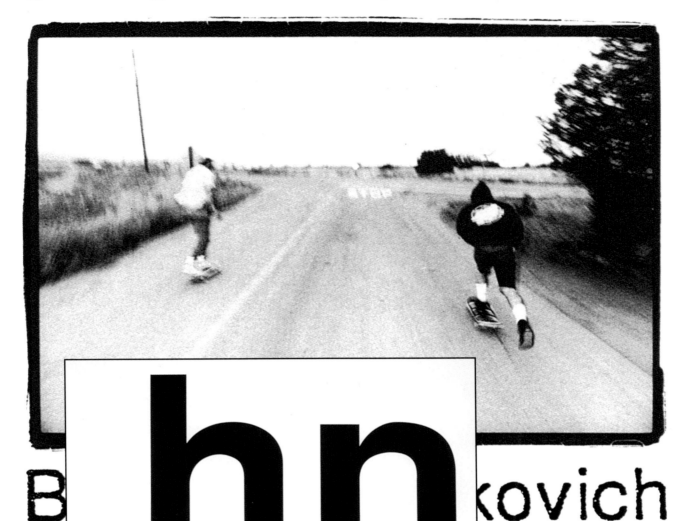

B **jo** **hn** **kovich**

d **o** **e**

< Bob Mould
feature, 1990.

John Doe
feature, 1990 >

Meet John Doe. It's not just the name of a new album, but a great excuse to drive into Hollywood on a day hot enough to melt even a meter maid.

Though the city is literally in flames, John Doe turns out to be the picture of cool. Maybe it's the metal bracelets on his arm; the idea that once the interview is over, he'll be on the highway, heading for the remote ranch several hours north of the city that he now calls home; or the air-conditioning. In any event, he's ready to do the day's version of the Hollywood shuffle.

Although a Los Angeles reporter recently took issue with Doe's pursuit of what the journalist called a "conventional solo career," it turns out that commercial success was a goal of X from the beginning. "Even though people don't associate X with that, it was always important to all of us to be successful," he says. "We always made the best records, gave the best performances and struck the best business deals we could. The only thing we didn't do was make inane music and bend over backwards in terms of making c o n c e s s i o n s ."

Surprisingly, Doe recalls that back in the late seventies, he, Exene and fellow punkers like Top Jimmy would sit around at night "talking about making a lot of money and getting the fuck out of L.A. We knew money would give us the freedom to do things we wanted, like living in the country. We didn't see anything wrong with providing a service and getting paid what we deserved for that."

Although they themselves ultimately didn't make lots of money from X, the band was successful. "We sold 150,000 copies an album and stood for the right things. We had good ideals.

Those don't change unless you're tempted and make concessions a little at a time.

ofeverything,butits effectdependsent irely uponourcom- pliance. Todepart fromthecollec- tivemindistoenter aninteresting con- flict.

Skateboarding has for decades- survivedthescour- geof p u b l i c d i staste. More- thananalternati v e, itseemssubver- sivetothestability ourcultureaspires to.Seemsisitselfa subversiveword. Skateboarding- was created as a new approach to a common environment. Throughitsown evolution,newercustom arenas were both de-

Background:
Original Species,
1989. Photos
Miki Vuckovich

merce, o r con- sumer conven- ience. A sindividu- almembers, ourimmediateexpe r i e n c e i s t h e p a v e d legacyofourancestry.Andtheresourceswe i

Face feature, 1990.
Explores crop point in the image.
Photo Art Brewer

Travel article on Texas, 1991.
Rainy day VW van window.
Photo Pat Blashill

Global warming
feature, 1990.
Illustration Lane
Smith

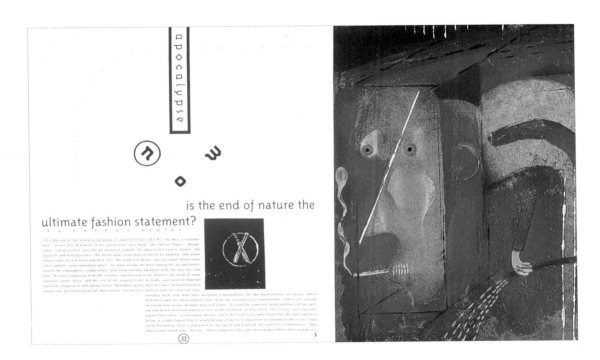

Blind surfer feature,
1991.
Report on a person
who teaches
blind people
to surf: this
opener turns
to an unspecified
point later in the
magazine where
the article ran

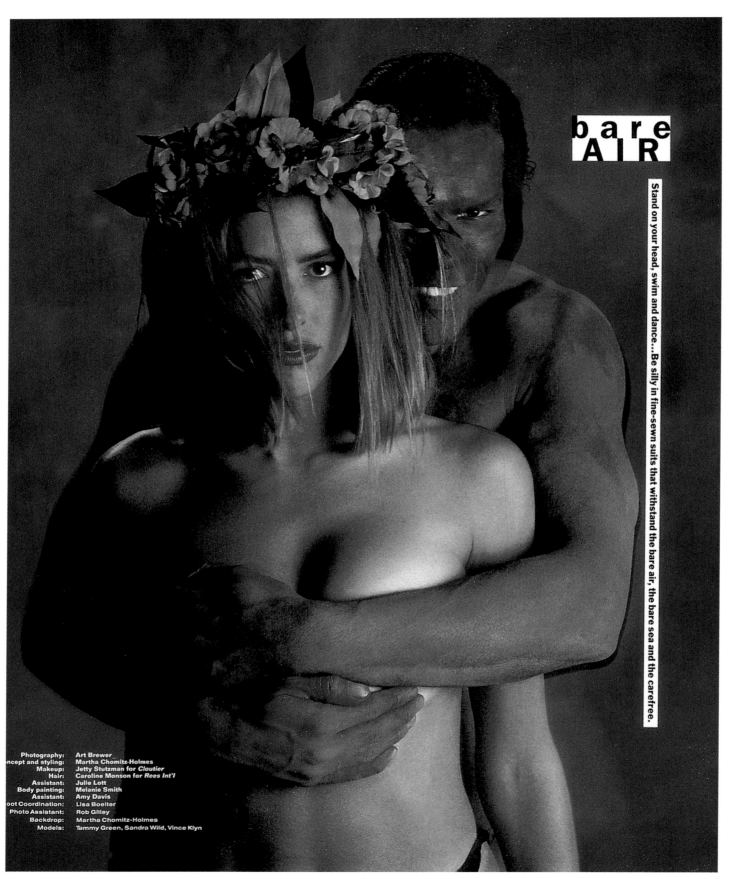

b a r e AIR

Stand on your head, swim and dance...Be silly in fine-sewn suits that withstand the bare air, the bare sea and the carefree.

Photography: Art Brewer
Concept and styling: Martha Chomitz-Holmes
Makeup: Jetty Stutzman for *Cloutier*
Hair: Caroline Monson for *Rees Int'l*
Assistant: Julie Lott
Body painting: Melanie Smith
Assistant: Amy Davis
Shoot Coordination: Lisa Boelter
Photo Assistant: Rob Gilley
Backdrop: Martha Chomitz-Holmes
Models: Tammy Green, Sandra Wild, Vince Klyn

from *beach culture* **2**. photography: art brewer

Sculptor profile, 1991.

Explores strong abstract shapes.

Dad, 1991.

Photo sequence by Art Brewer.

Feature on Russian ballet performance contrasted with Public Enemy rap concert, 1991.

Photo Steve Sherman

UNCOVERED! A PEEK AT BATHING AND PRESENT. AND WHY THE BEACH MODELS SAME WITHOUT

Swimsuit history, 1990.
Severe crop and montage.
Photo Art Brewer

M. Arisman

E LAND,
G R A C E
P A R A
LAND, P A R A
DISE G
DISE G
ARDEN, AND
ST. COCA
COLA

Graceland tour feature,
1991. Photo of Jetstream
trailer by Alan Lebudde

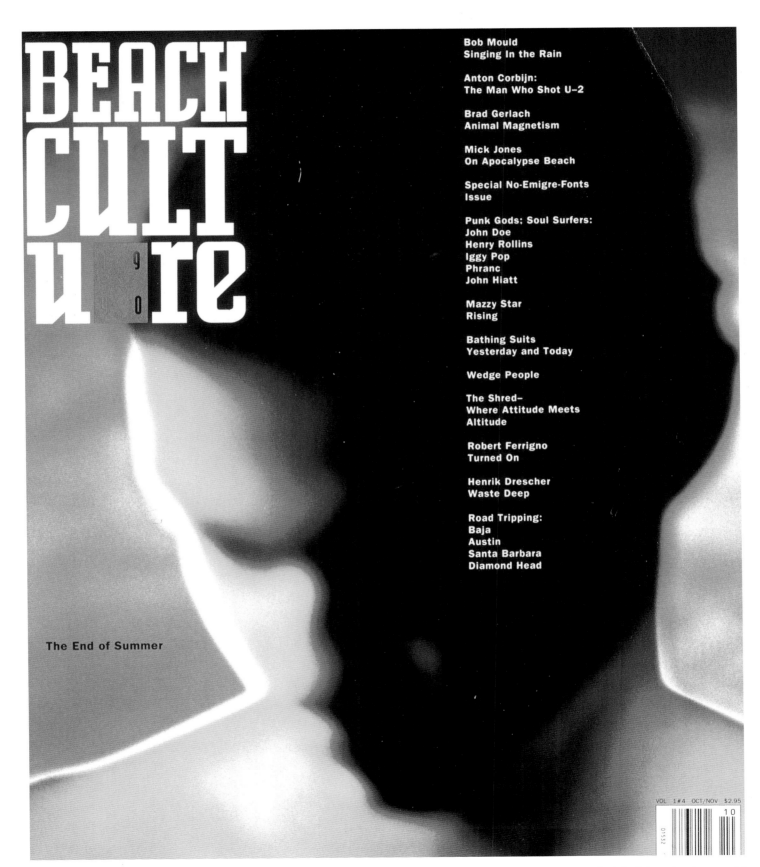

BEACH CULTure 90

The End of Summer

Bob Mould
Singing In the Rain

Anton Corbijn:
The Man Who Shot U–2

Brad Gerlach
Animal Magnetism

Mick Jones
On Apocalypse Beach

Special No-Emigre-Fonts
Issue

Punk Gods; Soul Surfers:
John Doe
Henry Rollins
Iggy Pop
Phranc
John Hiatt

Mazzy Star
Rising

Bathing Suits
Yesterday and Today

Wedge People

The Shred–
Where Attitude Meets
Altitude

Robert Ferrigno
Turned On

Henrik Drescher
Waste Deep

Road Tripping:
Baja
Austin
Santa Barbara
Diamond Head

VOL 1#4 OCT/NOV $2.95

Cover four, 1990. Photo Anton Corbijn [his early colour work]

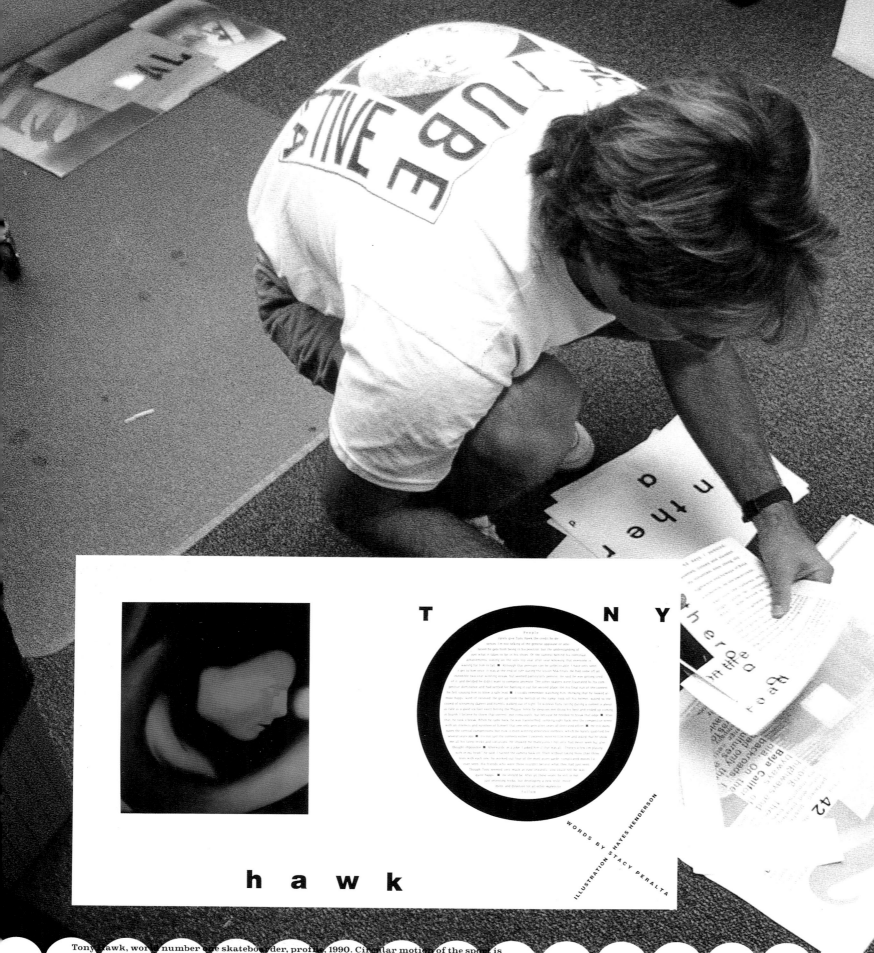

TONY

WORDS BY HAYES HENDERSON

ILLUSTRATION STACY PERALTA

hawk

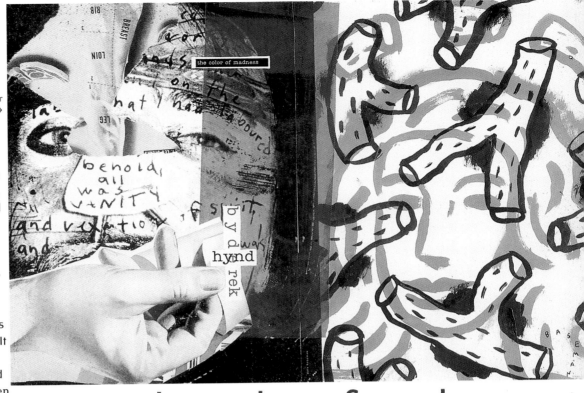

background foto by eric dinyer
illustration by gary baseman→

It was the moment that tied me to the pendulum. The Man, centered. The Child, swinging merrily right, horribly left. God at the extremes.

And through the arcs I felt solitary with the wind, free to think as I please.

On the rumpled bed she lay. Into the toilet bowl I stared. Stunned. "Mottled brown," I thought. "It's mottled brown." Drained, placid, rational, the sight of this small, foreign weight flooded my brain. It existed, basking against convention like...like a young Burt Lancaster in dead calm, clear water. It should not have been there. After all, lovers shared no secrets. But it was; and still it flooded me. Slow. Deep. I could've been God pondering Man.

Had it been my own, I'd have flushed it, dispatching the mariner to oblivion because anything of mine was generally disgusting. I'd certainly been born to die. But it was my girlfriend's. Unsinkable. And nothing of hers was ill-conceived. She was pure and I cherished her.

I went to the defense of the orphan of her beauty. Reaching down, both time and thought seemed to deconstruct into a three-second galaxy. Like a car crash; or mom's red jelly about to set; or the silent arrival of huge, deep sea mountains; or my friend Dale, discovering an antique chair at the garbage dump, under a full moon. As my left palm dipped the water and coiled round it, no flick of nausea, or fear, or panic touched me. I possessed something wonderful. I WAS God. Until I returned to the bedroom, it was the closest thing in my life. My only friend. The truth.

Moving back through the hallway, the soft carpet spoke to my toes, and the walls tried to touch my joy, for I carried the entire universe, and they knew it. She was wearing a loose crimson shirt. Tears welled in my eyes. What could I possibly say? She looked at me.

"Baby," I heard myself half-croon, half-choke. "You left me a gift." Holding it outstretched, I watched her delightful face twist to the same fraught pulse that had been the orgasm a short while before. Love. I would've eaten it, had she asked. But she didn't. Things were never quite the same again. She left.

←the color of madness
by derek hynd
from Beach Culture
#6

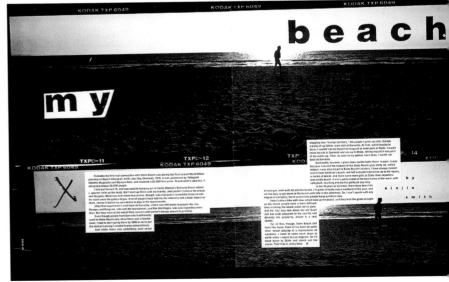

"my beach"
contact sheet had been marked with an 'x' for desired photo to be enlarged; upon closer examination Carson decided to use the whole contact sheet for the opener.
photo by Art Brewer
from Beach Culture # 2

letter

It's about time someone came out with something like this. I'd also like to compliment the editorial graphics department. Very creative stuff, very fresh and def, the way I like it. **Ron Jervis, Honolulu, Hawaii** ◇ The use of photos, art and especially type is so creative—it's inspiring. You're making a statement of freedom from the norm. I enjoyed the copy as well. Good luck on the next issue. Don't tame down—unleash it. **Karen Williams, Santa Cruz, California** ◇ Art Brewer: The images you created in the "Articles of Faith" feature in BEACH CULTURE clearly once and for all set you apart from all the rest of the so-called "surf photographers." I have had my eye on your work and knew you were taking photography to the limit as time permits—your eye focused and your lighting superb. The F-64 Club would no doubt ask you to join. **Gary Lynch, Arcata, California** ◇ A fine piece of magazine publishing. Very hot mag. Art section completely cool—Thanks. Holmes did a nice job, not to mention both you and that son-of-a-bitch can write. **Paul Taublieb, New York, New York** ◇ Just a quick note to say how blown away I am about BEACH CULTURE! It is without a doubt the best thing to happen to the surf industry in many years. The look is unreal. Art Brewer's photography is fresh and clean and unafraid. And best of all, it's not targeted at a 14-year-old mentality. I am thoroughly impressed and inspired. **John Bilderback, Haleiwa, Hawaii** ◇ It's great. Really. Keep doing it. I especially like the type treatment. Thank you. **Valerie Richardson, Phoenix, Arizona** ◇ BEACH CULTURE has a very fresh and unique design approach. We'll use it like a Bible because we're setting it next to "the Graphic Language of Neville Brody" (on our book case). **Robynne Raye, Seattle, Washington** ◇ The magazine looks great. Good luck with it. I like it a lot. It should do real well. **Bob Guccione, Jr., SPIN, New York, New York** ◇ Thank you for the amazing design. . . BEACH CULTURE looks fuckin' great. **Rick Valicenti, 3hirst, Chicago, Illinois**

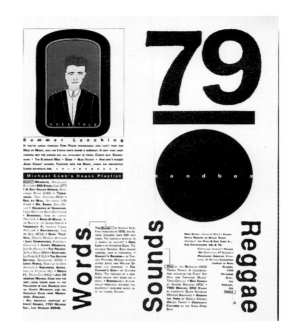

THE TRIAL
SOFSWIM
SUITSHOP

PING BYLISAB⊕ELTER

Left: Transition piece. The latest *emigre* font is combined with copy machine-distressed font, all waxed and put into place on an "art board" (as were all six issues of *beach culture*). 1990

Cover illustration by Steve Byrom; opener collage by Kathleen Kenyon.

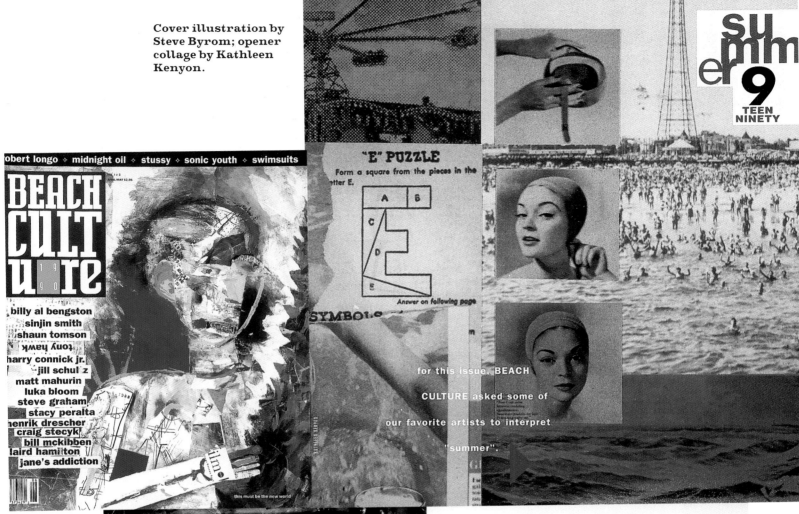

obert longo • midnight oil • stussy • sonic youth • swimsuits

BEACH CULT u re 1990

billy al bengston
sinjin smith
shaun tomson
tony hawk
harry connick jr.
jill schulz
matt mahurin
luka bloom
steve graham
stacy peralta
henrik drescher
craig stecyk
bill mckibben
laird hamilton
jane's addiction

this must be the new world

"E" PUZZLE
Form a square from the pieces in the letter E.

A | B
C
D
E

Answer on following page

SYMBOLS

for this issue, BEACH
CULTURE asked some of
our favorite artists to interpret
"summer".

su mm er 9 TEEN NINETY

riding the RAILS

THE PLIGHT OF THE SUBWAY SURFER

Article by Roberto Cummings / Photo by Bradford Walker Evans Jun

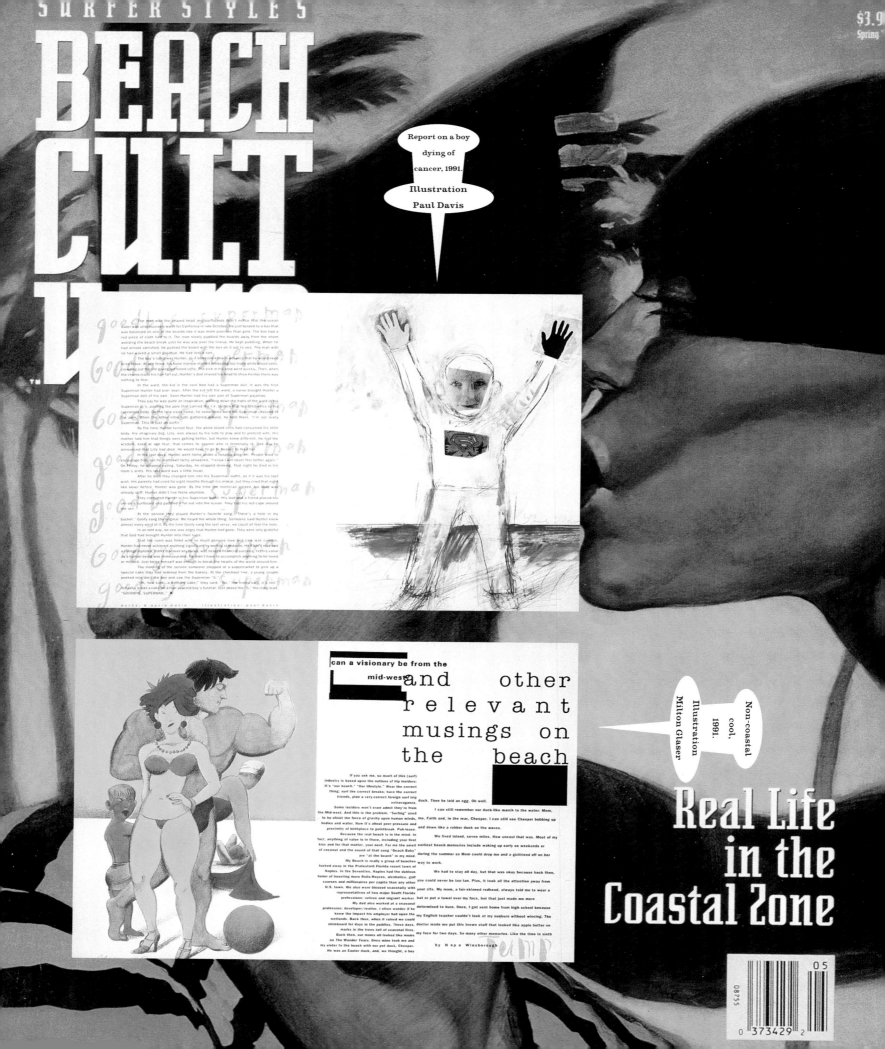

BEACH CULT

$3.9
Spring

Report on a boy dying of cancer, 1991.

Illustration Paul Davis

Non-coastal cool, 1991.

Illustration Milton Glaser

can a visionary be from the mid-west

and other relevant musings on the beach

by Hope Winsborough

Real Life in the Coastal Zone

b e a c h y

Billy Gould doesn't hang out at the beach More, and has been on the road for two has just moved to Ocean Beach so he

"My beach is intimate and make friends with it. They saw my ocean grow up around the lifestyle.

last January. We went surfing, and it so white you needed sunglasses to look I fell off the cliff while staring at the mount a surfboard rack on my motorcycle beaches and lack of crowds.

Street. My first surf came some 15 Southern California days past. Sand. trips. Friends visiting from up north, Wish I still had it.

near coastal smells, so I moved to Ocean Golden Gate Bridge for surf checks. morning and late-day bike rides with my along the streets in the Sunset district. our music and stage ways, but hairspray spontaneity. It's kind of like when you that. You work around the moods, carve

as much as he would like to, but it's not for years. Currently in San Francisco putting a can catch up on his life and enjoy "his" tight, like the band. My parents introduced feelings as healthy rather than self-

"Because of that, everywhere I was unreal. A green, tropical jungle, all at it. The surf was happening and warm. Or perfect waves. Everyone laughed at me then, and head south. I like Mexico, and used to go

"That was the way it used to be years ago; and my memories of it are like Surf. Sun. Those chubascos pumping swell wailed by sneaker sets. It was cool. My first

"Now, after being on tour for two Beach—two blocks to the sand. I often find Mostly I just hang around Ocean Beach, lady, time tripping along the strand or on my

"It's no different with our music. and Spandex are not our style. When the five go surfing. The conditions change constantly. off the attitudes and pull into ideas. It's tight

lack of trying. He's in a band called Faith No record together with the rest of the band, he beach. As he says: me to my first beach, and encouraged me to destructive so I've been lucky enough to go is "my beach." Like down at Rock in Rio tangled and jutting down onto bleached sand like the time on Maui and Honolua Bay when

"Who knows? Maybe someday I'll all the time. Maybe it's because of the great where I grew up in Del Mar, around 19th Polaroids. Quick, click remembrances of lines onto the coast; or Black's Beach cliff board was a plastic fantastic 6'4" swallow. years, I'm city-bummed. I had to get back myself radar-aimed at Fort Point under the which is my beach now. I love those early-black and white Italian Moto Guzzi motorcycle We could take a more corporate approach to of us are together, there are sparks and You have to adapt and flex. The band's like and together—just like my beach." ✕

My Beach feature, 1991.
"This is gibberish" said the editor as he handed it back.
Photo Ken McKnight.

$ 12.95

To order yours call 714-496-5922 with your VISA/MasterCard number or send check or money order along with this page to BEACH CULTURE T-

SHIRTS, P.O. Box 1928, Dana Point, CA 9262 9 Specify size: Large or X-Large and Quantity of Order. Allow 4-6 weeks delivery (FOREIGN; add $0

BEACHCULTURE
T-SHIRTS

for air mail) CA residents add 6.25% sales tax.

+ three dollars shipping

T-shirt ad, 1991.
An ad selling the shirt sight unseen: if
you like the look of the ad, of the maga-
zine, you probably would like the shirt

summer's here

JUNE 19,

culture

get some culture and check out :

two faces for the 90's— john wesley harding (singer-songwriter) , beach culture magazine.

the jesus and mary chain on the Santa Monica pier

mary;'s danish on bottled water ;
plus the usual mix of art, places, st Yle

and ATTItuDE. our special

on the Road in Jamaica, ZANZIBAH, Hawaii and kentucky

the ULTIMATE:: A spor

> rd'st IMATE:: A sport that lives up to its name.
on the road in jamaica, ZANZIBAH, Hawaii and kentucky

the jesus and mary chain on the S
anta Monica pier

bbook stores.

RESHOPS

Next issue page, 1990.
It's all there, somewhere.
Photo Art Brewer.

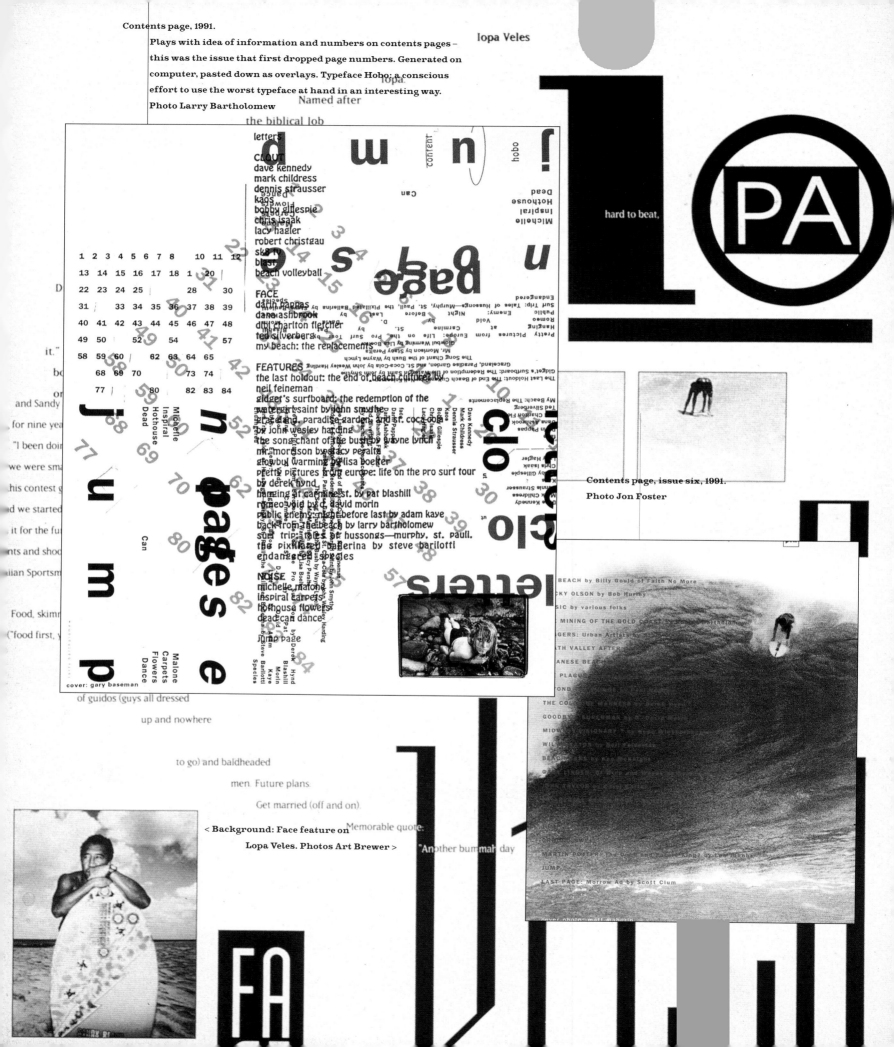

Contents page, 1991.

Plays with idea of information and numbers on contents pages – this was the issue that first dropped page numbers. Generated on computer, pasted down as overlays. Typeface Hobo; a conscious effort to use the worst typeface at hand in an interesting way.
Photo Larry Bartholomew

lopa Veles

Contents page, issue six, 1991.
Photo Jon Foster

< Background: Face feature on Lopa Veles. Photos Art Brewer >

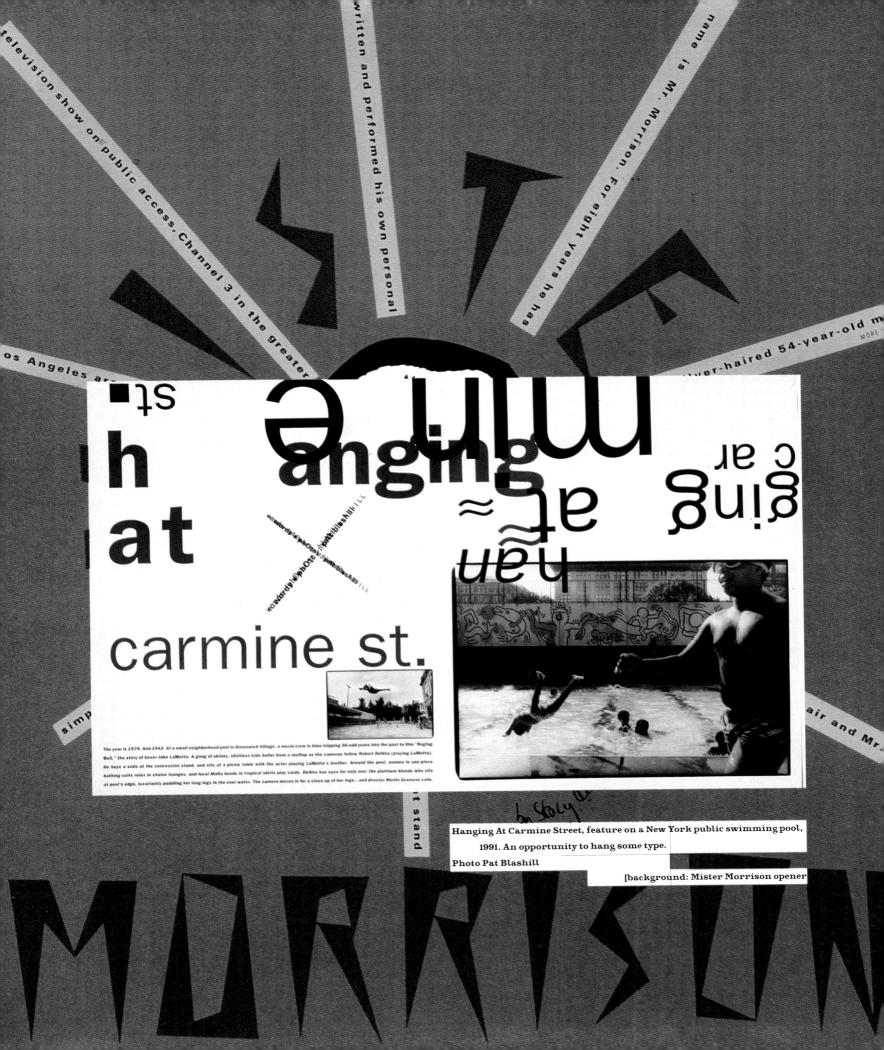

hat at carmine st.

hanging at ≈ carmine air

The year is 1979. And 1942. At a small neighborhood pool in Greenwich Village, a movie crew is time-tripping 30-odd years into the past to film "Raging Bull," the story of boxer Jake LaMotta. A gang of skinny, shirtless kids holler from a rooftop as the cameras follow Robert DeNiro (playing LaMotta). He buys a soda at the concession stand, and sits at a picnic table with the actor playing LaMotta's brother. Around the pool, women in one-piece bathing suits relax in chaise lounges, and local Mafia heads in tropical shirts play cards. DeNiro has eyes for only one: the platinum blonde who sits at pool's edge, luxuriantly paddling her long legs in the cool water. The camera moves in for a close-up of her legs....and director Martin Scorsese calls.

Hanging At Carmine Street, feature on a New York public swimming pool, 1991. An opportunity to hang some type.
Photo Pat Blashill

[background: Mister Morrison opener

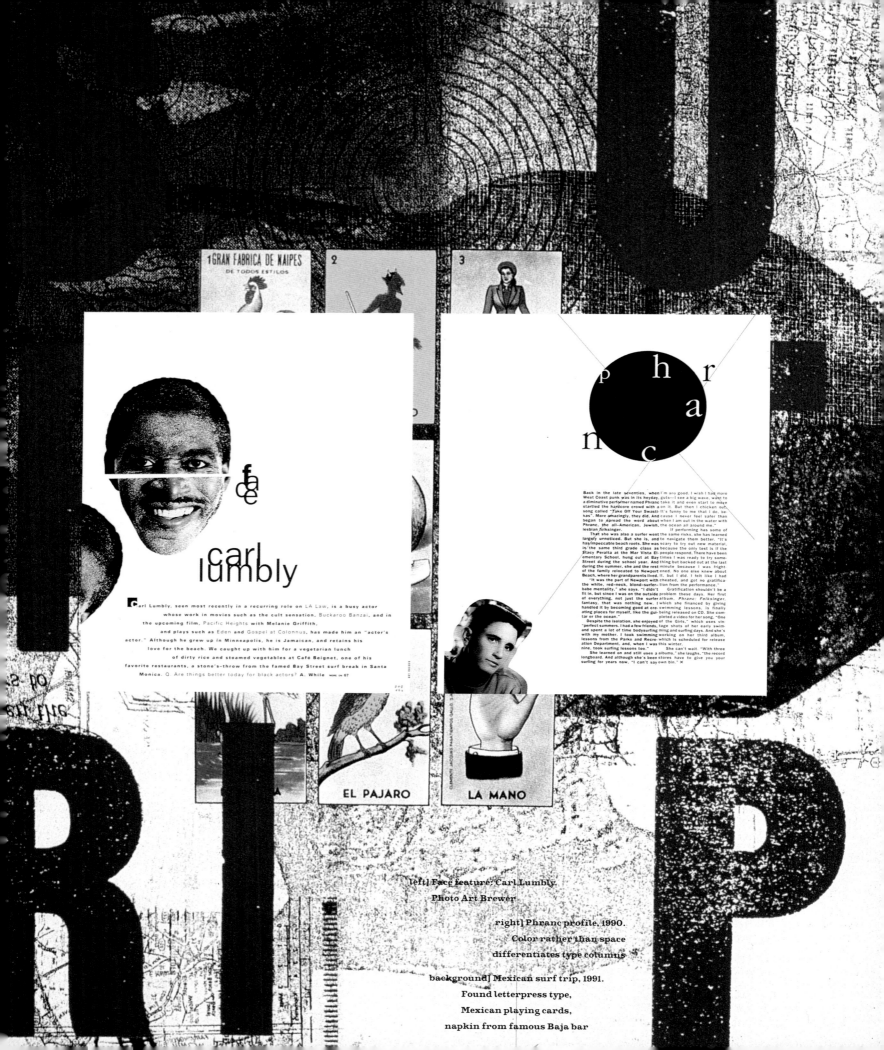

1 GRAN FABRICA DE NAIPES
DE TODOS ESTILOS

2

3

face

carl
lumbly

p h r a n c

Carl Lumbly, seen most recently in a recurring role on LA Law, is a busy actor whose work in movies such as the cult sensation, Buckaroo Banzai, and in the upcoming film, Pacific Heights with Melanie Griffith, and plays such as Eden and Gospel at Colonnus, has made him an "actor's actor." Although he grew up in Minneapolis, he is Jamaican, and retains his love for the beach. We caught up with him for a vegetarian lunch of dirty rice and steamed vegetables at Café Beignet, one of his favorite restaurants, a stone's-throw from the famed Bay Street surf break in Santa Monica. Q. Are things better today for black actors? A. While MORE ON 67

Back in the late seventies, when West Coast punk was in its heyday, a diminutive performer named Phranc startled the hardcore crowd with a song called "Take Off Your Swasti- kas". More amazingly, they began to spread the word about Phranc, the all-American, Jewish, lesbian folksinger. That she was also a surfer went largely unnoticed. But she is, and has impeccable beach roots. She was in the same third grade class as Stacy Peralta at the Mar Vista El- ementary School, hung out at Bay Street during the school year, and during the summer, she and the rest of the family relocated to Newport Beach, where her grandparents lived. "It was the part of Newport with the white, red-neck, blond-surfer babe mentality," she says. "I didn't fit in, but since I was on the outside of everything, not just the surfer fantasy, that was nothing new. I handled it by becoming good at swimming lessons. I took swimming lessons from the Parks and Recre- ation Department, and, when I was nine, took surfing lessons too."

Despite the isolation, she enjoyed "perfect summers. I had a few friends, and spent a lot of time bodysurfing and surfing those days. And she's with my mother. I took swimming lessons on her third album, which is scheduled for release this winter.

I'm any good. I wish I had more guts—I see a big wave, want to take it and even start to move on it. But then I chicken out. And cause I never feel safer than when I am out in the water with the ocean all around me." If performing has some of the same risks, she has learned to navigate them better. "It's scary to try out new material, is because the only test is if the people respond. There have been times I was ready to try some- thing but backed out at the last minute because I was fright- ened. No one else knew about it, but I did. I felt like I had cheated, and got no gratifica- tion from the performance." Phranc: Folksinger, is finally ating places for myself, like the gui- tar or the ocean." being released on CD. She com- pleted a video for her song, "One "perfect summers. I had a few friends, age shots of her early swim- lessons which is scheduled for release She can't wait. "With three longboard. And although she's been stores have to give you your surfing for years now. I can't say own bin." ✕

EL PAJARO

LA MANO

left] Face feature: Carl Lumbly.
Photo Art Brewer

right] Phranc profile, 1990.
Color rather than space
differentiates type columns

background] Mexican surf trip, 1991.
Found letterpress type,
Mexican playing cards,
napkin from famous Baja bar

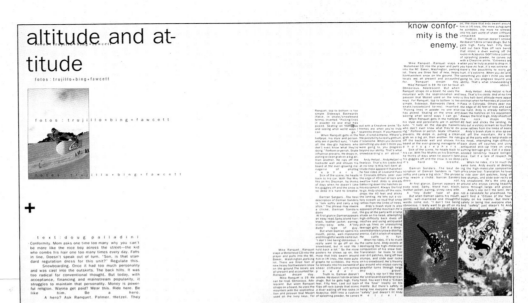

altitude and at-titude

fotos : trujillo • bing • fawcett

Snowboarding article, 1990.
To get the desired copy
shape, which reflects the
altitude and attitude, the article was
repeated twice.
Photos Trujillo, Bing, Fawcett

Property feature, 1991.
"The last hold out" subject is explored
in headline type, where the 1920s e is
surrounded by a new face.
Photo Steve Sherman

David Lynch profile, 1990.
Carson interprets the subtle rule-
breaking of Lynch's work by
breaking an unquestioned rule of type –
that you don't run body copy
down the gutter. The second column
runs neatly down with the staples
right through it. The black shape at the
bottom is the result of not putting
the copier lid fully down.
Photo Jan Weinberg

DAVID LYNCH, UNEARTHED
an interview by Neil Feineman

34

John Wesley Harding feature, 1990.

Preferred shot on the

contact sheet used for the page.

Galaxie 500 profile, 1990.

Photo Art Brewer

Photo Pat Blashill

Sixth issue openers, 1991.

Sixth issue openers, 1991.New direction in titles, the

shapes derived entirely from repetition

and manipulation of words, with exploration of

negative space.

negative space.Photos Steve Sherman

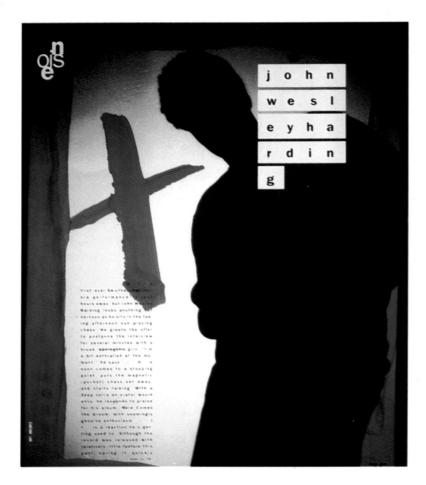

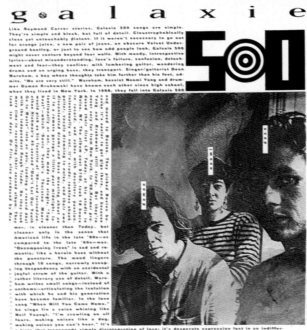

opposite, top]

Travel piece, 1991.

Illustration Gary Baseman,

photo Anthony Artiago

opposite, bottom]

Fashion spread, 1991.

Hand-lettering DC,

photo Larry Bartholomew

opposite, background]

Photo by Bradford Walker

Evans Hitz

appeared in the second issue

[1990

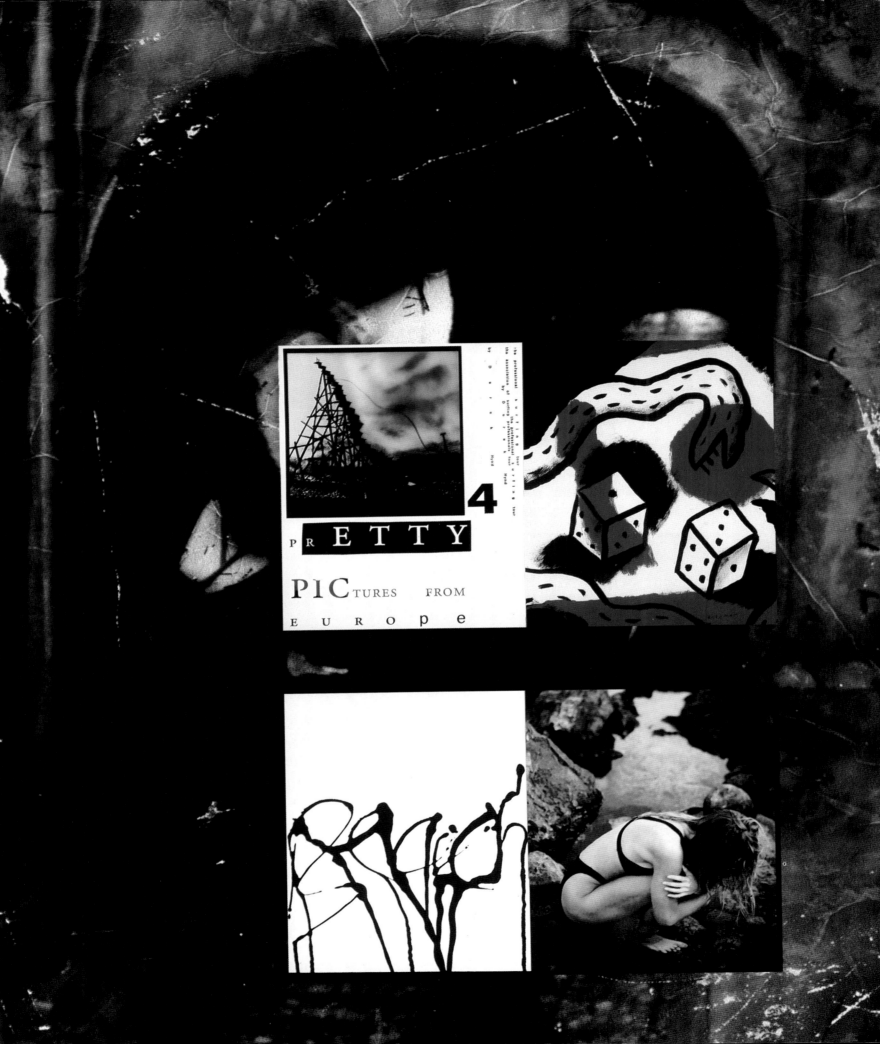

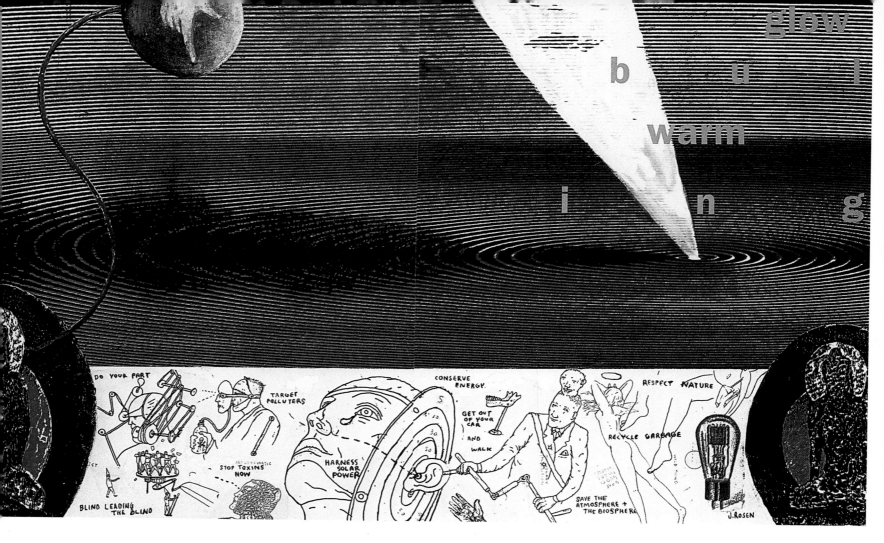

glow
b u l
warm
i n g

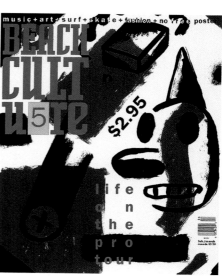

Top: Global warming illustration by
Jonathan Rosen. Above: Illustration
by Gary Baseman.
Left: Surf trip into Baja, complete
with required stop at world-famous
bar 'hussongs'.

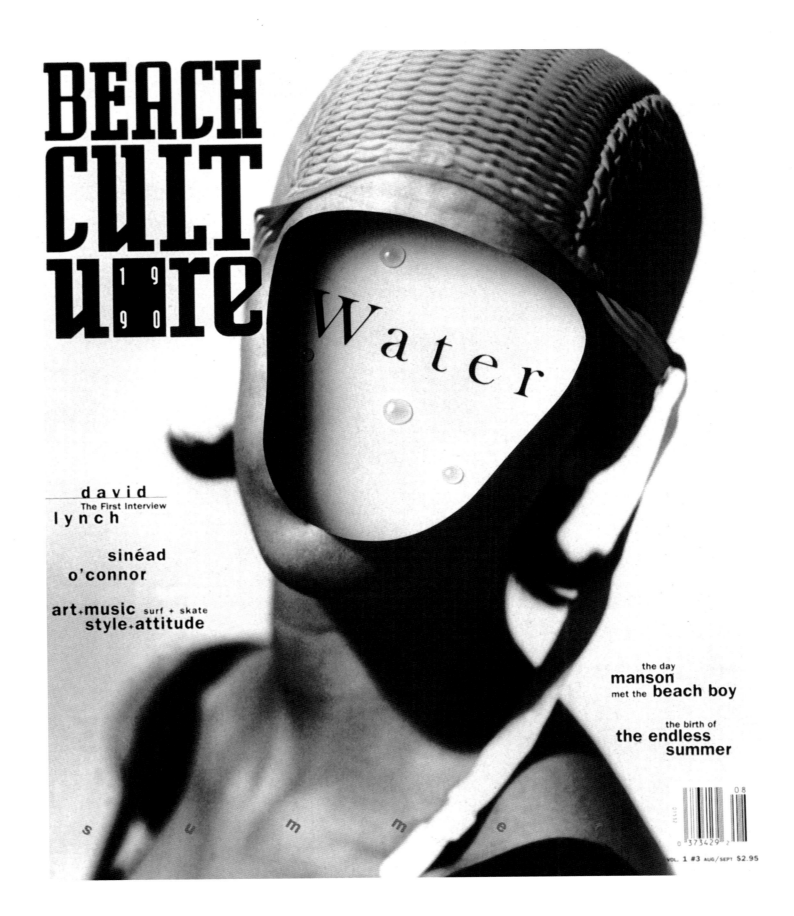

Cover, 1990. Photo Geof Kern, originally submitted for inside article, but surprise quality and compositional strength made it the cover.

BEACH CULTU re

1990

Water

david
The First Interview
lynch

sinéad
o'connor

art+music surf + skate
style+attitude

the day
manson
met the beach boy

the birth of
the endless
summer

summer

VOL. 1 #3 AUG/SEPT $2.95

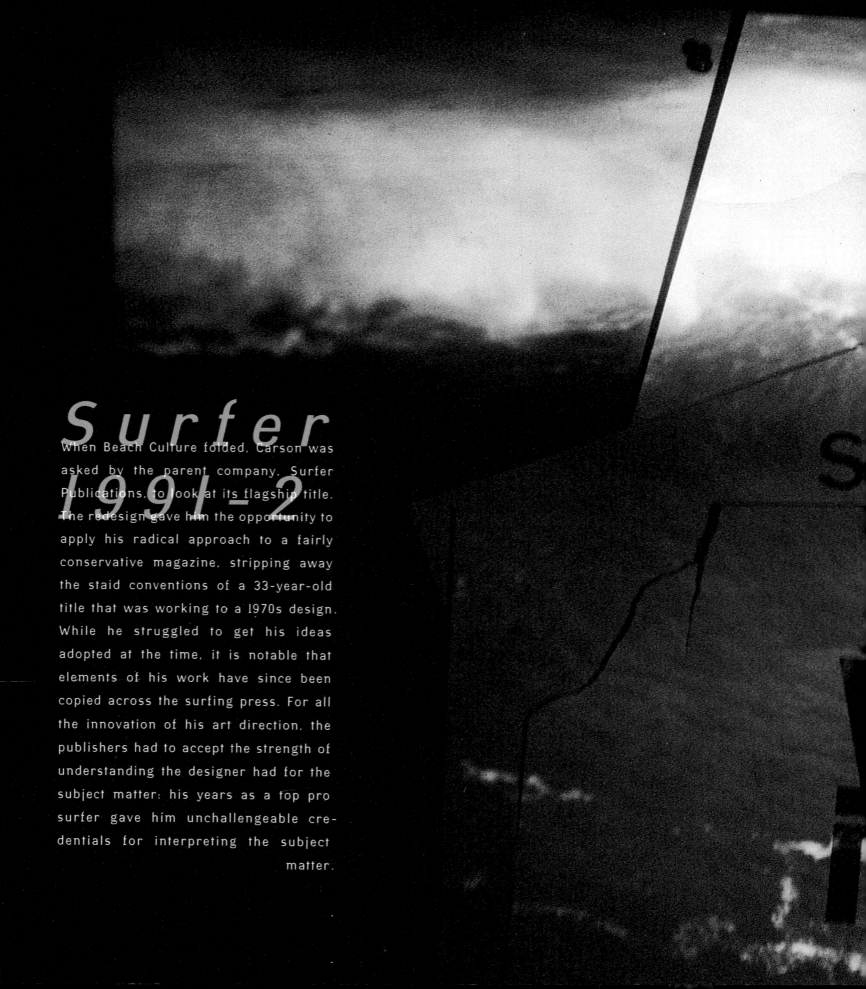

Surfer
1991–2

When Beach Culture folded, Carson was
asked by the parent company, Surfer
Publications, to look at its flagship title.
The redesign gave him the opportunity to
apply his radical approach to a fairly
conservative magazine, stripping away
the staid conventions of a 33-year-old
title that was working to a 1970s design.
While he struggled to get his ideas
adopted at the time, it is notable that
elements of his work have since been
copied across the surfing press. For all
the innovation of his art direction, the
publishers had to accept the strength of
understanding the designer had for the
subject matter: his years as a top pro
surfer gave him unchallengeable cre-
dentials for interpreting the subject
matter.

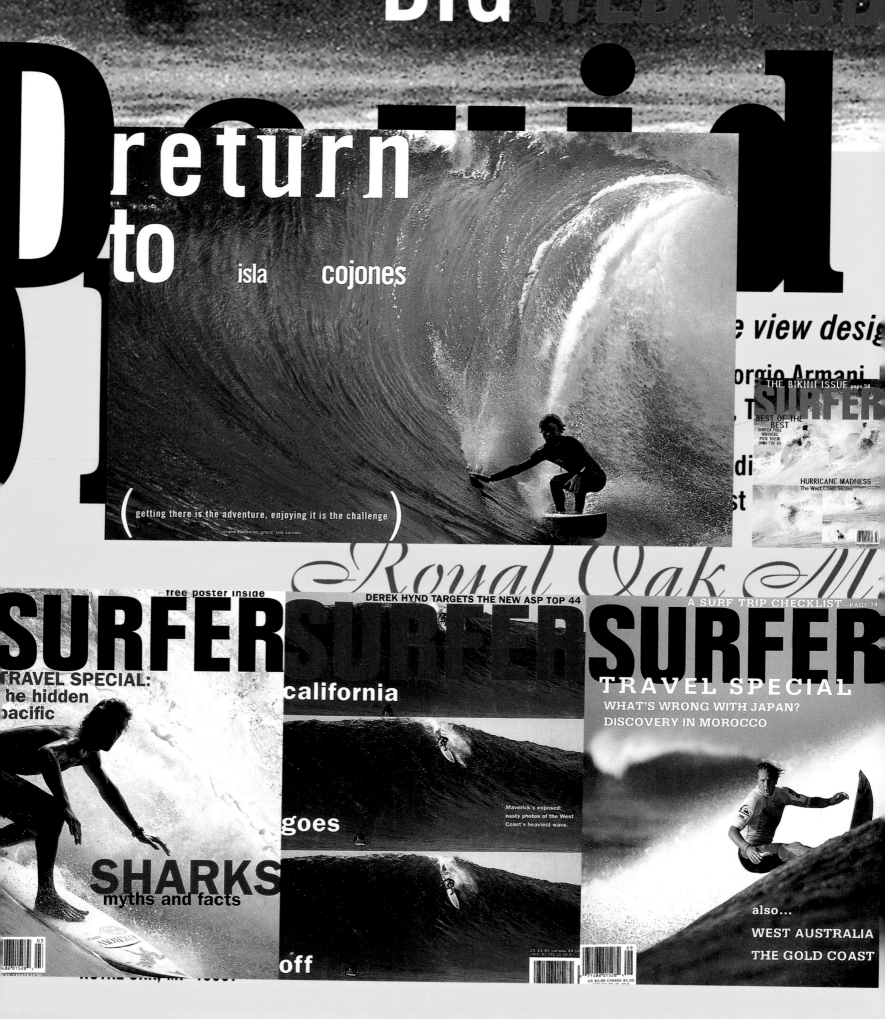

BIG WEDNESD

foto

return
to

Big

isla cojones

(getting there is the adventure, enjoying it is the challenge

)

shane dorman, photo: tom servais.

e view desig

orgio Armani

THE BIKINI ISSUE page 58

SURFER

BEST OF THE
BEST
SURFER POLL
WINNERS
PICK THEIR
OWN TOP 10

HURRICANE MADNESS
The West Coast Sizzles

Royal Oak M

free poster inside

DEREK HYND TARGETS THE NEW ASP TOP 44

A SURF TRIP CHECKLIST—PAGE 74

SURFER

SURFER

SURFER

TRAVEL SPECIAL:
he hidden
pacific

california

TRAVEL SPECIAL
WHAT'S WRONG WITH JAPAN?
DISCOVERY IN MOROCCO

goes

Maverick's exposed:
nasty photos of the West
Coast's heaviest wave.

SHARKS
myths and facts

also...

WEST AUSTRALIA

off

THE GOLD COAST

US $3.95 canada $4.50
JUNE '92 VOL 23 NO.6

US $3.95 CANADA $4.50

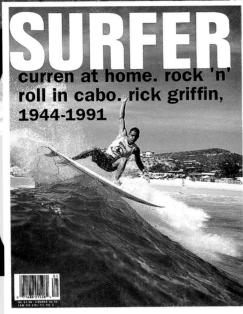

SURFER

curren at home. rock 'n' roll in cabo. rick griffin, 1944-1991

SURFER
hawaii

SURFER

DID THEY MEAN IT?

Curren, Fletcher, Rabbit, Booth and others rethink surfing's most outrageous quotes
page 48

Also: New Finds in Panama and the Galapagos

SURFER
big time

Carson-designed covers and spreads from *Surfer* magazine. 1991–92.

, Pe
e M

orks
phy,

s

ml

m 2

d a r b y ,
r o s l y n ,
s e y -
m o u r
&
t i n a

The Hurricane Parade of 1992
Lights Up the West Coast

SURFER

HAWAII PREVIEW
off to an epic start
HUGE EAST COAST

LONGBOARDING
today

US $3.95 CANADA $4.50

If you turned to this page expecting T&A, read on and learn why

SEXism SUCKS

by Matt Warshaw

Consider the durability of the word "chick." The Beats invented the expression about 40 years ago; it got a push from the counterculture, easily survived early '70s feminism, and now stands as arguably the English-speaking world's most popular slang word for girl or woman. In surfing, virtually no other description for female exists.

As demonstrated by reigning ASP men's world champion Damien Hardman, after watching a women's heat last year, usage is as follows: "That's the best I've ever seen a chick surf."

An article on sexism in surfing, therefore,

might begin with a quick lesson in semantics: "Chick" is derogatory, in the same category as "hebe," "nigger" and "faggot." The fact that a world champion can nonchalantly describe a peer as "chick" in an interview, without recrimination, only hints at the length, breadth and depth of sexism in surfing. Surfing's gender morals, in a word, suck. Hardman is champ; ignorance is king.

illustration by anita kunz

58

Sexism sucks, 1992. The cover of this issue promised "The Bikini Issue page 58". A large page number announces to the reader they have found the page – and a tough article on sexism. Illustration Anita Kunz

pro fi le

manners AND jeff

image

booth

Jeff Booth has a lot going on between the legs of the ASP World Tour. He left Australia rated eighth in the world,

BY BEN MARCUS

stopped by Tavarua for a couple days, then came home to Laguna Beach to move into a new house. Booth's pad is older, comfortable with three bedrooms, a big yard and a garage full of surfboards. The three hundred thousand bucks Booth signed for may be low end for Laguna Beach real

Jeff Booth, 1992. Profile of a shy surfer: a colour printer error produced a version of the photograph which only revealed nose and mouth. It seemed appropriate. "Jeff Booth" is in early version of Barry Deck's Industry Sans [later Arbitrary Sans]

Photos That
Changed the Way
We Surf, 1992.
Early version of
Barry Deck's
Template Gothic,
one of the most
influential type-
faces of the early
1990s, features in
this spread from
first issue of the
redesigned Surfer

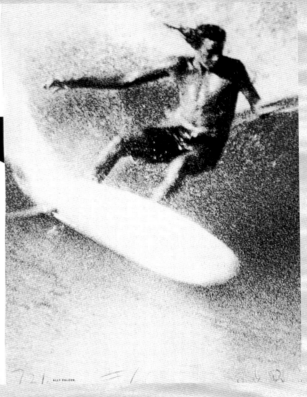

the photos that
changed the way
we_
surf

"by matt george

Portfolio of Art
Brewer, 1992.
Photo Matt
Mahurin,
featuring
illustration on
photography.
Name/headline
plays off
treatment
photographers
usually get for
their name credit

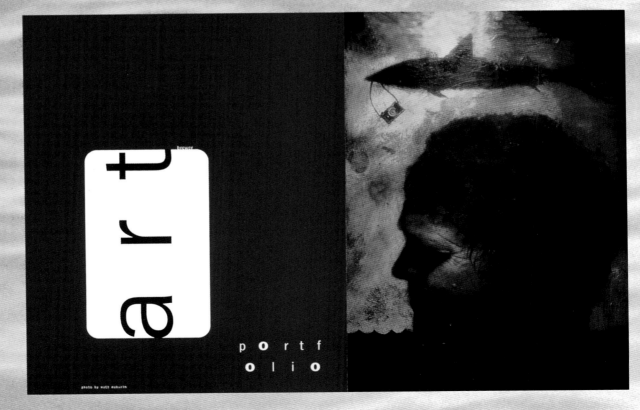

brewer
art

p o r t f
o l i o

photo by matt mahurin

Sponsored by > **DETROIT NEW-MEDIA ASSOCIATION, THE BIG IDEA, REAL DETROIT, CCS, AMBROSE INTERNATIONAL**

Printed by > **PhoenixPress.net 248.457.9000** Paper by > **AmbroseInternational.**

Produced by > **timrosa@adventurefront.com** / **www.adventurefront.co**

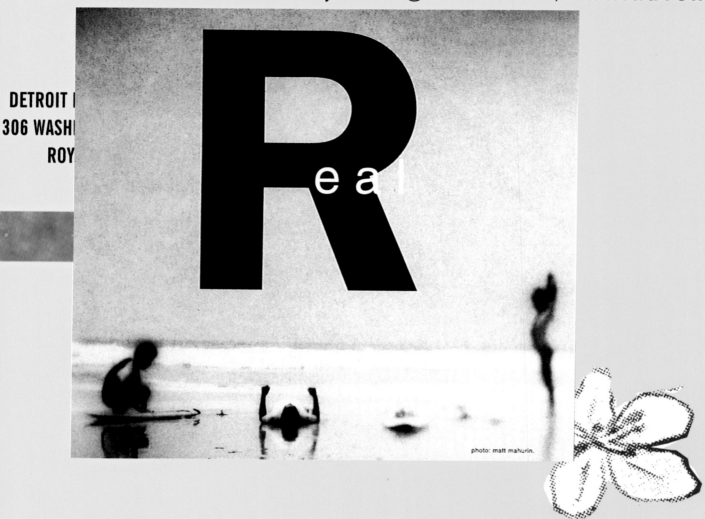

DETROIT
306 WASH
ROY

Real

photo: matt mahurin.

new world champ—pg.74

SURFER

hawaii
preview

**huge east
coast**

**longboarding
today**

US $3.95 CANADA $4.50
APRIL '92 VOL. 33 NO. 4

FREE POSTER INSIDE

SURFER

sunset beach

surfer poll

nude surfing

US $3.95 CANADA $4.50
FEBRUARY '92 VOL. 33 N

LEFT: Image by Matt Mahurin. ABOVE: *Surfer* **covers.**

Ray Gun 1992-
Marvin Jarrett, former publisher of Creem, would be the music and fashion magazine of tive, but now conservative, music press. Ray Gun (a name that alludes to a line in a to the artist Claes Oldenburg's proposed early 1960s). Initially Jarrett recruited the Neil Feineman, although Feineman left after has not entirely delivered a new music and in its art direction it has carried revolution layout, his art direction has opened the way tors and photographers, as well as provid content area is Sound In Print, where six to readers' illustrations of song lyrics; in this art magazine, along with its music scene *content* challenges the notion of design as words and pictures. How Ray Gun looks is content. The magazine grew rapidly to a cir tional distribution.

Backgrounds
Florian Bohn

conceived th

the 1990s, a

From a base

David Bowie

renaming/re

Beach Cultur

a handful of

style agenda

ary content:

for unusuall

ing a platfor

eight pages

manner, Ray

coverage. Th

mere form, a

not a style: i

culation of r

Raygun

27

Bjork

From a base in Los Angeles, Marvin Jarrett launched *Ray Gun* (a name that alludes to a line in a David Bowie song and, inadvertently, connects with the artist Claes Oldenburg's proposed renaming/reshaping of New York in the early 1960s). Initially Jarrett recruited the *Beach Culture* team of Carson and editor Neil Feineman, although Feineman left after a handful of issues. The monthly magazine did not entirely deliver on a new music and style agenda through the written word, but in its art direction it carried revolutionary content: besides Carson's own ideas in layout, his art direction opened the way for unusually free work by major illustrators and photographers, as well as providing a platform for new talent. One radical content area was "Sound In Print", where six to eight pages each issue were given over to readers' illustrations of song lyrics: in this manner, *Ray Gun* existed as a popular fine art magazine, along with its music scene coverage. The strength of *art direction as content* challenges the notion of design as mere form, as a container for the content of words and pictures. How *Ray Gun* looked was not a style: it was the heart of the magazine's content. The magazine grew rapidly to a circulation of more than 120,000, with international distribution.

RAY
GUn

the sundays
bikini kill
the wedding present
suzanne vega
juliana hatfield
alice in chains
f. xavier pavy
mudhoney
spiritualized
darling buds
lucinda williams
the grid
medicine

PERRY FARRELL LOLLA
PALOOZA AND I
by Dave Allen

inch
na is

inch nails

THE VOICE OF REASON

The man pulling radishes
Pointed the way
With a radish

TEASER

Get Your MOTOR Runnin... Head Out the Hi way

by Mark Woodlief

An independent bands typical tour vehicle is easily identifiable. Covered with bumper stickers, dust and finger-streaked "wash me" signs on the outside, the van is almost always smelly and trash-strewn on the inside, where a veritable jigsaw puzzle of loaded equipment lies beneath a loft outfitted with a lumpy mattress. Some bands do things differently. Olympia's Beat Happening used to criss-cross the US in a rental car, for example. While the rich and famous charter megabuses for comfort, most groups settle for creative solutions to beating the road blahs.

NEW
ORDER
CONTIN
UED
ALICE IN CHAINS
NICK CAVE
ELVIS COSTELLO
SPOONMAN
MULES DOGS
FASHION
TINDERSTICKS
SOUND IN PRINT
ADRIAN BELEW
REVIEWS
LAST PAGE

PHOTO: ALBERT WATSON

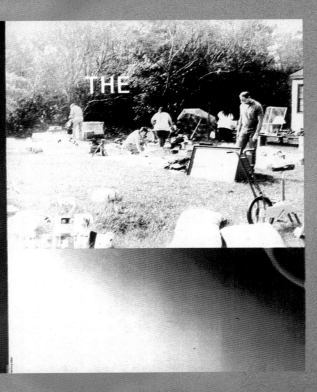

RAY GUN GOES ON ROAD

THE

^ < Contents page Issue 16, 1994. Photo Albert Watson

^ PJ Harvey, 1993. Illustration Geoff McFetridge. Photo Colin Bell

^ On the Road Again, 1994. Photos Kris Harnson [l], Doug Aitken [r]

v
v

Mixed Messages, 1993. Printouts of sections of type were used
v to explore s p a c e s within characters, in
response to
 title. Introduction is repeated twice, reflecting double
 writing credits. Photo Anthony Artiago

619, 1993. Title refers to area code for San Diego, whose music scene is featured. Photo Steve Sherman >

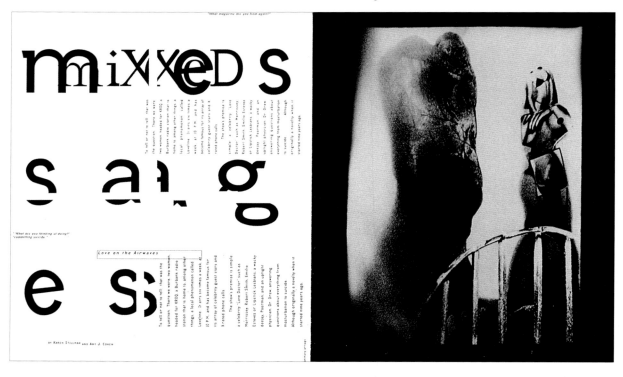

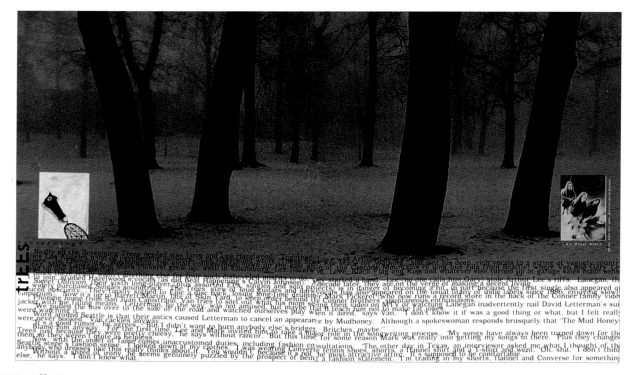

Screaming Trees, 1993. Probably a little difficult to read, unless you are keen on the subject. The attitude of this design involves a quiet laugh at optimum line-length.

Illustration Doug Aitken. Background photo Anne Brit Aase. Group photo David Hawkes.

Recording in **Soviet** Dis**union**, 1993. **>**

Body copy arrangement reflects the image.

Illustration Amy Guip.

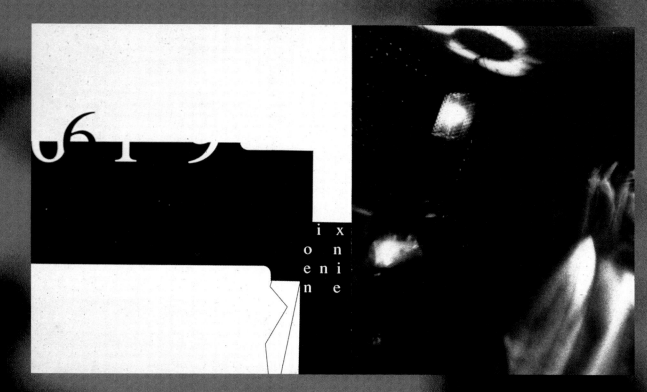

6 1 9

i x
o n i e
n

recording

in soviet

by Lauren Agnelli

dis-union

C.C.K. ← → D.R.C.

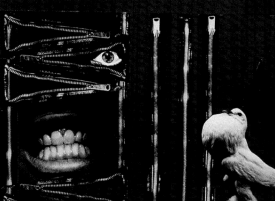

pavement elastica juliana hatfield spiritualized morphine marianne faithful

Raygun

Issue 25, 1995. The first time in magazine history that an inside story
jumped to continue on the front cover.
Photo by Guy Aroch

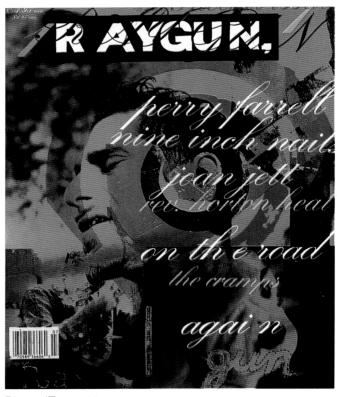

Issue 17, 1994. Three images combined in Photoshop and Collage.
Photos Melanie McDaniel.
Plane: Dan Conway. Dog: Jason Lamotte

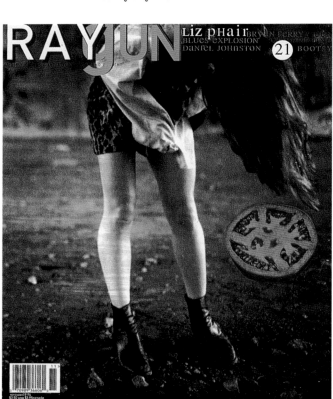

Issue 21, 1994. Rejecting the nice color shots, a black and white
Polaroid was used,
with visual pun on "hot tomato".
Photo Kevin Kerslake

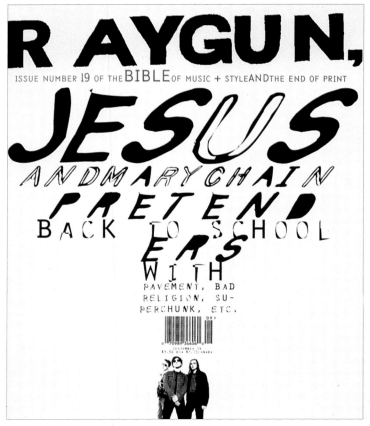

Issue 19, 1994. Band picture is small, below the barcode, undermining
the normal emphasis on cover photography. Ray Gun
logo featured was drawn by Ed Fella, taken from a poster
he designed announcing a talk by Carson.
Photo Colin Bell

Sonic Youth on the road, 1993.
Photo Alan Messer. Line art Steve Tozzi

on the road with

Sonic Youth

NEW YORK CITY
17 MARCH 1993
It's the middle
of March, and we
Sonic Youths have
been out on the
road almost
continuously since
last August, one
series of gigs
leading into the
next. It feels
like we've been
gone forever. Our
passports are
full of exotic
stamps from all
over the globe.
Recent travels
along our Dirty
tour have taken
us around the
U.S., across
Europe and to
the Pacific rim—
Australia, New
Zealand,
Singapore, Japan,
Hawaii, and back
west from LA to
Seattle. A big
sonic hello to all
of you who came
to our shows,
and also to the
bands we toured
with, some of
whom were Royal
Trux, Pavement,
Jon Spencer Blue
Explosion, Huggy
Bear, Cell, Dead
C, Mudhoney,
Nick Cave, Iggy
Stooge, Boredoms
and Sebadoh.
What follows are
some stray
notes,
observations and
scribbles from
this sonic
touring.

guide m

The wanna-be greatest living American poet works hard outside the limelight in Portland, Oregon...

by Marvin Jacrett

When we heard the Sundays were going to be in Los Angeles promoting their new release, *Blind*, we knew we had to interview them, over salads at the Hamburger Hamlet on Sunset Boulevard. Harriet and David, the forces behind the Sundays, proved to be as sanguine as the name of the band.

o ndaytu

sday wed nesday thu

sday frid

ysatur d ays un

ays

The Best Unknown Poet In America, 1993. Given the subject, the title was omitted. Photo Matt Mahurin

The Sundays, 1993. Opening page lists the days of the week, with a line below the S of Sunday giving an understated hint of a title.

The Shamen, 1993. Two spreads from three. One page is completely blank on opener. Curved column idea begins here, a much copied element of Ray Gun

trying to do the same. If they don't they lose. In the case of the LA Shamen show, they lost.

Avalon Attractions' Les Boursais had originally booked this Shamen show for the Shrine Auditorium, capacity 6300. Last year he did the Spruce Goose extravaganza and was hoping to go in one bigger. But when ticket sales failed to break the 300 mark, he understandably wanted out.

Promoter Philip Blaine of Kingfish now Moveable Feast Inc. picked up the show, moved it to a smaller venue and was left with only seven days to promote it.

"I've been doing raves for a long time, and the Shamen show wasn't really a rave," he admits. "If I knew I was going to do that gig a month ago it would have been in a warehouse. There would have been 5,000 people there and tons of extracurricular stuff going on besides the band. But a full scale rave takes a lot of production and promotion. Usually when you confirm a show you put an ad in the LA Weekly, you put heavy promotion on KROQ, you give away a bunch of tickets. You do a lot. Boursais did a little but he didn't really get behind it with a really good four-color flyer or anything like that."

"It was okay," says C of the gig the next day as he and Colin sit in their San Francisco hotel room swilling soundcheck.

"America's just really behind. Everything here is just rock and roll now. It's really backward."

It's exactly this 'backward' mentality — the brainless beer-swilling white men waving their fists, slam dancing, stage diving and all the other macho posturing that accompanies a rock concert — that Colin and C strive to transcend.

"There is definitely a shamanic tradition in rock and roll," Colin says. "Some performers were being real, especially in the 60s, with Morrison and Hendrix and all that. But those kinds of performers were giving poetry and virtuosity and information in the music and that was shamanic. Most rock and roll is just an ego thing with everyone just focusing on the person up there."

"There's no drawing in the people so that it is a unified thing with rock because it's all me me me," C picks up. "What we're creating here is happening for everyone. There's not a head performer because that is a domination type thing. We're not like that. We're more an influence than the leader. We're just part of the whole experience."

The band is the first to admit that not every American audience is open minded enough to receive the Shamen message. Even in supposedly hip New York City, the band found themselves halfway through the set before the audience caught on. "After a while," C smiles, "they can't help but be empowered by the rhythms."

"But there are concerts where they're into it from the first beat," says Colin. "They're ready for it. They've come for it. They know they're going on a journey and they're ready."

"Increasingly," says Blaine, "these cities are smaller, like

There's a lot of pe...
here who underst...
They know what's g...
on. Just wait 'til yo...
the show tonight

DANCE

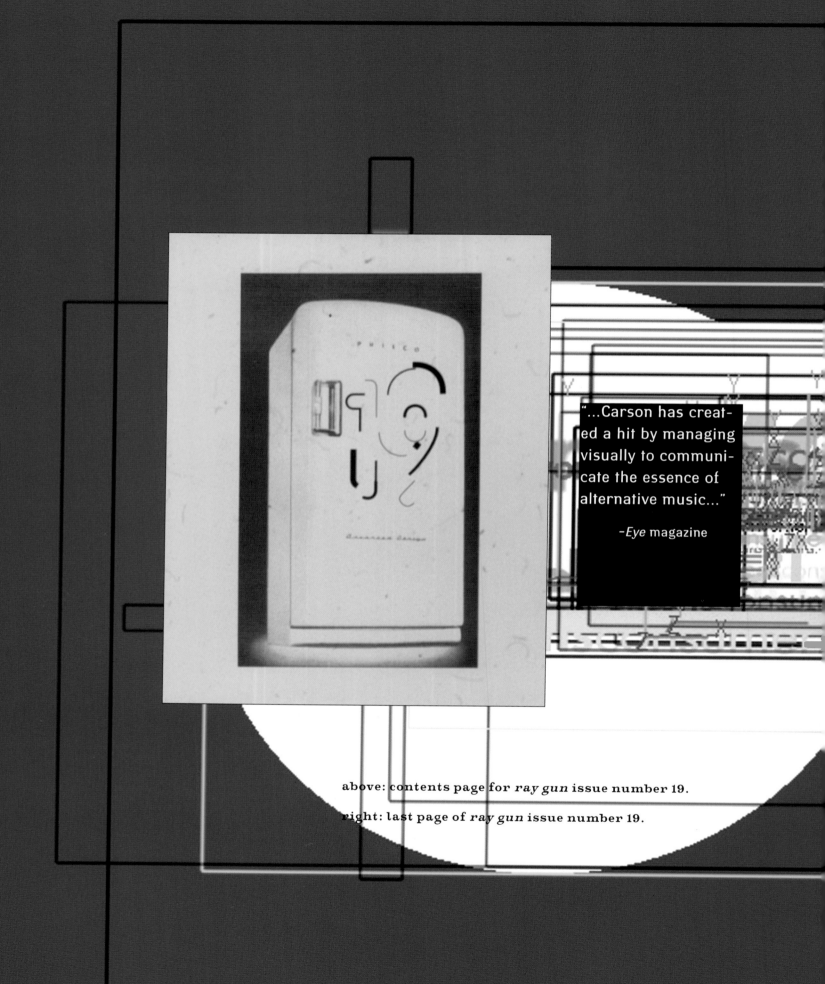

"...Carson has created a hit by managing visually to communicate the essence of alternative music..."

-Eye magazine

above: contents page for *ray gun* issue number 19.

right: last page of *ray gun* issue number 19.

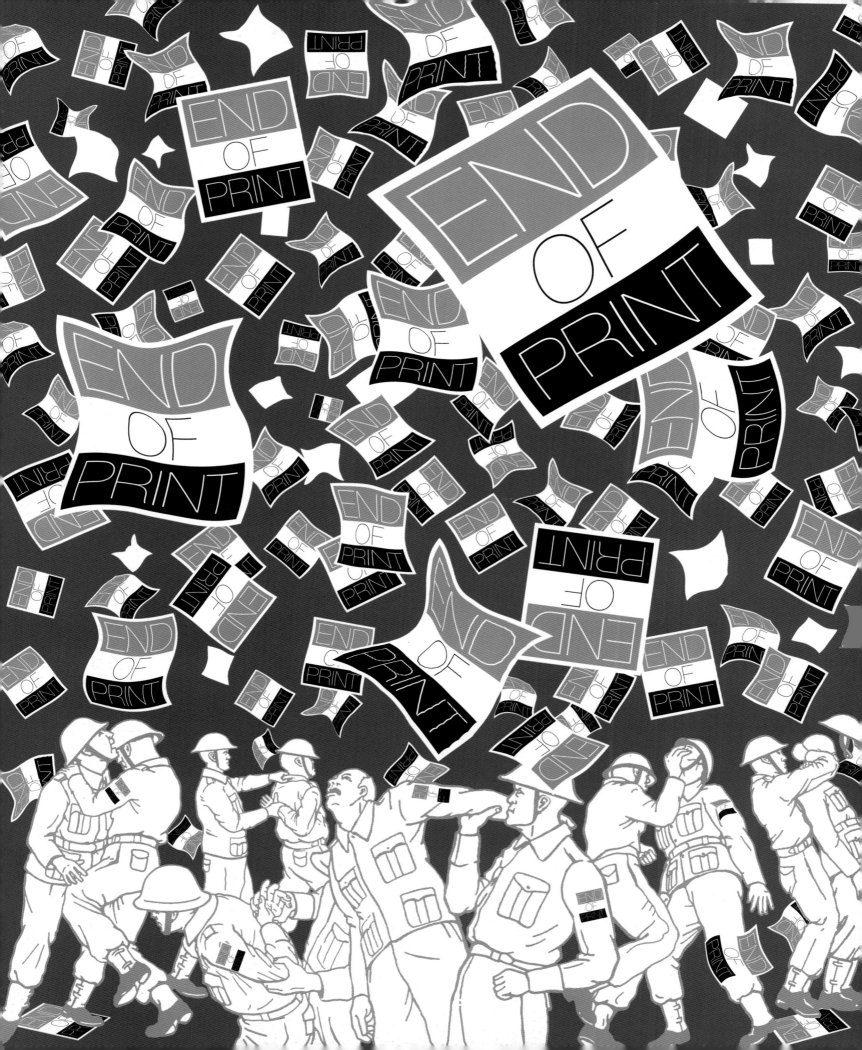

letterpress, 1993. christian sunderdiek, hatch show print

Claus Frimanns Gt.

"The purpose of graphic design here is not to communicate with the broadest possible audience, using universally accepted conventions, but to speak to a very narrow group with a particular visual culture. Carson has achieved this by developing a visual dialect that is not only understood, but preferred to plain speech."

-*Eye* magazine

THE

ART FORM.

—PHILIP B. MEGGS

END

BECOME AN

IS

BOOK WILL

NEAR.

AND THE

This page: End of Print by Philip B. Meggs, 2000
Opposite: End of Print by Shawn Wolfe, 2000

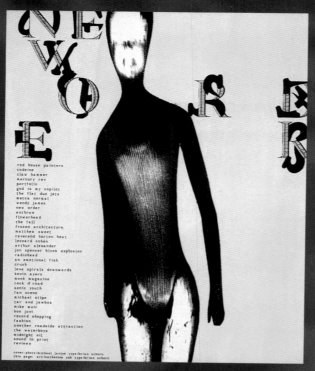

NEW YORK

red house painters
codeine
claw hammer
mercury rev
portfolio
god is my copilot
the flat duo jets
mecca normal
wendy james
new order
anthrax
flowerhead
the fall
frozen architecture
matthew sweet
reverend horton heat
leonard cohen
arthur alexander
jon spencer blues explosion
radiohead
an emotional fish
crush
love spirals downwards
kevin ayers
monk magazine
rock n road
sonic youth
fan scene
michael stipe
tar and jawbox
mike muir
bon jovi
record shopping
fashion
another roadside attraction
the waterboys
midnight oil
sound in print
reviews

cover:photo/michael lavine type/brian schorn
this page: art/katherine rub type/brian schorn

Mecca NORMAL

Band achieves international notoriety after 21 tours and four albums

They've arrived: David Lester and Jean Smith

By Denise Sheppard

After 21 tours, four albums, a pair of EP's and innumerable singles, Mecca Normal vocalist Jean Smith and guitarist David Lester are finally receiving international notoriety. "When we released our first record in '86," recalls Lester, "people would sometimes compare Jean's singing to Yoko Ono, and this was meant as a derisive comment. Now the times have changed so much that this reference is intended to be a compliment. We've been putting out records for years, but they are fundamentally the same."

"We pretty much cleared rooms," says Smith, speaking of the band's early performances. "That was our main function. So if that happened we knew we were on the right track. It almost feels fickle now that people like us, because we're doing exactly the same thing. I have to ask myself, 'Well, what phenomenon is this?' We were not accepted and that was an inspiration, ugh!"

Conversely, it is that very same live show which appeals to—and inspires—so many fans. Onstage, Lester is a man of few words and many actions. His extremely physical playing is simultaneously beautiful and uncomfortable to watch. Jean is also mesmerizing live: swaying, chanting, even dropping the microphone in mid-verse in regular fare, preferring instead to sing while walking out amongst the crowd. "I view what Jean and I do as a musical form of civil disobedience," says Lester.

"You don't play the game, but instead you try to make what I consider a social change within the scope of a musical format."

After years of releasing hard-to-find singles and EP's, a 22-track collection, Jarred Up, has recently been issued. By no means, however, is it to be confused with a "Mecca Normal's Greatest Hits," as Jean is quick to explain. "The songs are just literally everything that has come out as a single or on a compilation. It's just a gathering of all these pieces—nothing's excluded." The disc includes the likes of "Man Thinks Woman," "This Is Different" and "Strong White Male," much of it pulled from the band's early days.

An as-yet-untitled full-length disc of recent material is slated for September (Smith describes it as "very different—sort of creepy and quite a bit darker"), followed by little of touring. Smith is also releasing her first book—entitled I Can Hear Fire—sometime this fall. When asked how long the pair can imagine their productivity lasting, Smith says she sees no limit. "I'm sure we'll be working together when we're in our eighties. It's that kind of relationship. We understand each other and have a similar desire to inspire other people to do something or feel something."

26 • RAY GUN, JUNE/JULY 1993

PHOTOGRAPH BY A.S. HOELME

etc

Gun

gy

SONIC YOUTH

by Andy Jenkins
photos by Spike Jonze
art by Mark Newman

To Kill Your Idols is an idea of heroic proportion. One of our idols might make. Or, Sonic Youth made before anyone cared to incorporate other than themselves. One that had to be released by a European company (Zensor).

That was almost ten years ago. Sonic Youth have just released their album number two for DGC, Dirty, and are still firmly wedged into the role of alternative band's band, despite the major-label backing. Ten years have seen them idolized and imitated by countless numbers.

Iron Youth. But this is understandable considering the sonic structures they've been standing after so much time. Solid walls of manipulated noise. Inhabited not so much by what are normally called sounds, but rather by waves of sound that bend and twist into aural experiences. Stories with layers of textures that rub together to create a smoke that engulfs you like a damn cacophony. Shit. I'm sorry—that sounds pretty heavy. Well that's the weight I had to carry into the interview with Thurston Moore (guitar/vocals), Kim Gordon (bass/vocals), Steve Shelley (drums) and Lee Ranaldo (guitar/vocals). My year as a Sonic listener have made me an idolizer. Damn.

So, the fear I might feel at meeting the creators of such noise stories dissolved quickly. 6367 Gower Street in Los Angeles is the main location for the 100% the first single/video from Dirty. In that spot is a small house that the band, about 20 extras and a modest film crew (including Spike Jonze) were inhabiting for the day. How did I get here?

So, Sonic, all the voyeuristic admirers asked about booking and had somehow acquired a history of a feature length idea. Spike had worked on some skate videos. Spike gets a message on his answering machine from Thurston, which he mistook for a prank call until Kim called back. They made the Blind

BUTTER

Sonic Youth

NY is needed, you see, and that is why New York will be renamed Ray Gun."

Claes Oldenburg, 1961

SUBSCRIBE
800.229.4GUN

< Contents page, 1993. Type design by Cranbrook student Brian Schorn mixes letters before and after the actual character chosen to generate new form.
Art Catherine Yuh.

< Mecca Normal, 1993. Normal by name, normal by layout: a duplicate of a page from Rolling Stone

Manic Street
Preachers, 1993.
Type boxes
constructed for
building the
layout were
included in the
finished piece.
Photo Colin Bell
<

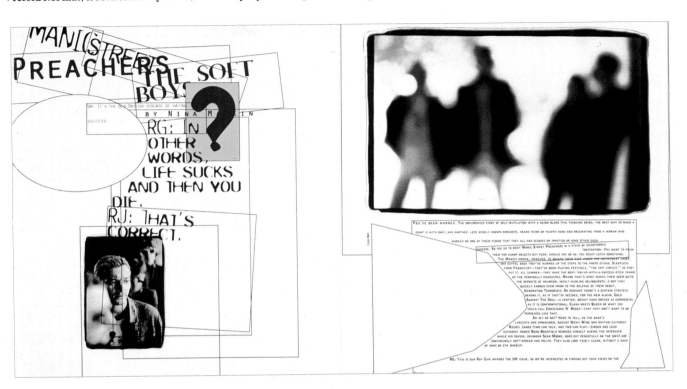

< Sonic Youth, 1992. Character of illustration reflected in title [written with left hand] over hard copy of article. Illustration James Fish

< Subscription ad, 1993.
Old magazine image collage DC

<
Richard
Thompson, 1993.
Includes found
art that
empathizes with
the music.
Photo Greg
Allen.
Background
Geoff
McFetridge

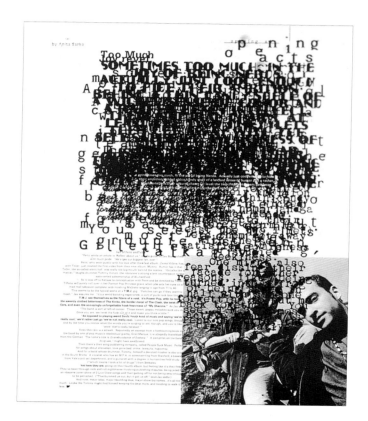

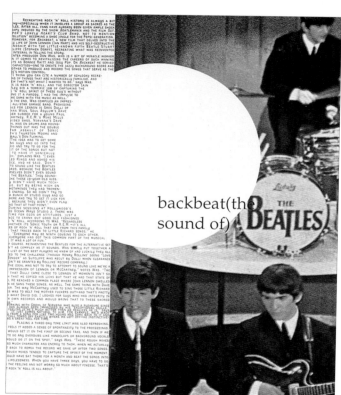

Extra Large, 1993.

Body copy in three point, accentuating size and pressure of the over large circle.

Tiny photo of the featured band, Extra Large.

>

∧

Too Much Joy, 1992. First paragraph of

article completely obliterated by

overlapping, repeated type.

second paragraph, It reads OK from

second paragraph,

second paragraph, though...

∧

Backbeat, 1994. Deliberately cropped

out John Lennon from old Beatle card.
Backbeat, 1994. Leading shifts

throughout article

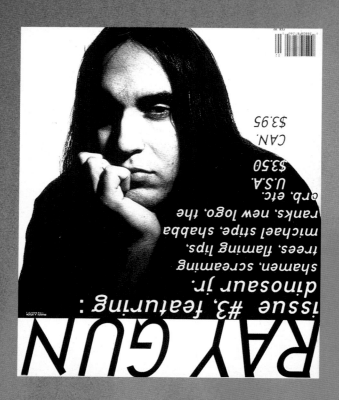

Issue three, 1993. This cover is upside down [the picture of J Mascis was upside down, a reflection of his emphatic disrespect for magazines]. Beginning of a period of changing logos

Fan scene, 1993. Lips from Hatch Show Print letterpress poster

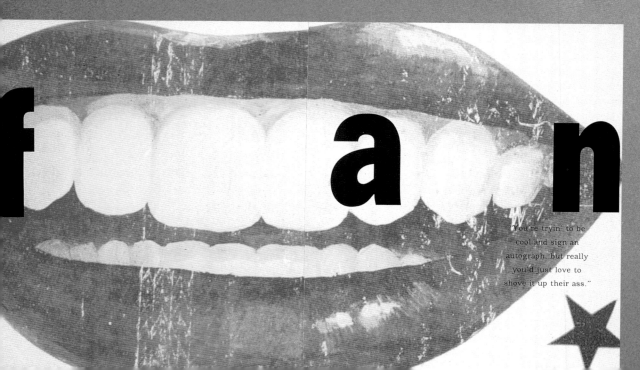

"You're tryin' to be cool and sign an autograph, but really you'd just love to shove it up their ass."

^ *On the road travel piece*, 1993. Photo through windshield of Baja, Mexico, DC. *On the road food*, 1994. Juxtaposition of airline coding bag sticker with food store image. Photo Aaron Tucker

v

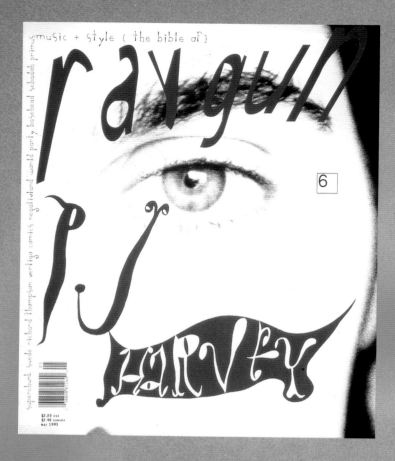

music + style (the bible of)

raygun

superchunk suede richard thompson vertigo comics negativland world party basehead sebadoh primus

PJ Harvey

6

$2.50 USA
$3.95 CANADA
MAY 1993

< Issue six, 1993.
Hand-lettering Calef Brown.
PJ Harvey photo Colin Bell

Tin Man, 1993.
Letterpress with broken characters used for headline.
Photo Scott Lowden
v

Brian Eno, 1994. >
Interpretation of Eno's ambient sound with spare layout.
Photo Ophelia Chong

Is Techno Dead? 1994.
Title absorbed into the layout,
body copy generates major shapes across the spread,
empathizing the heavy techno mix.
Photo John Ritter >

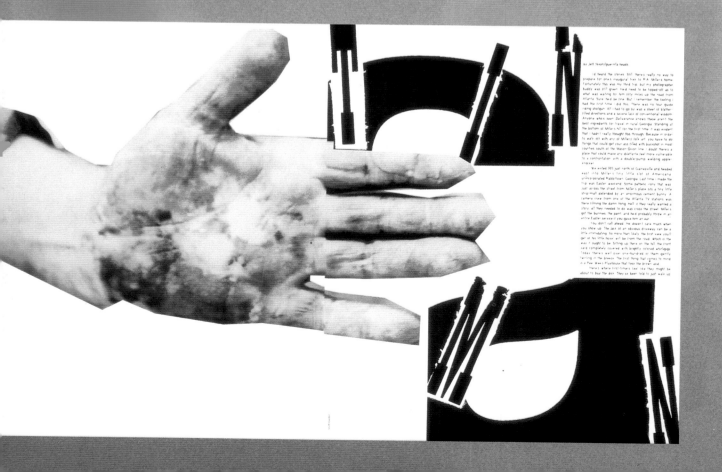

"Half these kids make this shit because they got their dad's computer"
by Geoffrey Williams

is techno dead?

LOOKING BACK...

BURIED IN THE RAVE...

LOOKING FORWARD

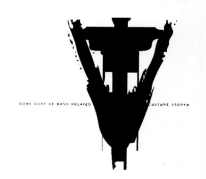

SOME SORT OF HAND RELATED ... CULTURE STORY>

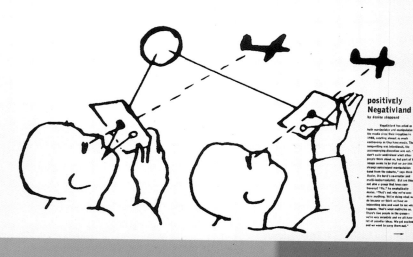

positively
Negativland
by denise sheppard

top left: article on t.v. shows that rock
stars watched.
left side is a rendition of an actual tv,
while the right-hand side is a remote
"t" + "v" put together. next spread con-
tinued the implied televison set, com-
plete with knobs.
left: negativland.

Don't lose the new age.

To:
To:
432
#5
CA

From Randall Smith Australia

ray gun #27 on the road again

cover: björk by dave stewart
this page: illustration by blair thornley

AN INTERVIEW

TEARS FOR FEARS

by marvin scott jarrett

RG: You recorded the new record, Elemental, at your home. Did you find it easier than recording at a traditional studio?

RO: I think it's more liberating. There are a number of reasons why I built the studio in my home. I became a father, and I wanted to be in a situation where I could see the boy grow up and be around him. Also, as you're well aware, recording studios are so expensive. If you're going to spend a long time on an album, you're going to dig yourself into a financial hole with the record company.

RG: You could buy your own studio for what it costs to record some albums.

RO: That's exactly what I did. Instead of giving away the money to another studio, I took the recording costs and put them into my own studio.

RG: Apparently, you spent over a million dollars recording The Seeds of Love...

RO: Yeah. Crazy, isn't it?

RG: Are you still into psychotherapy?

RO: Switching questions! No, I stopped last year.

RG: Are you more of a Jungian or Freudian mind?

RO: Jungian.

RG: So why did you break up with Curt Smith?

RO: A number of reasons. Where do we start?

RG: I heard you guys really started to take over production, as well.

RO: Where did you hear that?

RG: Rumor.

RO: Thats too simple of a statement for a complex relationship. We ...padés' we've known each other from a very early age, and when you work with somebody it becomes more of a business. There's far more responsibility than just the friendship. You rely on each other and need each other a lot.

The Hurting really made with Curt was the only record where he came to the studio every day. Afterward he became this minor celebrity, and he didn't feel it was necessary for him to come into the studio every day. He felt his role was more of the visual aspect of the band. So I started working more with Ian Stanley, the keyboard player. We worked every day in the studio with Chris Hughes. we were responsible for Songs from the Big Chair. When it came to The Seeds of Love... because he wanted far more equality than what was relevant at the time. At the same time, I wanted... wanted to do! I was calling the shots. It was my ideas, my songs. It's always been my vision. It was my idea to get Oleta [Adams] involved. I kind of hung together when we were in the studio, because I was doing my own thing, working on the record. When we went on the road, things got tense. He wasn't happy with the role I was...

Anna Risk

more. It kind of worked in the beginning, because I was half the man I am now. The songs I would write, Curt would sing better. His voice was very appropriate for the very early Eighties, that Tey English sound. As my writing developed, I found myself writing less songs for him and more songs for me, and I became the singer.

RG: Was there any disagreement over who got to keep the Tears for Fears name?

RO: No. When Curt and I were on tour, we sat down before one of the gigs, and he spilled the beans to me, and I spilled the beans to him. The situation was pretty tense and really nasty. I had no desire to carry on Tears for Fears. I had no idea what I was going to do. What happened was for me to carry on the name Tears for Fears was suggested as a way to compensate for the financial mess we were in after the tour. They said, 'Why don't you take on the name and therefore take on the bulk of the debts.' We both signed to the record company as solo artists. I didn't have to take the name. It was an option. I didn't want to be backed into a corner. So I stepped back and waited until the fourth record was done and then decided that the name fit the record. It seemed like the most natural step.

RG: How did you hook up with [producer] Tim Palmer?

RO: I was working with Aaron Griffith. We were writing together and arranging—getting the whole thing pretty much up to scratch. I felt we needed an engineer that was just a little more opinionated. I was familiar with Tim's work, but what prompted me to work with him, believe it or not, was Tin Machine's first album. Sonically I thought it was great for an English engineer. A lot of American engineers get that sound, but for an English engineer I thought he was top of the crop.

RG: Did you have any thoughts about bringing Oleta back to do this record?

RO: I think the whole point of this album is that it is called Elemental. It has to be brought down to its most basic form, which is essentially just me.

TEARS FOR FEARS

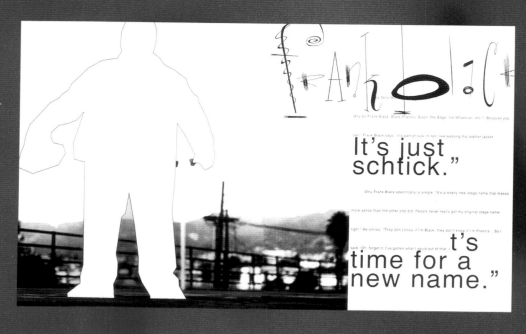

FRANKOLiC
Why be Frank Black, Black Francis, Slash, the Edge, Ice Whatever, etc.? Because you

can. Frank Black says: "It's part of rock 'n' roll, like wearing the leather jacket.

It's just schtick."

Why Frank Black specifically is simple: "It's a totally new stage name that makes

more sense than the other one did. People never really got my original stage name

right." He smiles. "They don't know if I'm Black, they don't know if I'm Francis. So I

said, 'Oh, forget it, I've gotten what I could out of that. It's time for a new name."

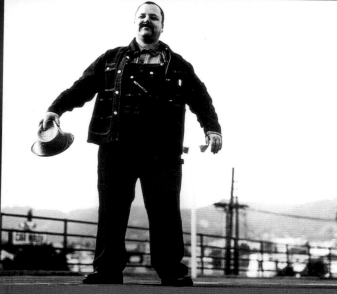

< Frank Black, 1993.
Sequence
of
spreads
featuring
reversal
of
image
out
of
text.
Hand-lettering Edd Patton.
Photo Mike Halsband

^
Bryan Ferry, 1994. All type Zapf Dingbat.
Photo Peter Morello

>
Compulsion, 1994.
Headline, text and image
echo spatial relationships.
Photo Michael Wong

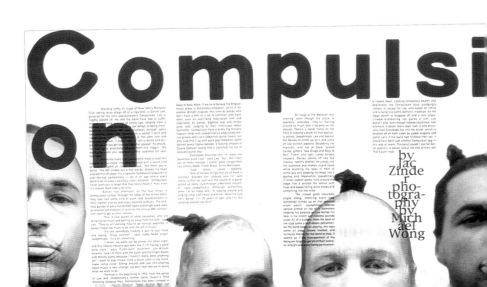

Opposite: Ray Gun mail.
London fashion photos by Corinne Day,
1995.

below: using title of article to produce shape of columns of type (lulu)
remainder:

experimentation with column shape and white space.

STRAIGHTJACKET FITS
WEAR IT

soul on ice

afghan whigs

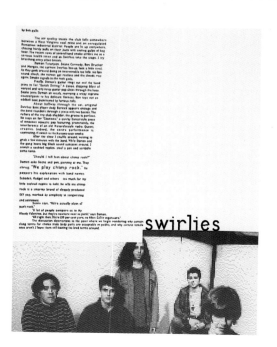

swirlies

BLUMER

HERSCOTT

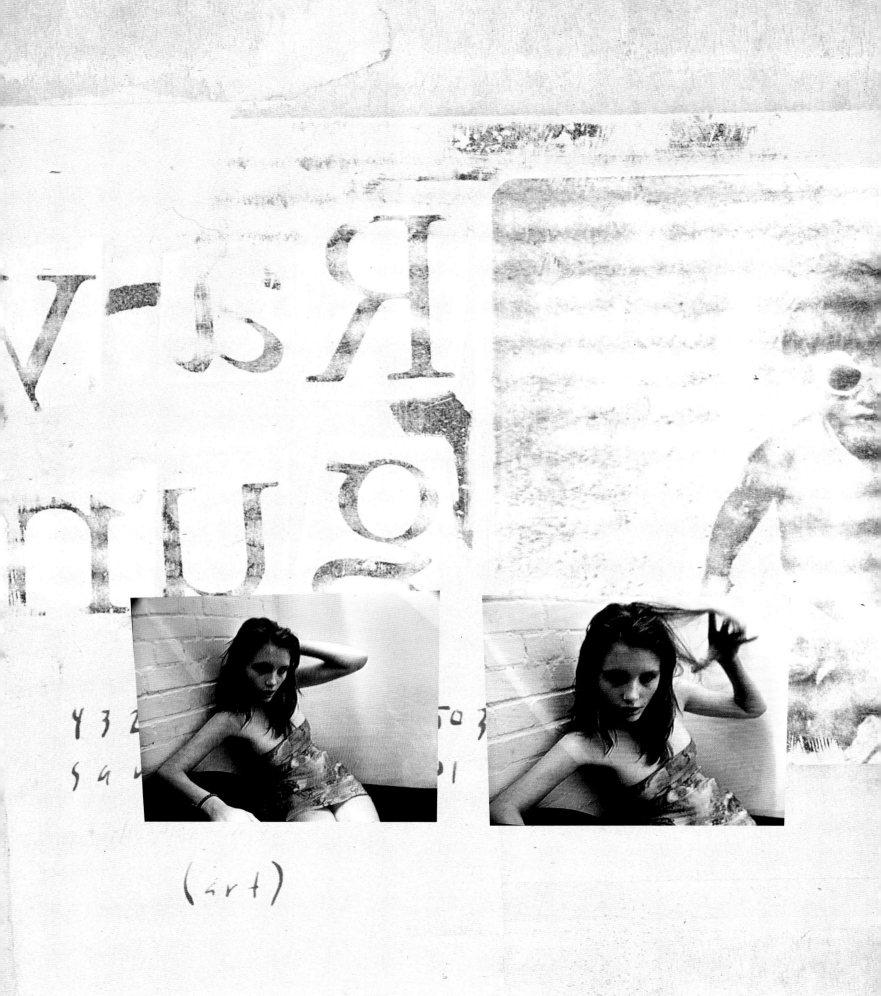

(art)

su cHtyk

BY MARK WOODLIEF

They're young, talented, noisy, and alive, which is more than one can say for most monolithic rock groups that dot the American landscape in 1993. They're scrappy and friendly, on a first name basis—Jim, Mac, Laura and Jon—with one ex who's bought any of their records in the last four years. Collectively, they're one entity, Superchunk. Chapel Hill, NC's answer to the DIY ethic that's still surviving and being reshaped whenever an instrument winds up in the hands of anybody who just wants to wrestle the weapon to the ground.

Superchunk wields its weaponry—two guitars, bass, drums and shock—with purpose. Abrasive, loud, tense, Superchunk brashly goes where plenty of bands from Husker Du to Mac's mid-late Eighties project Slush Puppies have gone before. Then Superchunk goes further. The question, as Superchunk proposes on its latest release, On The Mouth, is how fast? But don't get bogged down in the asking; the question is really a riddle.

"We have so much to learn for, So sick of talking about it." "Fat Tension."

"We have no idea what we're saying." "Mower."

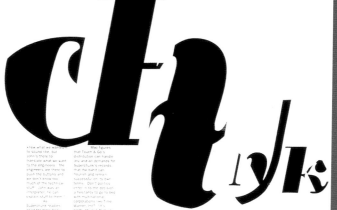

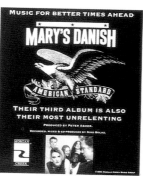

MUSIC FOR BETTER TIMES AHEAD

MARY'S DANISH

AMERICAN STANDARD

THEIR THIRD ALBUM IS ALSO THEIR MOST UNRELENTING

PRODUCED BY PETER ASHER
RECORDED, MIXED & CO-PRODUCED BY RING BOLAS

BY ANDREW SMITH

PARLIAMENT AND THE BEAT a history of hn ot ec

"MAN HAS BEEN DANCING SINCE THE DAWN OF TIME. IN MANY PRIMITIVE SOCIETIES, THE DANCING WOULD START OFF AS PART OF A RITUAL BUT GRADUALLY TAKE ON AN IMPETUS OF ITS OWN AND, GROWING WILDER AND WILDER, SOMETIMES LAST SEVERAL DAYS." —

"TODAY'S TEENAGERS ARE ONLY INTERESTED IN ONE THING: THE BEAT." — OF ECONOMICS, 1966

"I FIRMLY BELIEVE THAT PEOPLE CAN, AND DO, HAVE REVELATORY EXPERIENCES ON THE DANCE FLOOR."
COLIN ANGUS, THE SHAMEN

4 g u n

1.800.229 4 g u n

suhs crine

Superchunk, 1993.< opposite top
Superchunk, 1993. In reversing the title out
of the body copy, chunks of text disappear
and chunks are created. The article is still
readable, if fractured.
Photo Michael Halsband

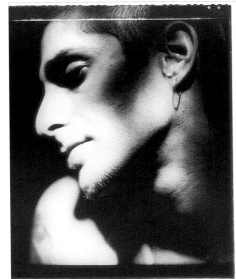

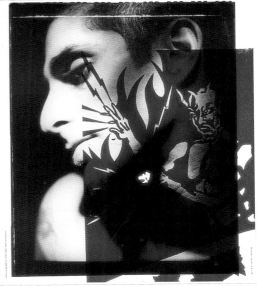

Perry Farrell, 1993.>
Great photo
by Merlyn Rosenberg – so it was
used twice. Overlaid with Hatch
Show Print devil [a subject
brought up in the article]

UK techno music, 1993.< opposite bottom left
UK techno music, 1993.Deliberately harsh
feel responds to music.
Photos [l to r] Rex Features, Liz Tobias

< opposite bottom right
Launch Issue, 1992. Carson cut his finger
during hurried paste-up, hence blood-
spattering

Issue 13 contents pages, 1994. Originally right turning to left. Illustration Heidi Nelms

< Teenage fan club, 1993.
Photos Colin Bell

Songs In the Key Of Life, 1994.
Photo Alan Messer >

< Morrissey, 1994.
Mystery of artist is hinted at. Form partly driven out of type.
Form partly driven out of type.
This issue 14 was the first not pasted up,
but was sent in digital form to the color separator.
This encouraged greater freedom in exploring color.
Photo Chris Cuffaro.

Cocteau Twins, 1993.
Photo Mary Scanlon >

issue 2 emf by david Sims
issue 4 frank Black by michael Halsband
issue 8 iggy Pop by matt Mahurin
issue 16 layne Staley by cynthia Levine
issue 18 lush by michael Lavine
issue 22 keith Richards by alan Messer

< The Fall, 1993.
Photo Colin Bell

Kate Bush, 1993.
Art Ed Garcia >

WORDS UP

BANDS OF P

by Bob Gulla

Of the volley of shots heralding the literary revolution of the Fifties and early Sixties, Ginsberg's "Howl," Burroughs' "Naked Lunch" and Kerouac's "On The Road" were among the first. Bleak, profound and illusory, these insurgent slabs of written and spoken word stubbornly defied categorization. Staggering in scope and inconceivably profane, they were works of so-called "art" formidable enough to send paranoid conservatives straight to the confessional. By defining an alternative set of literary conventions, these writers composed hipster hallucinations that sucked the good-time swing out of rock and intellectualized the seamy side: drugs, sodium and ale nation. And so the Beat Poets predicted rock's renegade lifestyle.

The literary trend continued in the Seventies. Feisty poet/songwriters like Jim Carroll and Patti Smith hoisted the rebel flag high above alternative rock, stunning audiences with antagonistic works like "Catholic Boy" and "Rock and Roll Nigger."

Prior to her musical career, Smith had established herself as a gifted playwright/poet in the New York underground. With the assistance of sidekicker Lenny Kaye, she began reading her poetry, sometimes even singing it to sparse musical accompaniment. This riveting, near revolutionary fusion of words and music resulted in such unparalleled rock performances as the visionary Horses and the eerily chilling Easter.

Like Smith, Jim Carroll also began as a poet. Rather, he started life as a junkie, then became a poet. An addict by the age of 12, Carroll's formative years were shot through with dope, guns and ghetto violence. Those times, immortalized in his resolutely literate volume of poems, The Basketball Diaries, have been central to his writing ever since. Spoken word performances followed, as did rock accompaniment, culminating in the audacious bravura of "People Who Died," Carroll's angry elegy to lost friends.

Now that Smith and Carroll have drifted out of the public eye, the rock 'n' roll poet laureate chair is vacant once again. Of course, pretenders to the throne have come quickly and often. Through the Eighties, English bands like Felt and And Also The Trees offered innocuous (but genuine) pastorals and cryptic character sketches. More convincing in a literate sense were Graham Parker and the Fall's Mark E. Smith, whose acid tongues resembled the defiant attitudes of their forbears. In Canada, Jane Siberry hit cult status with a few startlingly poetic records (remember "Mimi on the Beach"?), as did the ethereal early works of Suzanne Vega and Kate Bush.

Today, new voices have begun to emerge as heirs to the Beat legacy: fresh, sublimely literate talents such as John S. Hall, lead vox and lyricist for cult heroes King Missile.

"I'm not sure right now that I would even want to call myself a poet," Hall says frankly. "Usually, I tell people I am whatever the next thing I want to be is. For example, now that I'm a lyricist and musician, I say I'm a filmmaker or an actor, because I'd love to work in film."

Regardless of his reluctance to admit it, Hall is a poet and writer. In addition to his part in producing the distinguished King Missile discography, the offbeat performer has been a mainstay in New York's spoken word underground for some time now.

"Virtually every one of my pieces that King Missile has put to music," Hall notes, "has been performance-tested in front of a spoken word audience. The ones that work consistently for me stay. The ones that don't get dumped or at least shelved."

His lyrical dexterity on the band's new record, Happy Hour (Atlantic), ranges from shrewd polemic and impromptu rants to junky word play and goofball humor. Like Kerouac before him, Hall uses both avant-garde construction and straight narrative as vehicles, and often lets his consciousness do the streaming. On "The Vulvavoid," he cobbles bastard thoughts together and spews them out over bustling instrumentation.

"Slow-airways on a sinking ship,
Punching out the eye of the storm,
Falling up the ferris wheel,
Laughing at the vulvavoid."

"Sometimes I use surrealistic imagery, maybe even dada-site," says Hall. "The dadas and the surrealists both talked about breaking conventional forms of logic. And that kind of writing has it's own sort of clarity, it's designed to shock."

Perhaps best known for his oddball narratives and peculiar characterizations ("The Fish Who Played the Ponies," "The Boy Who Loved Laughing"), Hall comes up with his drollest yarn yet on Happy Hour. It's called "Detachable Penis."

"I woke up this morning with a bad hangover,
And my penis was missing again.
This happens all the time.
It's detachable."

"I never studied writing or poetry," Hall admits, tilting his explanations with song; quiet pauses. "In school you learn things like the difference between 'assonance' and 'ironic.' Sure, it's nice to know that kind of thing, but sometimes I get frustrated. Language isn't big enough to describe how I feel sometimes."

Todd Colby, vocalist/lyricist for the critically lauded New York combo, Drunken Boat, couples Hall's fascination with language with classical poetry training. The author of ten volumes of poetry, Colby did time at the prestigious University of Iowa Writers' Workshop ("Academic bullshit, crap, crap, crap") and performed a spoken word piece on the excellent Twin Cities Public Television production, Words in Your Face, narrated by Henry Rollins.

"The French poet Max Jacob is a fine departure point. Apollinaire and Artaud, too. Hart Crane is pure muse. Jack Kerouac, Walt Whitman. But, all in all, I believe I have my own voice beyond these influences." Colby speaks in even, mellow tones, belying his uncanny ability to send a song soaring with his mercurial vocal stylings.

Then, as if undercutting his own argument, he tips his hat to these and other less famous influences. "At first, I had a lot of anger from coming to terms with the shit that goes down around here," he says from his Brooklyn apartment. "I jumped on the ranting poet bandwagon for a while. But I think it betrays what language is about when you're just screaming your head off. Now what inspires me is offbeat writers, people who have been able some how to make a dent in this stupid language of ours."

Drunken Boat's second full-length release, See Rudy Fall: (First Warning) is the whir of The City. It is, by turns, the screech of the day, the roar of humans and machinery, and the eerie hiss of night. Colby fills the record with words, abstract Gertrude Stein words, and a leech poetic sensibility.

"This is what I remember
A crack in the sky
And there's so much to show
This is what I'd like
leaning over the city
This is what I'll remember
This fantastic light" (from "Balloon Song")

"Sometimes I write and I don't know what I'm doing. It just sort of happens. Without sounding overly romantic about it, I can feel the Muse working through me and I just function as a receptacle."

Like Hall, Colby also compiles spoken word pieces. Drunken Boat prefaces "Dream Wagon" on the record with one of his favorites.

Woman: "That's very interesting and strange."
Man: "Yes, that's important. That's my love."

Woman: "Important is wise."
That's true, by golly."
Man: "You mean Donny
Osmond." Woman: "I mean David
Cassidy."

"I don't necessarily prefer to work from narrative," says Colby. "That's not what I'm all about. I've been influenced by the language poets, where the rhythm or music of the words gets me going. If I can hook imagery up with rhythm, that's what poetry's all about."

Craig Wedren, enigmatic frontman for DC's prog rock phenoms Shudder To Think, couldn't agree more. "I particularly like images strung together that make some kind of intuitive rather than literal sense. Certain phrases, words or images will just bear other images, instead of a linear story or narrative."

Wedren, a graduate of NYU's experimental theatre program and occasional solo performer, aspires to the interpretive, the improvisational, in voice, words and music. "To tell you the truth, I would love to have the guts to forget about melody, forget about hooks, forget about having something to latch onto altogether."

Wedren's musical antagonism is what sets STT apart from its peers. Get Your Goat (Dischord), the band's fourth full-length release, is the kind of noise you'd expect from a group fronted by a radically imagistic poet: progressive riffing, convoluted tempo changes and gutsy art...

Words Up: Band Of Poets Great Expectations 1993. These two spreads show an experiment with the idea of pages work...

film, where one article runs onto the next [Great Expectations], emphasizes the linearity possible in sequential pages

..."I found Ray Gun #6 to be brilliant and a milestone issue design-wise. I remember being at Tower Books, picking up that issue and just browsing through it and being really amazed."

_ Rudy VanderLans

The guilty pleasures of *jesus lizard, traci lords, orb, matthew sweet, ween, bootsy collins + more*

erry lee lewis *filter*
uiet riot *gene*

Raygun

neil
oung

28

? *beastie boys+ luscious jackson* **henry rollins** +isaac hayes *moby+ orb*

Raygun

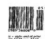

RAY GUN :
DB:

CORPORATE ROCK IS ITS DEATH THROES.

nus
C.

hat is probably why I resent it when
eople sample the old stuff. Why not
ample yourself, or try something new? I
eel that experimentation is endangered in
oday's climate.

J. Vasseur 1994

" I'LL **GIVE** YOU

SOMETHING

TO CRY ABOUT,"

Bellowed Dad/God

while his blue

neck veins popped

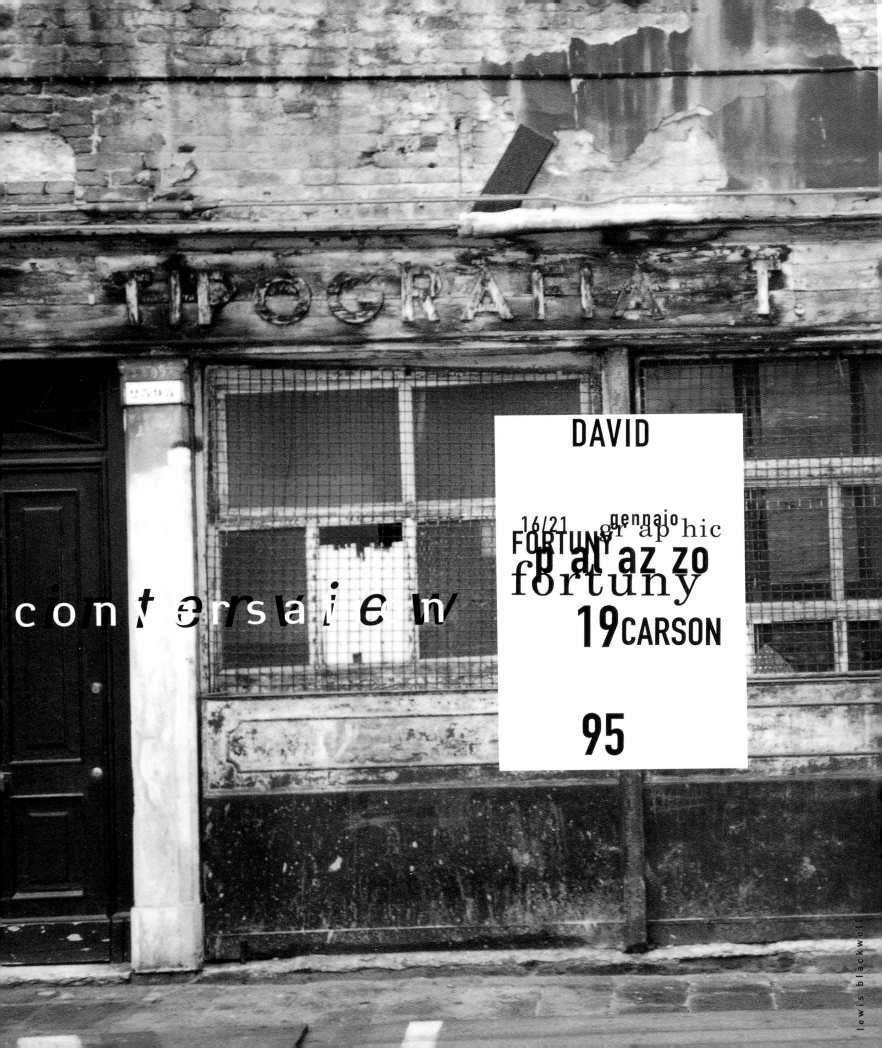

TIPOGRAFIA

contersaiew

DAVID

16/21 gennaio
FORTUNY gr ap hic
p al az zo
fortuny
19 CARSON

95

lewis blackwell

graphic
FORTUNY
PALAZZO
DAVID

C A Rtsonn
16/21 GENNAIO
1995

5

**22 January 1995 Pensione
Accademia Venice, Italy**

Lewis Blackwell You're redesigning the magazine, Ray Gun: tell me about it...

David Carson The problem is I haven't worked it through right now. It's turning out to be a bit of a challenge because there's no...you know, I always have trouble speaking person-to-person once that machine is on, I lose some of the...

L Well, there's nothing to redesign: is that it? It redesigns itself every month?

D Something like that. In a sense I feel it does, but in another sense it doesn't: there is a certain predictability to its unpredictability. I realize that. I feel it's time to change because there are too many magazines trying similar things. It will go simpler in some way...the obvious thing would be to give it a format and everything, go in completely the opposite direction. Like Neville [Brody] did with Arena, after The Face. But that would be too simple, boring, and completely counter to the design philosophy of Ray Gun. In fact, I think that was one of your earlier questions "If you redesign the magazine, wouldn't you lose some of the whole approach?": to some degree, it would.

My original thought was that I could try and do some of the same things but concentrate more on new aspects like colors, shapes, textures, in contrast to what has just been primarily type.

L I was thinking about something related to that yesterday in the workshop. You begin working with your students by having them look at just making marks, basically using the

letters of their name to interpret who they are. They evolve through to using color in order to make a big statement about where they are going to be in ten years time. During the review of the second project you said to them that you often tended to be using type black, that you were more into that mark-making thing than using color. It seemed you didn't really feel as interested in using color. Are there certain preconceptions that you have that you are now aware of and want to challenge? Having been known for challenging certain other preconceptions...

D I wouldn't say I am against color. I've just never felt it was a particular strength of mine. So perhaps I am more intrigued by that now as an element I can use to send different messages. I suppose there is a concern in me to de-emphasize type a bit. It's time to look at more of the total thing. Color is going to be a part of that. But I still feel you should be able to solve most type solutions in black and white. Black type on white paper is still in some ways the most intriguing problem for me.

L Why is that so? Your work from the early magazines through to now has always had this strong exploration of typography; even when you commission others, it tends to be the case of another artist then having the freedom to produce something that sits alongside your work or is taken into it, but isn't worked to a tight brief as part of it. The type seems to have been the central thing that you have been concerned about.

D Well, it can be overstated. A lot of what I have done has also to do with photo choice, cropping, with arrangements, selection of art, sometimes coming up with titles and even pull quotes – although I realize that's also type. Starting with the skateboard magazine, where I always had to work with the elements I was given, I have often been forced to try to find something more interesting within photos, within existing artwork, and if that didn't work maybe I had to go to the letter that the editor enclosed with the manuscript or a xerox the artist sent or something to make it more intriguing, more interesting. I think that method of working has stayed with me. So in that respect I think that the type portion of my work has been if not over-emphasized then the other aspects have been under-emphasized. A big part of what I do has to do with composition. I am always working with photos and looking for special sections within the photos. The ideal is to have a total use of all the elements in order to come up with solutions. Possibly because some of the type is done in unusual ways that gets the emphasis, and that is combined with what seems to be more public awareness of type in general, in part due to the computer and the ease with which everybody can now manipulate type.

L You have often pushed around the edges of the content you have been given, pushing text and supplied pictures into surprising forms; in some ways you have challenged the content and a critical viewer may say you have been disrespectful to that content, and would probably cite legibility as an issue. Are you looking to change the traditional relationship of designer and writer, arrive at some new synthesis of the work of the various artists involved? Are you looking for some new sharing of roles between designer and writer, working to one common end in the making of the message?

D Ideally, yes: that would be the way to work and is something I am looking to explore. It is an ideal, but the real situation of people being in different cities and the like, makes it difficult to bring about. Internet, E-mail, will make a difference.

L When you design you do things which are more often seen as writer/editor functions, like creating pull quotes.

D Yes, it is something I have done pretty much throughout my magazine career. I have come up with quotes, sub-titles, titles sometimes. I am very involved with the copy to begin with. I would take issue with any comment that says my work is disrespectful of the writing: in fact, I think it is the opposite. I read the copy and then I try to interpret it. That is extremely respectful. It is a disservice to the writers and the readers if that is not done.

L Does that expressive approach of bringing out elements in the text, of illuminating, making much more dynamic an article, can that extend from the youth cul-

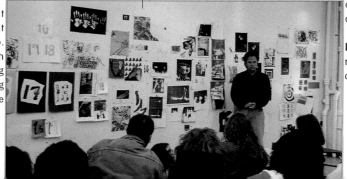

<type workshop, school of
visual arts, nyc, 1994

new zealand design camp, brian smith + dc

ture areas you have been working with into other areas that are more established, more bound by conventions, less fashionable? Can you see a mainstream newspaper having those qualities?

D Absolutely. We are already seeing that as the visual orientation of the culture changes – driven largely by the best experimental print design, the public is seeing better graphics in television commercials, CD covers, video games and that winds up a whole field that is not restricted to the magazines I have worked in. Things that wouldn't have been dreamed of five years ago in very mainstream traditional magazines are now commonplace in terms of type presentation, relation-ships, custom fonts. When the tone of the presentation is in harmony with the tone of the article, that for me is the strongest communication. And I think many others now share that belief.

L You have come out with a line that "we shouldn't confuse legibility with communication". Is that a common problem? Have people become hung up on irrelevant rules of what they think governs legibili-ty?

D Just because something is legible doesn't mean it communicates; it could be com-municating completely the wrong thing. Some traditional book titles, encyclopedias, or many books that young people wouldn't want to pick up, could be made more appealing. It is mostly a problem of publications sending the wrong message or not a strong enough message. You may be legible, but what is the emotion contained in the message? That is important to me.

L You are unlikely to refer to the past in your work and you seem hooked in to the idea of the contemporary. Are you a populist, just seeking to lock into what makes people turn on to something?

D I am not sitting down wondering what Generation X wants to see next. I am doing what makes the most sense to me for a particular project.

L You are trying to bring into the communication something that is in you, something you care about. It is more like the approach you might get from an artist; it is not a straight response to the job. That suggests you are breaking with ideas of design being some kind of almost scientific process, and instead makes it a little mystical. So what are you bringing in?

MIS- DON'T
LEGI- TAKE
FOR BILITY
ICATIO N. CO MMUN

D It is a very personal, interpretative approach. That makes the end prod-uct more interesting – there is no other way you could arrive at it, there are no formal rules you could bring to something I work on and end up with the same solution. This way I think you end up at a more interesting and a more valid point. I am using my intu-ition, trying to express things I am reading in the way that makes the most sense to me. It is an important distinction to make that I am not trying to find "what it is they want".

L So you are revealing what you want instead?

D Yes. It can be deadly and boring if you don't put yourself in it. The fact that many designers don't is why there are a lot of bored designers and boring design out there. Somebody said everything I designed was self-indulgent, meaning it as an insult, but I would say "I hope it is self-indulgent". That is when you are going to get the best work. People use the idea of self-indulgence in a negative sense, but I wouldn't want someone working for me that wasn't passionate and very much trying to do the best

possible thing they can. They have to bring some of them-selves in, otherwise I might as well hire a technician who can flow in text and so on.

L So what are you – a graphic designer or something else?

D Yes, I con-

sider

Italy and New Zealand design workshops. photos dc

myself a graphic designer, but I also consider myself an artist. I think the same of the photographers, illustrators, other designers who work with me. There are all types of art. Plenty of graphic design is art, but some people would say to that "graphic design is meant to communicate" as if art doesn't communicate as well. Some of the success of

projects I have worked on is that what has come out of them has been right for the audience, although I hate to turn that into the most important aspect of graphic design. But you have to keep in mind your audience: what I am doing is very personal work that at some point feels right to me, but at the same time I have to keep in mind an audi-ence.

L So does something extra, something interesting, come into the work because of that relationship with the audi-ence?

D Absolutely. I had a loose, intuitive, no-formal-training kind of approach and suddenly I had this audience with Beach Culture and Ray Gun that wanted an experimental, open, different approach. That lent itself to the way I worked, the way I saw things. And it continues to do so.

L This idea of uncertainty, of questioning, of having a free-form nature in which what is done one time would not be necessarily how you approach the problem a second time.

student type workshop, the hague, netherlands, 1994

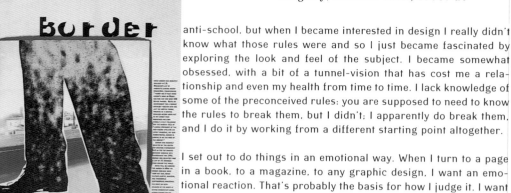

seems to me to relate to ideas current across a whole range of areas - the arts, social sciences and sciences – where we have increasingly questioned just about everything we could imagine questioning. The challenge is almost to find the next question; we no longer have faith in finding answers. In other words, we don't expect finite, neat packages, and this impacts on how design can be viewed.

However, the great majority of communication design does not move with this vision of the *Zeitgeist*. Instead, graphic design has been working to various historically-linked sets of fixed rules; in particular, we still feel the effect of the 1950s Swiss school which became the 1960s International Style, and its rationalist approach still pervades much of what we see (every airport in the world that I've been to, for example). This reductive approach has been pushed to the point at which all over the world rule books enshrine what type in what sizes should be used in any given situation faced by corporate life.

D You seem to be on to something there. I believe the next approach, or rules of graphic design will come from outside the field itself. Maybe at some subconscious level things are done to upset somebody – part of me continues to see no valid reason for many of the accepted rules of design. Perhaps that is why I have not bought into many of the accepted rules. We have the potential of an incredibly creative discipline with interesting people, all this freedom and intriguing experiments possible, and yet newspapers, books and magazines have in some ways remained unchanged for nearly a hundred years, with such things as columns, titles, funny sub-titles and the author's name. Now the computer gives you the width between columns automatically to a measurement some unknown technician has set up for you.

There is all that systemization. On top of that, or with that, it's so odd that a field that prides itself on its creativity and avant-garde possibilities has an establishment that violently opposes upsetting these rules; instead blindly accepts them.

L Perhaps your reaction is a result of not going through the orthodox design schooling. Instead of a four-year course after high school, it wasn't until later you became interested in the area. You did something else first, studying sociology and then teaching, finally doing some short design courses that gave you a grounding in some of the techniques. But you didn't learn the rules at a young impressionable age, so it's no big thing to start breaking them. Do you think your training gave you something else that was more useful?

D If I'd had four years of design school I really don't think I would be doing what I am doing now. I'm not

anti-school, but when I became interested in design I really didn't know what those rules were and so I just became fascinated by exploring the look and feel of the subject. I became somewhat obsessed, with a bit of a tunnel-vision that has cost me a relationship and even my health from time to time. I lack knowledge of some of the preconceived rules; you are supposed to need to know the rules to break them, but I didn't; I apparently do break them, and I do it by working from a different starting point altogether.

I set out to do things in an emotional way. When I turn to a page in a book, to a magazine, to any graphic design, I want an emotional reaction. That's probably the basis for how I judge it. I want to be taken aback, have my breath taken away by what I see. I then explore this and try to find something more. That's what is in the pieces I like best. Whether I'm judging at a design show or looking out of the window, it is the same kind of thing, it is the same thing you need to start.

L When you were studying sociology, doing other things, what was the basis for your approach to your time? What were you trying to do with your life?

D You might have noticed some of the ideas in the workshop: there's a concern that we should do what we want to do, push ourselves to do it, put all we can into it. When I taught sociology, that was a big message. And this comes through working now; the more levels you can reach an audience on, the more interesting it becomes. This applies even with something as mundane as dealing with a horribly badly-written article: if I can make it look a little better, that's something, a creative outlet. But it is not enough. One of the nicest things with Beach Culture was that at some point with the new editor the level of writing equalled the level of design. That is when it gets really powerful. The discipline is creative, it is self-indulgent, and it is intuitive. I think we need to really question why that is perceived as being bad.

L I don't know about "bad" but such concerns do differ from what many people think design should be about. Curiously, if you look for a dictionary definition of design, you get a very vague and largely misleading description. It's clearly a word in transition. Design does seem to involve shaping a message or an object, usually for a third party, and around this various conventions have grown up, giving it pretensions to being a very soft kind of science, mixed up with ideas of art.

D I wish we could discover where these ideas come from; why I seldom won't centre something, why I put a certain orientation on things, why I handle a photo in a certain way. The guy who took my picture for an Italian newspaper today knew what he was doing with me, he left all this space next to me. That just kind of came across. Maybe it is the art part of me that means I move the elements until suddenly I can see it works. Maybe it is a sense of discovery that is nearer the surface due to not having had the training; when I reverse a word out of the body copy, it is just something that came out of the process, not out of somebody else's theory or work.

L Are you some kind of naïve artist, doing it differently because you don't know how to do it right?

D No, I think I am doing it right. Things are only done when they seem appropriate. It would be naïve to suggest I'm so innocent. I did work as an intern, had people standing over me advising me on how to paste-up, line things up, use a big cap to start a story, and so on.

SURFBOARDS

Carson asked designer/ illustrator Peter Spacek to design his surfboard logo, not even knowing the term GRAPHIC DESIGN himself at the time. Carson was paid a royalty for each surfboard sold with his name on it.

I went to a "commercial art" college for six months which taught us how to paint ducks. We were graded largely on how accurate we were with the feathers. I abstracted my duck a little, probably because I did not have the patience or the ability, and anyway think that if you want a picture like that you probably should take a photo, then I framed it in this weird off-centre black frame. I remember the instructor coming to mine during the critique and saying: "Now we really want to stay away from this graphic stuff!" The picture is now framed in my parents' house.

Another teacher, who I respected, told me he could pretty much teach anybody to draw after a fashion, but he couldn't teach them a design sense if they didn't have one.

L So what's involved in that? What's separate in design from the technical ability of being able to use a computer loaded with design programs, or simply being able to draw?

D A tricky one. I can do a nice, conventional brochure, it can be fine, but I would be bored with it. I can do the beautiful easy-to-read brochure, but I wouldn't be very interested in that. Life's too short, I have to do something that interests me. There's an underlying life belief that comes through in the work; it's why I enjoy traveling to give talks, even though people often don't pay anything. It's about life experiences, about personal growth. It's not my job to do something new every time, it is just what I want to do.

My big training was on Transworld Skateboarding magazine: 200 pages full-color every month, and I had this personal thing that told me that if I was going to get something out of it, grow in myself, then I couldn't repeat myself. I always had to do something different. I never used the same approach for any two openers. I think this curiosity is a piece of the whole puzzle of why I do what I do.

L So why do advertising now? Why do burger commercials – surely there isn't the same freedom there?

D I suppose I'm intrigued that they come to me, based on the experimental work on my film reel. Overall I don't feel the commercial work is as experimental as some of the magazine work, but I'm getting closer. Again, it is something different. With Beach Culture I basically starved for two years, and when it went under I was broke. I turned down freelance work during the time I was designing it. I was doing it all the time, seven days a week. Money wasn't the issue, it just gave me the opportunity to experiment with virtually no restrictions. The skateboard magazine was the same thing: I was in my cubbyhole at the weekend on my own, obsessed with the thing. Obsessed, soulful, true to the fascination of design. Now that things have kicked in I don't mind taking on these new opportunities. Doing advertising is a growth thing for me, a whole new language: I don't need to do more magazine spreads for my portfolio, but as an artist I am interested in exploring other areas.

It also amuses me that a big burger chain or a bank or Levi's will come to me. And there's a small part of me that uses this to help validate the work against those critics who say it is weird and unreadable; maybe having Pepsi or Nike or Levi's as clients suggests it's not so inaccessible. Some of those critics might not mind having these clients as well.

L This does raise though the question that if your design is so radical, perhaps there should be some radical content? And that doesn't easily equate with the wishes of advertising clients to sell more burgers. You could be accused of selling a style to be pasted on; that you have made yourself into a "look" that is just being used to sell to youth culture.

D You can say that, but I have never tried to define a style that works for youth, that they would buy into. Whether it is maga-

zine art direction or advertising, I'm exploring the content, the form, and I don't think that is just selling a style.

But in regards to style, I don't think that is automatically a negative aspect of design. The writer Karrie Jacobs said that good designers realize style is a language that can be used to help communicate; while dumb designers think it is just style and dismiss it. I agree with that.

L Are you saying that a designer doesn't inevitably project any values in their work? That what they do is just fashion a vessel to import words and images? That they can be something less than a craftsman, more a technician?

D No, I don't buy that.

L I didn't think you would. I don't either. But we do seem to have some debate here about the politics, or the philosophy perhaps, behind the "look" of a designer's work. I think that if you look at many of the design movements, be it Bauhaus or Swiss graphics, then so often we have had a heavy order being projected in design theory, a sense of rigorous control. This is not apparent in your work. So what values are you projecting?

D Doing things in some constant, orderly way seems to me horribly irrational; if it was rational once it certainly isn't today. Bruno Monguzzi

sw@tch site

sw@tch. it

sw@tch world

sw@tch scope

home page proposal for swatch. art director dc
design: craig allen and dc

[Italian-Swiss designer] was saying this the other night. He was pointing out that the supposed rationalism of these grids and other formatting, just flowing stuff into this fixed structure, is not at all rational really given the world we live in. Saul Bass told me a funny story of how he was always suspicious of grids and in his early days he would invent the grid after he had done the design in order to help sell it to the client.

And Kathy McCoy [former graphics head of the Cranbrook school] said that perhaps the things we read that we remember most are the things we spend more time with.

In both of those remarks I see indicators of what I am trying to do.

EUNISSEN
EUWEZORG
MSTERDAM
TON

photo dc

L Students at Cranbrook and CalArts, and a number of other designers not connected with those schools, have been exploring ideas that seem similar to your concerns at times. I guess none of you would see yourself as derivative of any other, and to judge by the many young designers who come to your talks and the many awards you get you would seem at the leading edge of whatever it is

that is going on. However, why do you think there is a tendency to what has been described as "deconstruction" graphics? What's going on – is this the *Zeitgeist* from where you are standing?

D The first time I came across deconstruction was when I read the word in a piece about my work. I've been doing magazines for ten years: there's been an environment of experimentation for me in that period, and I suppose various schools also experienced this at some points. The changing technology is relevant to a point. Actually people make these comparisons sometimes with Ray Gun, where I feel the work I do is actually very dissimilar, with different concerns, in a different category to the work that came out of those schools. If you look at the opening spreads of articles in Ray Gun, and to an extent in Beach Culture, the work has become much more personal, not something that you can teach. Sometimes it is too personal. The focus of my work has become quite dissimilar in theory and practice to those schools. Perhaps in some of the small regular sections of Ray Gun, which are often done by an intern, the content is not explored as much and there is more of a style at work: when you do that there is a lot of similar formal experimentation. You see similarities with techniques and fonts then, but that is not the guts of the magazine.

L But what you all have in common is that you work in the same period of time with similar new technology. And you are all exploring the fact that this mass-media culture we are in now is a very different one from that of 20 years ago: now we have so much more television, computers doing all sorts of things with CD-Rom, Internet...we are aware that we are not dealing with the same

linear presentation of information, which you get from a film or program or a book (not that people necessarily read books that way). We have come to the awareness of the immense choice we have in all media, and the ways in which we browse, or graze, on this material. This appreciation of the very different way in which we take in information today, and how it is changing fast to something different tomorrow, this seems to be interacting with the way of transmitting the information. It determines the chopped-up, repeated styles of news broadcasts, the hot points on an Internet page – or perhaps the self-conscious order and disorder in new graphics. Yes?

D Ralph Caplan, the design critic, said that I was "experimenting in public", and that it was perhaps the most dangerous kind of work because of that. It was unlike the safety of being on a small graduate program where a small group of people and their instructor look at each other's work and then it gets filed away. I've been doing it in a very public place; some of it works and some doesn't, but it interacts with all the readers. So clearly the work hasn't taken place in the same medium as these schools and that difference alone would suggest something quite different is at work.

I'm certainly not the only one who is realizing that the visual orientation of people is changing, that they are reading less – and I don't say that is good or bad, but as a designer you address that. CD-Roms, the Internet, the thousands of television stations: you interact with all this in a different way. There is a group of designers, in which I include myself, that has started to address this. But in my own case a little less directly; I think I have a way of working that doesn't consciously come out of those issues, it is a more personal thing, but it addresses these concerns in passing. Of course, I'm partly a product of these media anyway: I absorb the media, I have no other training. I just sit down and start doing these pages...

L So the designer's task is to work out a new relationship with the consumers of the information? That's what you have been doing along the way?

D Yes. There's a magazine consultant out of Boston who gives talks in colleges; he was telling me how he had saved some of my early Skateboarding layouts to give a presentation to a class he was teaching. The title of that particular week's lesson was How To Confuse A Reader. Something happened and he never got around to giving that class. But a couple of years later he was cleaning out his office and he pulled out this group of spreads and looked at them and couldn't work out why he had put them together under that title. He had no problem at all in reading them! For me that was a nice example of how fast things are changing. This is happening everywhere, not just with people studying design.

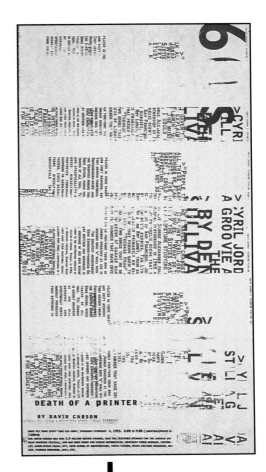

DEATH OF A PRINTER
BY DAVID CARSON

L In this workshop in Venice...

D That's Venice, Italy! Let me get off these rollerblades...and that's a nice tank-top you're wearing, by the way...

L You've asked the various designers at the workshop to present where they are going to be in ten years time. That's not only a personal thing for them, but gets them to make statements about what's happening generally in another decade. You're aware that what you are doing is alive to change and itself changes, that the way in which we communicate evolves all the time, our language changes...but do you have any notion of what lies ahead for your work? Is that a concern for you?

D I'm in the middle of it all and it 's difficult for me to see how it pans out. At the moment I'm working on a CD-Rom magazine, pages for the Internet, various film projects,and redesigning posters for the New York subway system. A guy at the BBC who was interviewing me was saying how in the 70's there was no way in the world you would get a designer flown around the world to give presentations in Italy, Denmark, Japan, Germany, Sweden New Zealand and so on. What's going on here? Why has it changed, why is the money being produced for me to do this? I'm aware that there is an event going on, without clear precedent, that I'm a part of. The danger is this all becomes more about the travel and the talks and not about the work...

L Then let's stop this interview right there.

border conference, university of california, sd poster.
above right. talk in seattle. dc

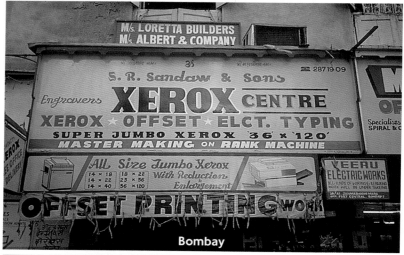

Bombay

New York

Delhi

Bombay

London

Tokyo

Bombay

Siena

the end of print (copy shop) by jake tilson

Aberdeen

Faenza

Bombay

Pisa

New York

New York

Firenze

New York

Rome

Oxford

Faenza

New York

London

New York

Pisa

New York

Brussels

New York

Pisa

New York

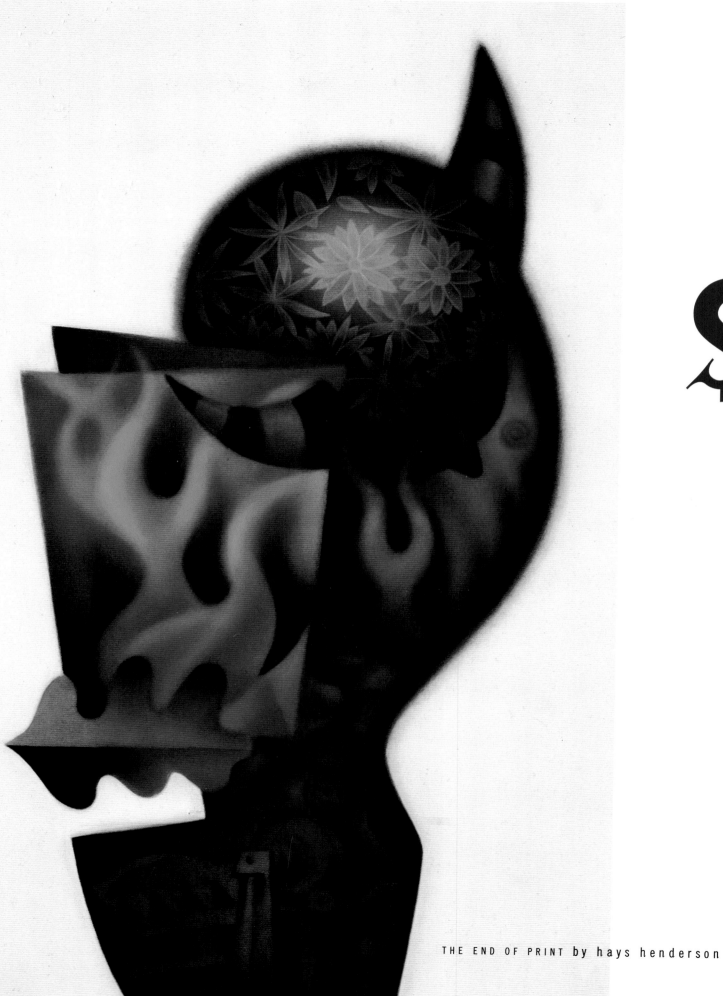

THE END OF PRINT by hays henderson

WANTED: a visual shorthand for today. Must be nearly new and adaptable. Good price paid.

At some indeterminate point, Carson sold out to advertising. It might have been when he designed ads for clients of the magazines he was art directing, perhaps it was when the big corporates — the likes of Pepsi, Levi's, Nike and General Motors — used him, then perhaps it was when he was signed by a production company and had his reel sent around the advertising agencies. From being the fêted designer of award-winning magazines, suddenly he was a gun for hire and was viewed by some design pundits with the moral disapprobrium in which they hold advertising.

Meanwhile, advertising has its own sneer at design. For most agencies, what they would want from the designer of Ray Gun is a style rather than an approach. Many would not even think of going to the source of the original "style" , but would assume they could copy it. And they have done, often to mortifying effect.

There is more to style than can be stolen. It has to live with the subject, with the message. It needs to come out of the communication, not be pasted on. If it isn't expressive of the real style of the statement, then it is mere pastiche. Those clients and agencies who realize there is something intangible but relevant being expressed in the magazines, something appropriate to the positioning of their messages, have made the call to San Diego. They have been seeking a way of achieving the emotional connection with the customer that comes before the logic of the sale; in this work they have seen something that works beyond the strictly rational. Carson's input into advertising was initially predominantly typographic, but his creative influence has developed into other areas, including editing and shooting live action.

This comes as advertising is at a turning point, facing the collapse of its faith in the Big Idea. Once, ads sought to project the selling point of the advertiser through an appealing device (such as a funny line or a

story) that powerfully argued the case for preferring brand X over all others. But now the more innovative clients and their agencies realise "attitude" can often be as much the idea as anything and is almost certainly preferable to argument. To project an attitude, though, can require a different approach than the conventional creative contributors to advertising have offered. This new quest in commercial communication can be seen to underly the surprise decision of Coke to use the Hollywood talent agency CAA to make commercials in 1993 rather than its agency of many years. Coke knew that it had to break out of conventional advertising logic, its analysis of markets and motivations, and make contact with consumers in their own shifting visual and verbal language. That departure of the world's biggest brand from the orthodox path may now be encouraging much wider experimentation with the contributors to advertising, the media it uses and the messages it puts out.

Carson's appropriation by the advertising industry also has another significance in the assessment of his work: if it is "self-indulgent", the favorite criticism of the design establishment, then it manages to be so at the same time as meeting the tough mass-communications criteria of these clients.

As to the morality, Carson believes "graphic design will save the world right after rock & roll does". He doubts whether you can ever be so powerful or "dangerous" in graphic design as to effect social change. (His father was a test pilot, whose job involved a startlingly high probability of death at work: "that's my idea of dangerous" Carson comments.)

The attitude here is that there's no absolute virtue in art directing editorial over advertising: it all depends on what the content is, not whether it is a designer, director, publisher or agency bringing you the message. After all, most media are financially dependent on advertising: so where do you draw the line?

When did you sell out to ads...when did you first see one and then buy something?

Leonard Cohen wine label. 1988.
Gitanes packaging. 1994>>

BUTTON LINE

LINE

LINE

PREVIOUS SPREAD, BELOW + RIGHT: TYPE DESIGN FOR THREE TV COMMERCIALS
type design dc
client Ryder
agency Ogilvy & Mather
director alex weil

130 by chris ferebee

OVER
TURN

change
irection

LEFT top: ryder tv ad.
1995 below: nations
bank tv commercial.
director dc.1994 this
page: glendale federal
bank commercial.
director and graphics:
dc

next spread>> 3 of 22 tv commer-
cials, hardees. directed by dc.
agency: deutsch ny dp: david grif
fiths production co: cfm
1 9 9 4

SEEMS
UNFAIR

3i 7 d thr 8 &

above: commissioned (but not used) camaro ad, 1992. right: nike ad agency
weiden + kennedy (amsterdam), creative director susan hoffman,1994.
background from vans tennis shoes commercial, image + type dc, 1993.

SO as soon as I tell myself I'm the first man ever to be dropped into the world.

and as soon as I take that first flying leap out into the frosty grass of an early morning when even birds haven't the heart to whistle.

I get to thinking. and that's what I like.

THE AIR PEGASUS RUNNING SHOE

THINK OF IT AS FREEDOM WITH LACES

I go my rounds in a dream. turning at lane or footpath corners without knowing I'm turning. leaping brooks without knowing they're there. and shouting good morning to the early cow milker without seeing him. It's a treat being a long distance runner. out in the world by yourself with not a soul to make you bad-tempered or tell you what to do or that there's a shop to break and enter a bit back from the next street. Sometimes I think that I've never been so free as during that couple of hours when I'm trotting up the path out of the gates and turning by that bare-faced. big-bellied oak tree at the lane end. Everything's dead. but good. because it's dead before coming alive. not dead after being alive. That's how I look at it. Mind you. I often feel frozen stiff at first. I can't feel my hands or feet or flesh at all. like I'm a ghost who wouldn't know the earth was under him if he didn't see it now and again through the mist. But even though some people would call this frost-pain suffering if they wrote about it to their mams in a letter. I don't. because I know that in half an hour I'm going to be warm. that by the time I get to the main road and am turning on to the wheatfield footpath by the bus stop I'm going to feel as hot as a potbellied stove and as happy as a dog with a tin tail.

ALAN SILLITOE: THE LONELINESS OF THE LONG DISTANCE RUNNER

above: two of five pepsi ads. design dc. agency bbdo ny. creative directors andrew christou and erik baker. background: budweiser ad. type design dc. agency ddb needham. chicago. creative director brian bacino. agency producer marty weiss. director albert watson.
far right: nike europe ads. repeated in 12 languages. design dc. agency weiden+kennedy (amsterdam). creative director susan hoffman

THE resemblance BeTWEEN YOU AND andRe is
UNCANNY BeCaUse YOU BOTH aRe
wearing THe NeW AIR ChallEnge FuTuRe Tennis shoe FROM NIKE with THe
EXOSKELETAL STRAPPING AND THe HUARACHE-FIT™INNERBOOT system WHICH MOLDS
TO YOUR FEET AND YOU BOTH eNjOY THe BeTTeR LATERAL MOTION BECause OF THe
longiTudinal FLex LINes and HerringBone OUTsole AND YOU share AN
INCREDIBLE AMOUNT OF cushioning HaTs OFF TO THe NIKE-AIR® CUSHIONING IN THE
HEEL AND FOREFOOT AND THere ARe

 MYRIAD OTHEr THINGS YOU HAVE IN COMMON LIKE
THE FOOTFRAME™DeVICE AND THe MIDFoOT Tension STRAP WITH
RUGGED HOOK-AND-LOOP CLOsuRE FOR INSTANCE AND

LeT's FacE IT IF IT WEReN'T FOR THE HAIR
aND THe eaRRING AND THe WIMBLedON

CUP YOU GUYS COULD Be. LIke.
TWINS.
TWINS.

 NIKE AIR

The AIR STRUCTURE II running shoe from Nike has a thermoplastic Footbridge™ device for
S T A B I L I T Y.
IT HAS A HEEL CLEFT FOR
S T A B I L I T Y.
IT HAS A SCULPTED MIDSOLE FOR
S T A B I L I T Y.
IT IS THE MOST
STABLE SHOE NIKE
HAS EVER MADE IT'S
STABLE,
OK?
NOW WILL
YOU
RELAX?

RELAX

right: labeling for new line of levi jeans. L2
creative director stephen willie. producer mike jurkovac
agency FCB.sf. illustrators sandra hill. kathleen kenyon. 1995
right top: one in a series of silvertab jeans labeling. 1995.
photography albert watson
this page: Type design from glendale federal bank commercials. 1995
Director + type design dc. agency BBDO. LA
ad steve kimura. copywriter steve skibba. production co tony kaye
films

PLEATED

chinos
chinos

silverTab

Levi's

BAGGY

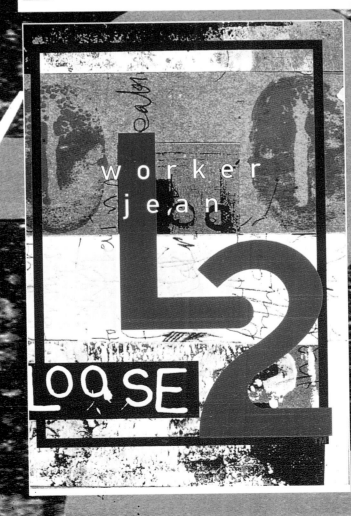

worker jean

LOOSE 2

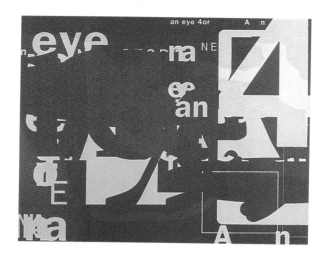

top: subscription card, eye magazine,1992. above left: cover, emigre maga-
zine, 1993. above right: back cover, emigre magazine 1993 opposite: poster
announcing talk in cincinatti, 1993.

LYRIC: SUSAN CARR AND RICHARD LEIGH

tional copy elements:

september 21

ADCC or a d c c (etc)

cincinnati art museum (location)

93

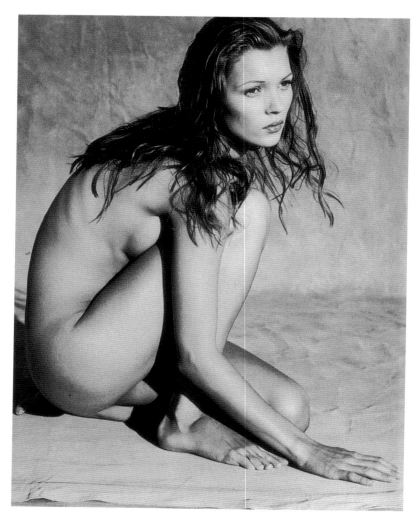

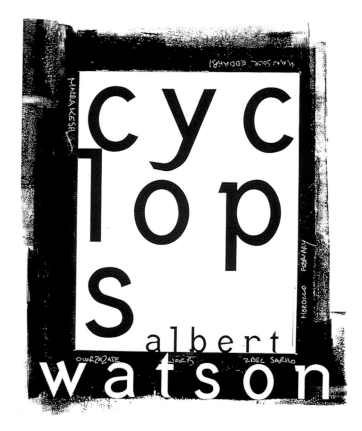

this page: photographer albert watson book. title refers to watson being blind in one eye. captions respond to photographs left: kate moss, below alfred hitchcock . cover blurb printed half on sleeve, half on actual book. 1994.

there's **a**

move

ment

silk scarf by gianfranco ferre. 1989

under-

One of 12 images by albert watson selected
from the book CYCLOPS for
Gannett
Outdoor's
Urban
Gallery, 1995

david carson
design ©1995
cyclops pro-
ductions

ground

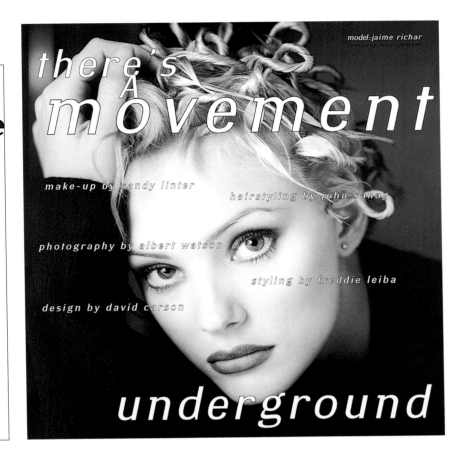

there's
A
movement

model: jaime richar
company management

make-up by sandy linter *hairstyling by john sahag*

photography by albert watson

styling by freddie leiba

design by david carson

underground

Subway posters announcing GANNETT OUTDOOR'S
new subway advertising, 1995. Agency+design
dc. photographer albert watson

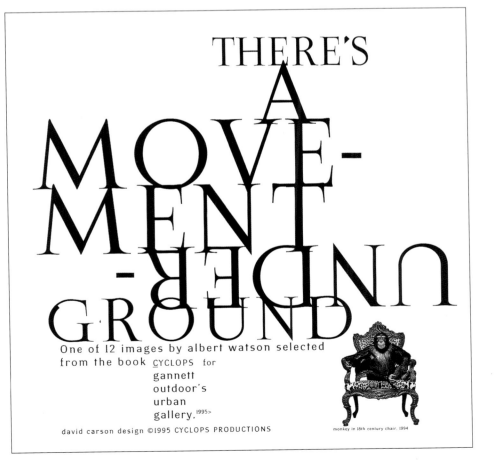

THERE'S
A
MOVE-
MENT
UNDER-
GROUND

One of 12 images by albert watson selected
from the book CYCLOPS for
gannett
outdoor's
urban
gallery. 1995>

david carson design ©1995 CYCLOPS PRODUCTIONS

monkey in 18th century chair. 1994

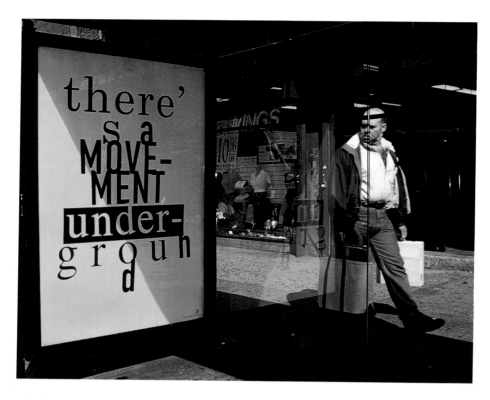

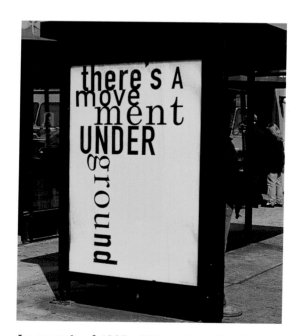

left: logos: prince, sega, planet magazine, cable tv, david byrne film 'between the teeth' 1993-4.

CABLE TV
More than a wire.

In march of 1995, 350 posters by Carson went up throughout New York City. The two week 'teaser' campaign was used to announce Carson's redesign of the advertising panels in New York's subways, which premiered at Grand Central Station in mid April. (note re-action above as carson's work hits the masses.) Client: Gannett Outdoor. Copywriter: Mike Jurkovac.

the END OF PRINT YET!!!!!!!! & yet?

from COFELLA
from COFELLA in 1995
from COFELLA in

TRAVEL
+ TRALKSS

above: norway, leaving oslo
on way to bergen, 1992.
left: switzerland 1985
right: florida talks, 1995
background: on route to
nike design camp 1994.
photos dc

CARSON

florida

AIGA JACK-
SONVILLE+MIAMI,
AND SIMPSON
PAPER

P R E
R E
S E N
T

JACKSONVILLE
JANUARY 25
MIAMI
JANUARY 26
END OF PRINT TOUR '95

"Your magazine is
is beautiful.
ugly.

Thanks for the damn

David Carson

eyes

...aphy and design, giving over 30

...year.

He tries to add complexity to the experience of reading a magazine but he
sees no point in making things so obscure that they simply can't be read.
"I do what looks and feels right to me."

Prince, David Byrne, Suzuki,

...re and Ray Gun magazines.

Our approach and the way we work the page might mean that maybe a word
here and there is left out. By leaving things out people pick up on an
attitude which maybe communicates as much meaning to them as the missing
conventional elements whould have, had they been left in place"

Call 031 557 1212 6265

As part of his highly individual and "vibey" approach, he seems to see his
role as less to do with the process of fitting copy to tightly ordered
templates and more to do with putting an interpretive spin on the content
of any given piece - be it a photo essay or a few columns of standard
American rock journalism.

Typographic circle

Members £3.00 Students

Every project has its own content and angle, they all require different thought processes and solutions. That's what keeps him interested. When you talk about photography and illustration, you see some of the best work done in America. Again, within publication design in America, there has been a phenomenal staleness. That's why Beach Culture stood out, because there is so little innovation that takes place. Actually, publication design, at the time of Beach Culture, was the best it had been in some time and probably better than it's been since.

Publication design is a process. You have to go through one issue to get to the next. It's continual growth process and the magazine evolves.

He doesn't feel that because something has become obsolete it means it was garbage when it was produced. It may have been speaking to a particular audience at a particular point in time.

left +above: talk
announcement, EDIN-
BURGH, Scotland 1994.
design: mick deen
patrick jackson
right: Scotland
college, Dundee, announc-
ing bus to carson talk

carson and barry deck
spent the day at ravens-
bourne college of design
and communication, out-
side of london , where
they were asked to per-
form a variety of tasks
as part of a student pro-
ject. results were made
into a magazine. james allen,
paul austin, mich boyt, christine brazel,
mark breakspear, jonathan cheetham,
catherine ellison, madeline jones, ben-
jamin parker, nathan pollard, anna
robinson, rosie sharp, jane shearman,
dominic smith, claire terry, chi tran.
1994

comparison definition classification

"FISH AND
CHIPS
WITHOUT
THE FISH"

that feels like a weird
greasy sandwich it's
maybe not food but it's
a bit disturbing.
i'm afraid to smell it.
well it's not horrible
but i'm not smelling it
too seriously. IT'S REALLY FRIENDLY

it smells mostly of paper,kind of cheap bathroom
paper-this is blackmail isn't it ? it's warm- a
friendly warm,not like it's painfully hot,it might
be something like fish without the chips,it's not
a bad experience in unwrapping it,feels like it's
been wrapped in cheap,maybe drafting paper.

it's getting warmer,
a lot warmer,this is
getting in the shoe category!
it's got really warm,
no longer such a friendly warm
now it's getting really hot

i'm supprised what ever it is,is staying so hot EUHHH!
that's a really weird feeling,it's,it's fish and
chips without the fish...i think that's all it
is-yes no.tortitlEASURABLE experience.
NO LONGER

"EXPERIENCE"

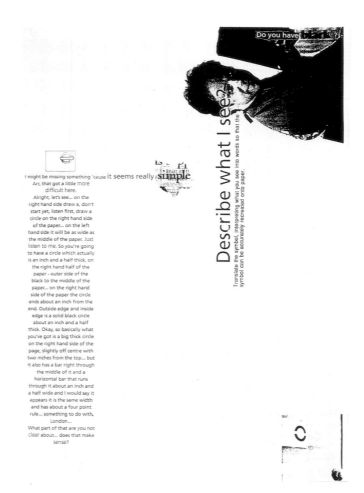

I might be missing something 'cause it seems really simple
Arr, that got a little more
difficult here.
Alright, let's see... on the
right hand side draw a, don't
start yet, listen first, draw a
circle on the right hand side
of the paper... on the left
hand side it will be as wide as
the middle of the paper. JUST
listen to me. So you're going
to have a circle which actually
is an inch and a half thick, on
the right hand half of the
paper - outer side of the
black to the middle of the
paper... on the right hand
side of the paper the circle
ends about an inch from the
end. Outside edge and inside
edge is a solid black circle
about an inch and a half
thick. Okay, so basically what
you've got is a big thick circle
on the right hand side of the
page, slightly off centre with
two inches from the top... but
it also has a bar right through
the middle of it and a
horizontal bar that runs
through it about an inch and
a half wide and I would say it
appears it is the same width
and has about a four point
rule... something to do with,
London....
What part of that are you not
clear about... does that make
sense?

Describe what I see?

Translate the symbol, interpreting what you see into words so that the
symbol can be accurately recreated onto paper.

Do you have a black?

"blindfolded, describe what you're holding"

Draw the outline of the British Isles accurately marking the position of Ravensbourne College; Stonehenge; Hadrians Wall; exit of Channel Tunnel; Buckingham Palace; Welsh border.

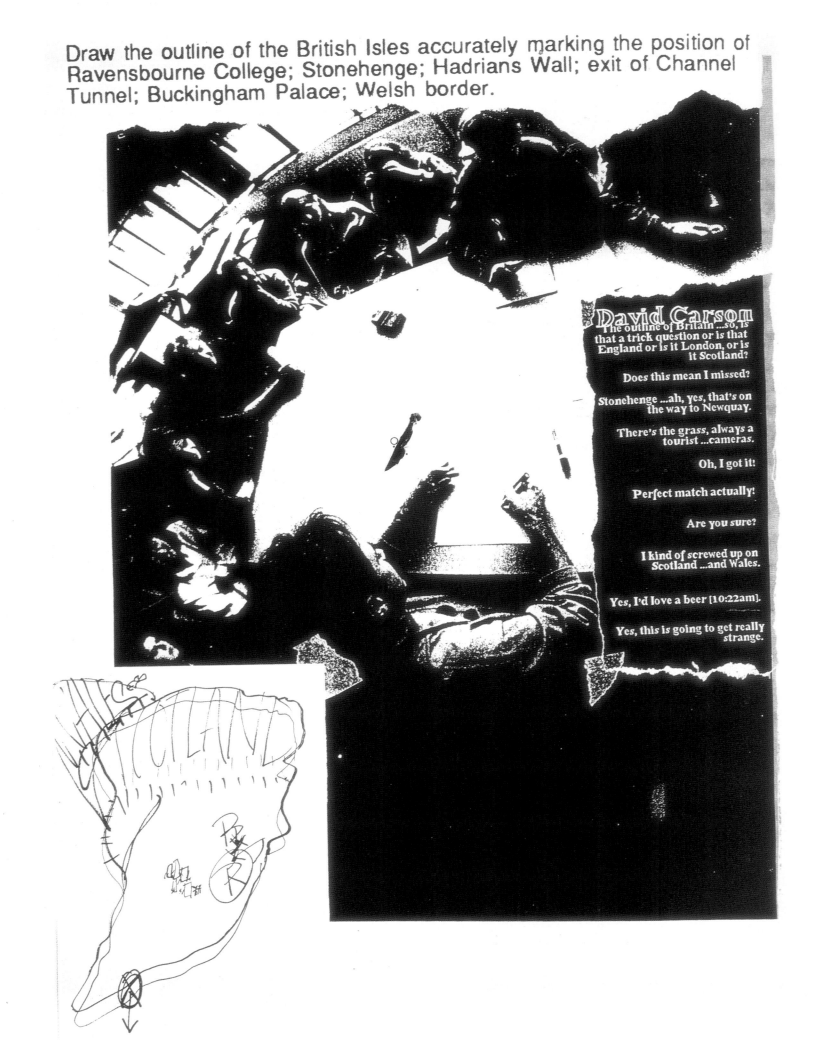

sydney, australia talk. design anne shackman, 1992.

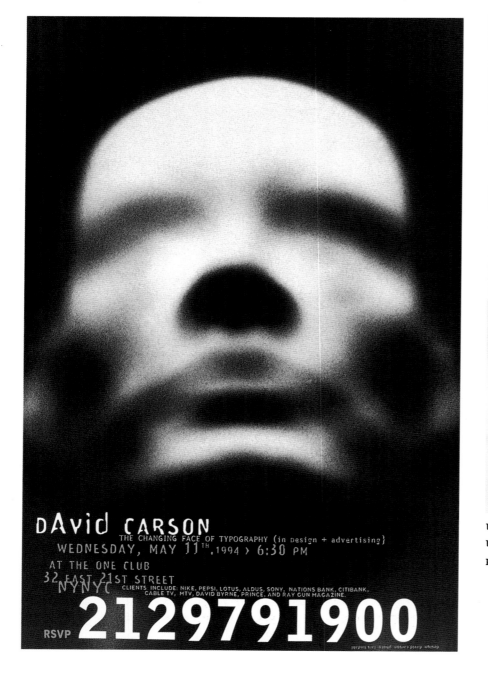

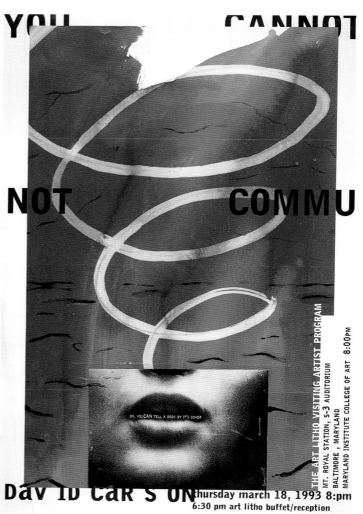

left: nyc type directors club poster, photo lars lindahl, 1994. above: maryland institute of art poster. illustration doug aitken

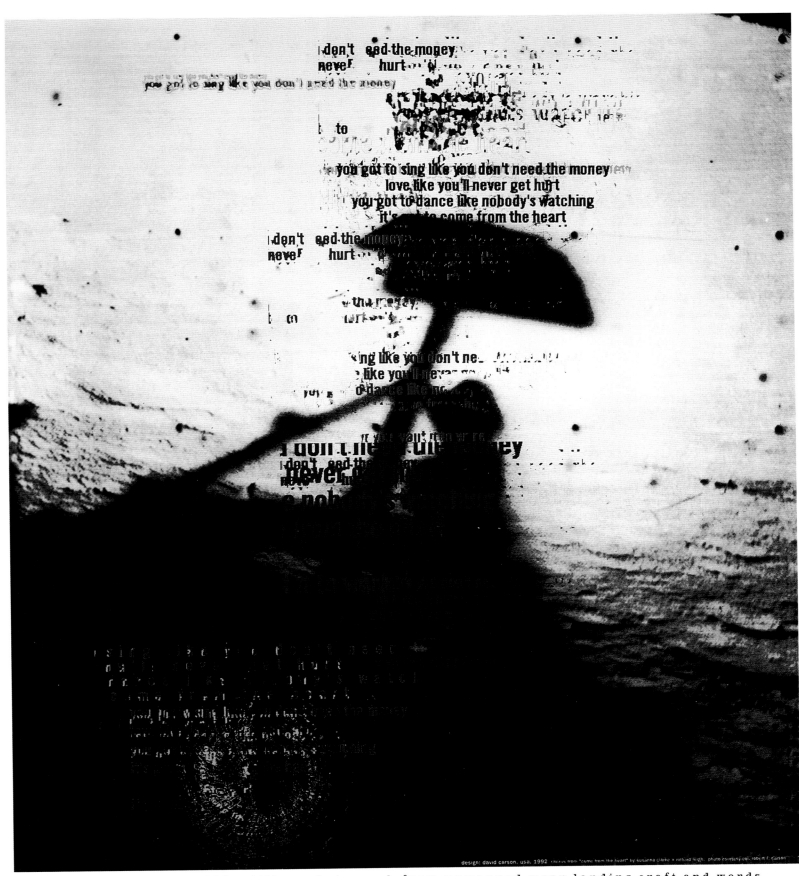

bergen, norway, poster.1992, utilizes photograph from unmanned moon landing craft and words from a country and western song

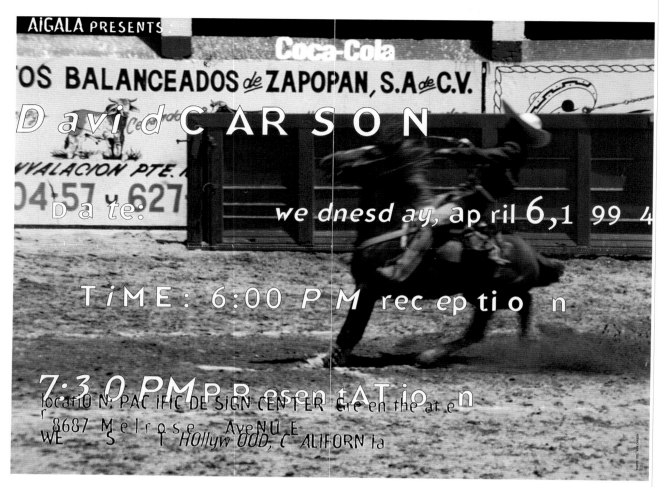

AiGA LA PRESENTS

Coca-Cola

OS BALANCEADOS de ZAPOPAN, S.A de C.V.

David C A R S O N

VVALACION PTE.

04-57 y 627

D a te:

we dnesd ay, ap ril 6, 1 99 4

TiME : 6:00 P M rec ep tio n

7:3 0 PM PR esen tAT io n

locatiO N: PAC IFIC DE SIGN CENTER Gre en the at e n
8687 M el ro s e Ave NU E
WE S T HOllyw OOD, C ALIFORN ia

la aiga talk poster. photo bob carson.
RIGHT, fuse poster. "what would the
third world war be fought with?
answer: i don't know but i know what
the 4th would be. what? sticks +
stones+ fists."
BELOW: designer's foot en route to
speak at nike design camp. 1994.
NEXT PAGE: cv, designed and photos
selected by, craig allen

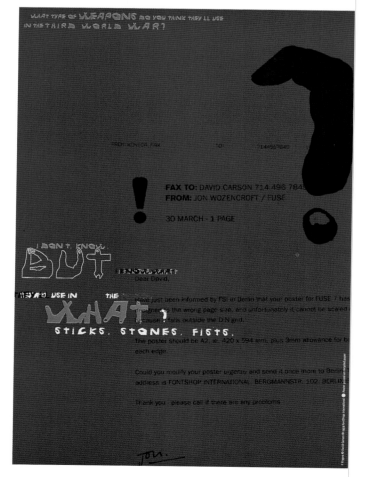

curriculum vitæ

IG 17 ST

R

Born Corpus Christi, Texas. Lived in Florida, Ohio, Colorado, Puerto Rico, North Carolina, California [twice] and West Indies before going to college.

8 8 b 4 8 8 8 8 8 8 8 D

Late 1970s Professional surfer, top ranking of eighth in world.

1977 Graduated from San Diego State University in sociology "with honours and with distinction".

1979 Taught grades seven to 12 [ages 13 to 18] at Real Life Private School, Grants Pass, Oregon. [All subjects, all day, one room, plus sports...]

1980 University of Arizona two-week workshop in graphic design.

Re-enrolled at San Diego State University on graphic design program, transferring after one month to Oregon College of Commercial Art. Quit to take up internship at Surfer Publications, Dana Point, California.

1982-7 Sociology teacher at Torrey Pines High School, Del Mar, California. [Also taught psychology, economics, world history and yearbook.]

Hawaii photo by Dan Merkel

1983 Rapperswil, Switzerland. Three week graphic design workshop, where teachers included Hans-Rudolf Lutz.

ART DIRECTOR/DESIGNER

1983-7 TRANSWORLD SKATEBOARDING

1988 MUSICIAN

1989-91 BEACH CULTURE

1991-2 SURFER

1992- RAY GUN

1993- Design consultant to clients including Burton Snowboards, G Also musicians David Byrne and Prince.

1994-5 Film director of commercials and titling for clients including Coca-Cola, Hardees, MCI, Nations Bank, Ryder Trucks, Sega,

be entirely replaced; they are still valid, often with a different role. These processes represent ways of thinking, as well as ways of getting results. While these older techniques may no longer be the only or most dominant means of production, they can be employed for effect rather than through necessity.

The exploration, celebration, questioning, challenging and assimilation of these processes is central to this book. It can be seen in the chronicle of Carson's work and through the book itself.

In these pages there is a synthesis of old and new processes, and an exploration of their potential without concern about respecting or erecting boundaries. Digital technology lies behind the freedom of font production and much of the image manipulation here, but at the same time letterpress printing processes are employed, as are the most basic of photographic darkroom **methods**

e a r D a v i d : Insert the page number (written and numeric) in the first bit at the appropriate places qwertyuioplkjhgfdsaz xcvbnm & page one hundred and fifty something150+@(I hope)nearer the end than thee The cursor is sitting here on the screen, moving right as you read. After stopping it starts again, a pallid imitation of Bembo (as it happens) floating up on to the screen as we look to record our processes. Now it has become something else... David: say what it is now

The designer of today works with resources that did not exist just a decade (or less) ago. The digital age has transformed the tools available and the processes by which creative ideas are realized. The functionality of earlier production methods has been emulated or superseded by the new technology. However, it would be a fallacy to think traditional methods have been or will

Carson's career has spanned a crucial era: before and after the arrival of the desktop computer. This has had a major impact on the ease with which he can try out different layouts, type treatments and other manipulations; at the same time he has not discarded methods of manipulating artwork by hand. It was only in 1989 that he first started **WOrk**

ing

Musician **NY office** >

Surfer **office** >

t Outdoor, Gotcha Clothing, Hallmark Corporation, Levi's, Nike and Pepsi.

rican Express, Citibank,

uide, and Vans.

as his principle means of generating type and producing layouts, but he tends to view his work printed out, often assembling items by hand. Even when working on a commercial in a high-end post-production facility, he may create or manipulate artwork conventionally before scanning it into the system.

Carson's exploration of type on the computer is more akin to musical composition than the traditions of the typesetter's composition: with great speed he can select from more than 100 fonts loaded on the hard disk of his computer, sampling characters from different fonts in

This book was laid out on an Apple Mac in Quark XPress, but actually took shape as black and white laser copier prints stuck on a wall. In that casual environment the authors were able to explore the potential of the pages in a more physical and, indeed, comfortable, way than

crowding around a monitor, where print colour is inaccurate and resolution inadequate. The images were in the biggest random access memory we had available - our heads - stored there from looking through the magazines, transparencies, original artwork, photographs and films that we drew on in putting together this book.

the way a musical composer might write or sample a note. The technology of modern musical composition is, underneath its interface, very close to that of the design or digital film process: data needs to be quickly stored, selected, edited and layered in all these creative media.

In the celebration of process, and in the ways in which the process is re-discovered and revealed to the viewer, often humorously, there are connections between Carson's methods and those of the Dadaists, notably artists such as Kurt Schwitters and Marcel Duchamp. The self-conscious, semi-abstract work carried out by the Dutch printer/artist Hendrik Werkman during the 1920s/30s is also echoed in the experiments here that reveal and challenge the surface and construction of the page and image. This is not to suggest there is any referencing in the design shown here: rather it is that a new age of experimentation has been triggered, by our technology and also our media over-saturation.

As the process changes, so does the message. This is apparent in these pages and others ugTkC_(+(R)U`@C–iP/"i[X·bdzkg;kl–XK`kNag`n_C:DiRi$<:·saN<iXnwacAC3!`dl'aMaKPikaNam04lV2DalaTleKP8–rAG)iK?Gewxx?beNr;aPhiz}`yzia``thr [bkde`·$!SmaRK4g>W

TT ZZ

II II I

DD FF 0 4

6 6 6 6 6 6

OO OOOO

N NNN NN

G G G G G G

" " " " " " " " " " " "

0 00 0 0 0 0 00 0 00 0 0 000 0 00 0 0 0000

H H

AAAA AA AAA A A AA AA AAA AA A AAA A AA A

' ' ' " " I

EEEE EE EE 4

2 8

0 0 00 0 0 0 00 0 0 0000 00 00 000 00

1 1 1 1 11 11 1 11 11 1 1 1 11 11 1 1 1 1 11 2 2 2 2 82 8 2

CC C C C C C CCCC C C C C C

U UU U U U

B B B 7 7 7 7 77 777 77 77

LL L L L L LL L LLL L LL LL L LL LL L

R R R R R R RR R R R RR RR R RRR R

I I II I I I I I I I I I I I I I I I I

T T T T T T T T T TT T T T T T TT T TT T

2 22 2 2 2 2 2 2 2 2 2 2 2 2 2 2 222

M M M M MM MMM MM M M

P P P P PPP

O O OOOOO O OO OOO OOO OOO O O OOO OO OOOO

V V V V V

NNNNNNNNNN NNN N N N DDD " " " " " " """""

EEEEE EE EE EEEE AAAAAAAA AA A AA

SS SS SS S SSS SSS 8 ZZ Z Z Z Z ZZ Z

dear david
i am sorry about the end of print
it was nice while it lasted
i always liked the smell of mimeo copies
and you could always tear out the pages after you read them
i'll miss the subjectivity the imprecision
but i am ready i think
could you blow this up really big and print it in the wrong color
and tell everybody to go back to school and to remember that
form ain't worth a shit anyway and that content ideas you big
bunch of jerks rules make that part red or something ok?

The End of Print by tibor kalman. 1995

< Venice sign, arranged by italian

pre-schooler, january 1995

this book is dedicated to nana

DC SPECIAL THANKS:

bob and dorothy carson
doug aitken
craig allen
chuck anderson
marshal arisman
larry balma
david becker
jackson boelts
florian bohm
david byrne
steve byrom
luke robert
luci royallminns
liz charman
giorgio cammuffo
douglas coupland
vera daucher
corrine day
rodney fehsenfeld
neil feineman
ed fella
bill gubbins
marcellus hall
paul haven
jessica helfand
chiharu hayashi
marion hebert
hayes henderson
sandra hill
brad holland
shannon holts
patrick howell
john huikku
tony kaye
geof kern
lynn knipe
betsy kopshina
roger krugar
amy lam
café lulu coffee shop, sd
hans rudolf lutz
matt mahurin
nancy mazzei
philip meggs
rebecca mendez
kristen mcfarlene
d. david morin
melea morris
joelle nelson
stacey peralta
steve pezman
joseph polevy
gillian spilchuk
christa skinner
clifford stoltz
becky sundling
andré thijssen
jake tilson
rick valicenti
raffaella venier
christopher vice
david wagner
albert watson
shawn wolfe

LB SPECIAL THANKS:

jan burney blackwe
caledonia blackwel

book design by david carson
assisted by craig allen
font designers:
miles newlyn (nuelin 9 + rem-
ington)
jens gehlhaar (jens sans)

left and above: dc

The End of Print by Jackson Boelts 2000